W9-ABP-096

A

TASTE

OF CUBA

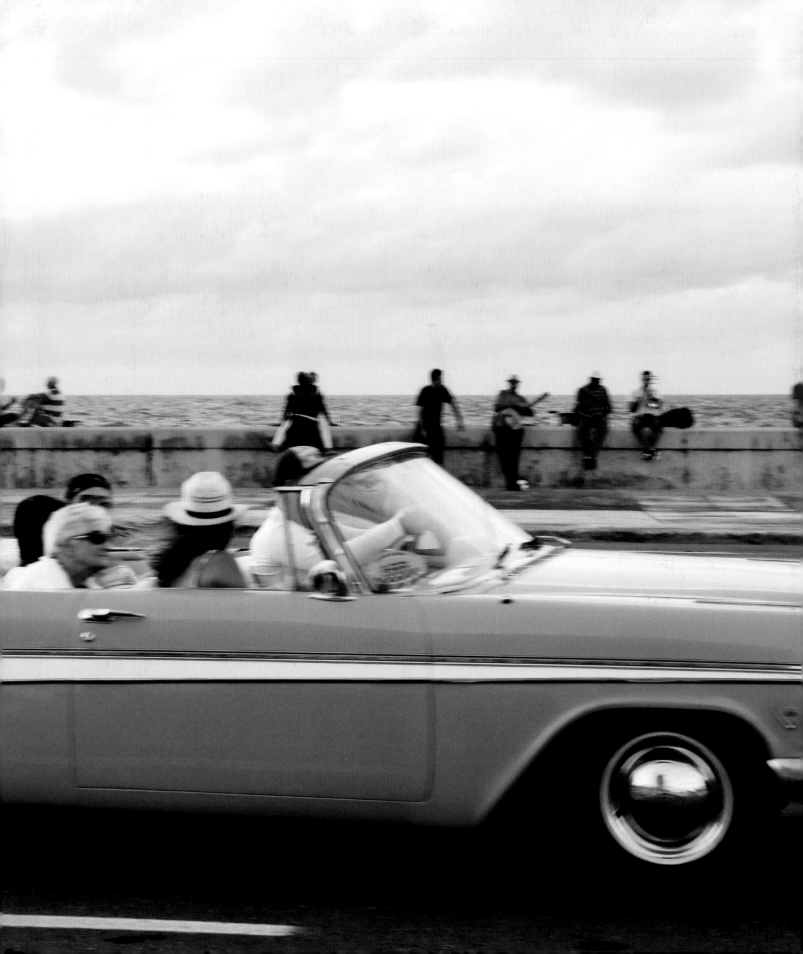

A
TASTE
OF CUBA

A JOURNEY THROUGH CUBA
AND ITS SAVORY CUISINE

INCLUDES 75 AUTHENTIC RECIPES
FROM THE COUNTRY'S TOP CHEFS

CYNTHIA CARRIS ALONSO

INTERVIEW AND TRANSLATION ASSISTANCE BY
JOSÉ LUIS ALONSO

RECIPE WRITING AND TESTING BY
VALERIE FEIGEN

APOLLO
PUBLISHERS

A TASTE OF CUBA
A Journey Through Cuba
and Its Savory Cuisine
Includes 75 Authentic Recipes
from the Country's Top Chefs

Apollo Publishers books may be purchased
for educational, business, or sales promotional
use. Special editions may be made available
upon request. For details, contact Apollo
Publishers at info@apollopublishers.com.

Visit our website at www.apollopublishers.

Library of Congress Cataloging-in-
Publication Data is available on file.

Cover photographs by Cynthia Carris Alonso.
Cover and interior design by Rain Saukas.

Print ISBN: 978-1-948062-00-8
Ebook ISBN: 978-1-948062-07-7

Printed in the United States of America.

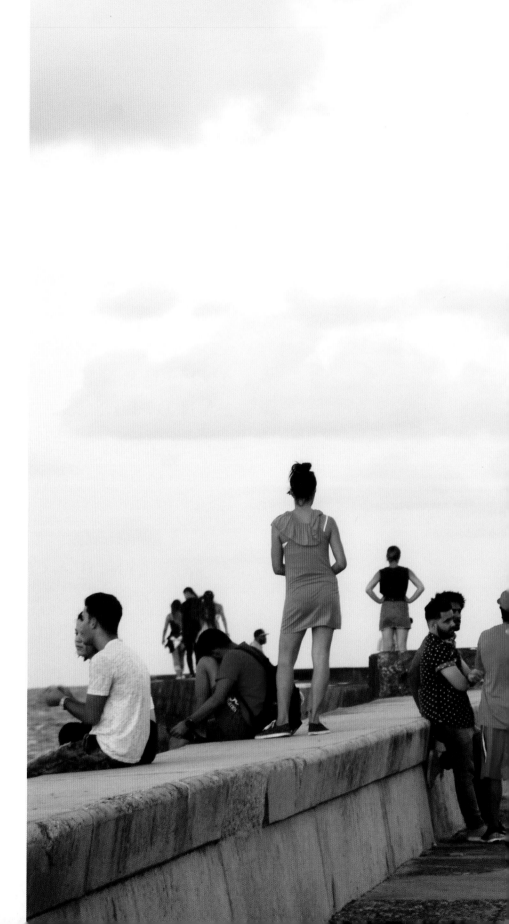

Page 2 and right: *People on
the Malecón in Havana.*

This book is dedicated to our ancestors who loved to cook and whose recipes and techniques were passed from generation to generation . . .

AND

to the talented and creative Cuban chefs who shared their recipes, stories, and inspirations with us for this book.

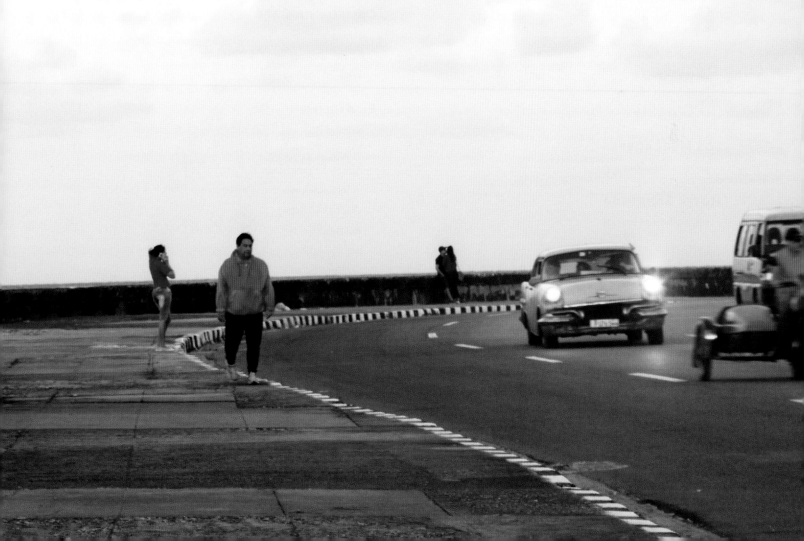

CONTENTS

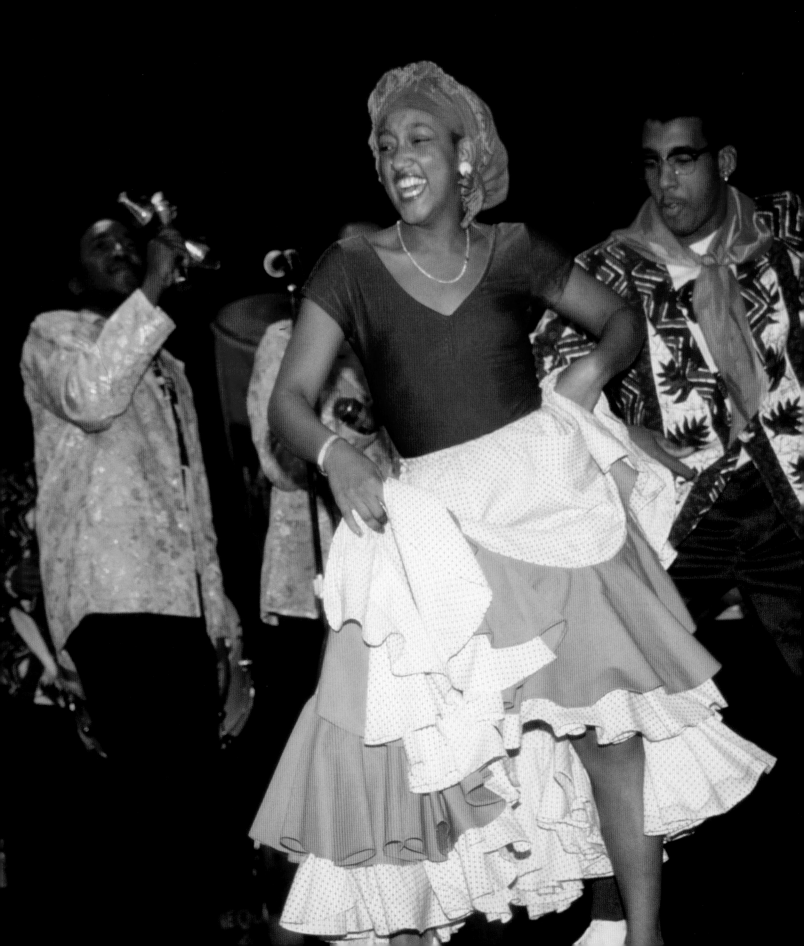

PREFACE

SHARING THE CUBAN SPIRIT: CUBA'S TOP CHEFS AND THEIR CULINARY CREATIONS

BY CYNTHIA CARRIS ALONSO

Cuban chefs are alchemists who transform limited ingredients into savory dishes full of flair and flavor. For this book, I had the great honor of collaborating with Cuba's most distinguished entrepreneur restaurant owners, chefs, and their staff members. I was welcomed into the kitchens of their privately run restaurants, or popular *paladares*—small, family-run restaurants located in their homes.

With this book, we give voice to Cuba's most notable chefs working today. We share their recipes—many written down and translated for the first time—and their stories, inspirations, and techniques. We also extend an invitation to you to travel with us into their paladares and restaurants, as well as the neighborhoods where they are located. My hope is that you'll be intrigued by the energy, color, and character of Cuba, and inspired to make its most flavorful dishes in your own home. Cuba is so close to US shores and yet, for many Americans, it is mysterious and foreign. *A Taste of Cuba* offers the opportunity to transcend time and politics, for a unique glimpse into the enigmatic Cuban culture through its people and their food.

I've been traveling to Cuba for twenty-five years, photographing and writing as a journalist with rare access. This book, my second tribute to the Cuban spirit, is a mix of historical information, my photographs of this unique country, exclusive recipes from its top chefs, a visual showcase of mouthwatering dishes, and step-by-step instructions for you to make Cuba's best dishes and embrace its complex flavors.

At a quick glance, Cuba appears in a surreal state, paused in time with classic cars, historical, neoclassical architecture, antiques, and other ubiquitous homages to the past. However, if one looks deeper, into the soul of Cuba today, one finds a rapidly changing and developing culture of entrepreneurship bubbling with hope, excitement, and opportunity. Recent Cuban

reforms and opened borders have created a new wave of renovation and innovation in Cuba, one flowing with possibilities and creative expression, particularly in the culinary realm.

In the early 1960s, when the Cuban political system transitioned toward a Communist society with economic support from Russia, which bought Cuban sugar at higher than market prices, meals were mostly confined to homes and state-owned restaurants. When the Soviet Union dismantled in the early 1990s, Cuba lost Russia's vast economic support, causing a scarcity of food and other basic necessities, including gas and electricity, needed for refrigeration and cooking. Ingredients became limited with the loss of Russian imports and could only be obtained with government-issued ration cards, or on the black market. To alleviate the situation, some Cuban chefs began secretly serving and selling meals in their homes, creatively using whatever ingredients could be obtained. After a few families petitioned the government, in the 1990s, they eventually received permission, with detailed regulations and restrictions, to open restaurants in their homes. These new family-run eateries were named paladares after the Spanish word paladar, which means "palate." Years later, in 2011, sweeping economic reforms encouraging privatization of business in Cuba, led to loosened paladar regulations and increased possibilities, particularly for food businesses. Today, there are close to two thousand unique paladares around the country.

Still, while opportunities for Cuban entrepreneurs have grown, their work is far from easy. The challenges facing Cubans, especially those working in the food sector, remain

Page 8: *A performance by Los Muñequitos de Matanzas.*

Right: *A man selling bananas in Taguasco, Camagüey.*

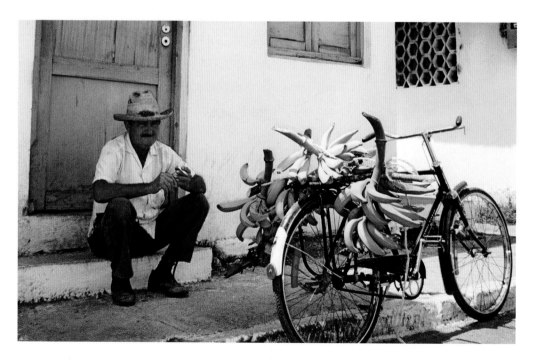

extensive. The owners and chefs who contributed to *A Taste of Cuba* shared stories about the difficulty of finding fresh ingredients in a country that is still struggling economically and has a lack of resources, including spices and other food items, as well as continued restrictions and regulations on private enterprise. Many of the owners and chefs who contributed to *A Taste of Cuba* told me that they spend their days "resolviendo problemas," solving problems. Consequently, the cost of running a successful paladar or restaurant has caused menu prices to escalate, and as a result, foreigners make up the majority of guests at the more upscale dining establishments. These establishments are prohibitively expensive for most Cubans, who are still struggling to provide food for their families at home.

Nevertheless, in true Cuban spirit, culinary entrepreneurs face their challenges with creativity, determination, and survival skills. In a nation that has long celebrated art and artists, talented chefs are now being given the opportunity to showcase their expertise. The result is a rapidly burgeoning advancement of the private food industry in Cuba.

Watching the chefs in this book at work gave me a firsthand look at their skills, inspiration, and innovation. The chefs not only have an impressive understanding of food and cooking techniques, but they also have an extraordinary ability to improvise and add their own special "Cuban touch" as they create dishes using the limited ingredients available to them at any given time. I visited each chef's kitchen several times while making this book and also e-mailed and called every owner and chef to verify ingredients, quantities, processes, and presentations. Each visit, message, and call brought me closer to the members of the paladares and restaurants, but they sometimes left me feeling I was farther away from knowing and understanding the recipes than I was before the visit or communication. It was this confusion that eventually led me to realize that because the availability of ingredients varies in Cuba, and chefs have to improvise accordingly, their dishes and menus are continuously evolving. Therefore, while the dishes featured in this book were made for us in the paladares and restaurants, it's possible that they will taste or look different, or even no longer be on the menu, if you have the opportunity to visit. Additionally, many paladares featured, even though they have delicious food, may not survive the hardships of running a business, or the turbulence of politics and natural disasters such as hurricanes. What is certain is that the meals you create from the recipes in this book are sure to be delicious: a dynamic feast from a country where trade barriers and political policies are constantly transcended.

In the pages that follow we share recipes for some of the remarkable, flavorful dishes the chefs made for us, so you can recreate and enjoy them in your own home. Some of the

measurements and preparation instructions given by the chefs were endearing and very "Cuban," as when I was told to add a "coffee cup"-size quantity of olive oil, or to "be sure to stop and lay the food out to dry in the sun." There was one chef who explained, "and then when you think it's ready, but it's not really ready, you stop." Another gave me a recipe that included one ingredient measured to a week's worth of quantity for the restaurant and another ingredient measured for a single portion. My last call about a recipe was with a manager who summed up the recipe-gathering experience when she said, "It would be much better if you could come back here in person again, so we can go over the recipe and cook together." The chefs didn't always know how to translate their work into words; their hands seemed to have a mind of their own.

The conversation I had with this manager confirmed for me that I had the team I needed to turn the vision of the book into a reality. My husband of twenty-five years, Cuban-born, award-winning writer José Luis Alonso, facilitated obtaining the recipes and interviewed the preeminent chefs and owners of the restaurants and paladares. José Luis loves to cook and grew up in Cuba cooking with his grandmothers. His help with the interviews allowed us to preserve the authenticity and intended meanings of the shared stories and recipes, particularly when Spanish had to be translated to English.

After our visits and interviews, back in New York City, José Luis and I worked with our longtime friend and gourmet Valerie Feigen, who meticulously ran our test kitchen using her analytic skills, tireless energy, and determination. Valerie translated metric units into US ones, created measurements from non-measured amounts, and made sure the Cuban dishes could be recreated using ingredients easy to find in the United States. Valerie understands gourmet cooking, food, and flavor, and was lured by the challenge of helping us understand what the chefs were thinking when they created each dish. Through every step, Valerie worked to recreate the chefs' original dishes and in A Taste of Cuba she helps explain how you can do the same.

The access and permission I was given to collect the text and photographs in this book was unprecedented. The Cuban entrepreneurs and chefs were kind, approachable, and generous with their time as they shared their secrets, stories, recipes, and techniques with me. Each moment I spent with them felt like a celebration of life—one mirrored in each dish they prepared and each recipe they shared.

The paladares and restaurants profiled include ones that have been providing exceptional food and a distinctive atmosphere since the 1990s, as well as newcomers to the Cuban epicurean scene. I was welcomed because of my experience and credibility in Cuba, gleaned

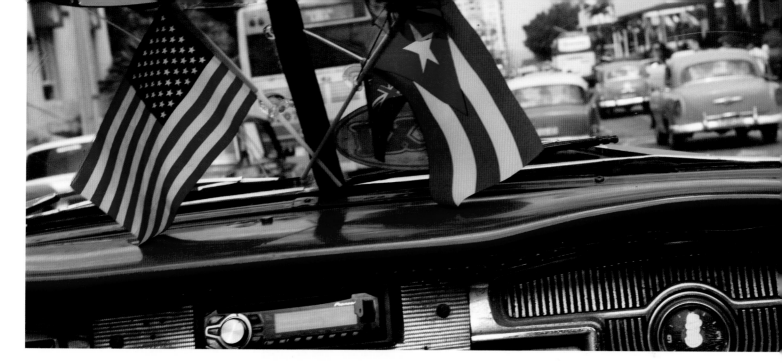

Above: *The Cuban and US flags displayed together in a car in Old Havana.*

from my many years photographing and documenting its news events, street scenes, daily life, and artists. Being married to a man from a well-known artistic Cuban family also helped open doors.

For me this book is the continuation of a love affair I've had with Cuba's culture and people since I first traveled to Cuba, in 1992, as an American photojournalist. Ever since, I have been inspired by the beautiful character and spirit of the Cuban people. Their seemingly endless appreciation for the pleasures of living, despite often-overwhelming challenges, flows through them with an abundance of passion, generosity, curiosity, and compassion. Cubans love to laugh, have a great sense of humor, and maintain an optimistic perspective on life. Even when faced with dire circumstances and uncertainties, they remain hardworking and find emotional strength and resilience through a heartfelt commitment to their values of education, family, friendship, food, art, and community.

Through the images I've taken over the years, I have aspired to reflect the effervescence, enthusiasm, energy, and creativity of the Cuban people and to celebrate their character. My goal with this book is to provide a visual entry into Cuba's culture, neighborhoods, and food through photographs, history, and recipes from the country's top chefs. While working on this project, during my travels to Cuba, I saw how the life-affirming character of the Cuban people is ever more apparent today, and ever more evident in the eating establishments showcased in this book.

We are grateful to everyone in the United States and Cuba who helped us create this book. We hope these recipes inspire your cooking and delight your palate, and that the information and photographs fuel your appreciation for the Cuban culture and spirit.

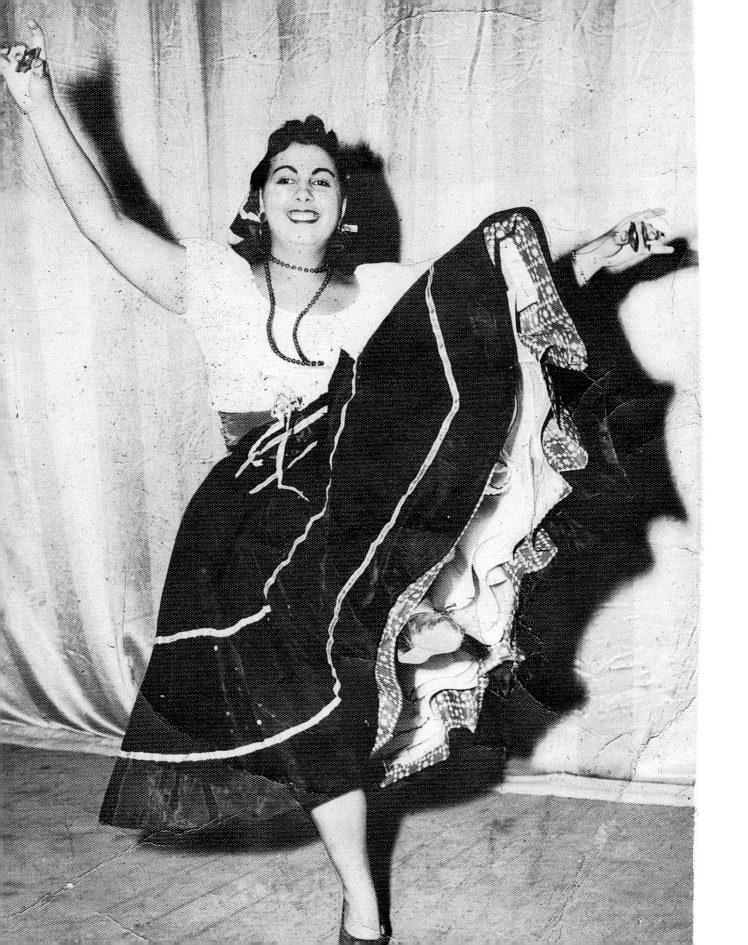

CUBAN CUISINE AT HOME: THEN AND NOW

BY JOSÉ LUIS ALONSO

My favorite memories of Cuban cuisine are from my childhood. Growing up in Cuba, there was a wonderful sense of sharing enjoyed while sipping *cortados*, small cups of Cuban coffee with milk. Family and friends would also spend time together enjoying the savory tastes of Cuban meals, a fusion of flavors from Taino, Spanish, French, and African cultures, as well as those of nearby Caribbean islands. We'd learn from each other's personal stories and we'd gossip, always surrounded by laughter.

The strong scent of coffee, most often made from beans harvested in the fertile farms of Pinar del Río, on the west coast of Cuba, heralded the start of each day. The soothing aroma of warm freshly baked bread with melted butter and eggs welcomed me to the breakfast table. With the passing of the years, I've come to realize that the real value of Cuban cuisine for families has always been about bringing different generations together to share recipes and cooking techniques, family traditions, and stories—all while enjoying the unique and delicious taste of Cuban food.

Each family honors these customs in various ways. In my case, I learned culinary skills at a very young age from my two grandmothers, one from Spain and the other of Cuban descent. Cooking and eating together was accompanied by stories about their experiences and traditions coming from their respective countries. Each story usually ended with a life lesson celebrating the values of Cuban culture: respecting and appreciating family, community, education, art, hard work, creativity, friendship, and, of course, food.

I often wondered on my way home from school what food was being prepared at home. When I arrived and opened the door I would be lured inside by the strong scents of onion, garlic, and cumin, common ingredients in Cuban dishes. My grandmother would playfully

Opposite: *José Luis's mother, Clara Alonso Alfonso, performing in the Cuban opera.*

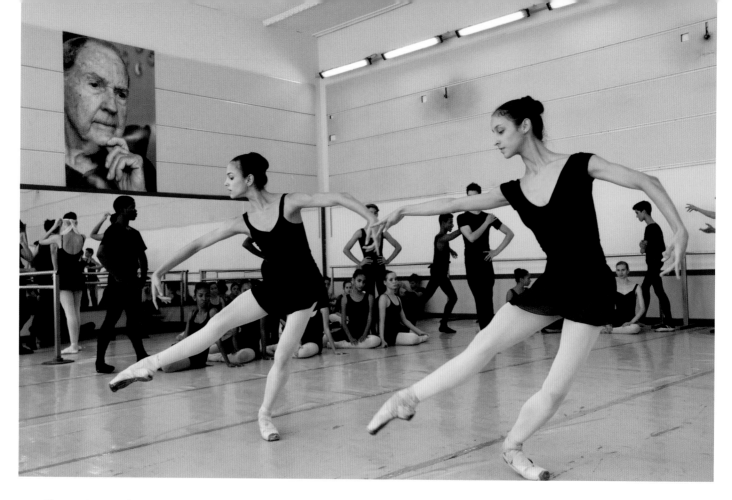

Above: *Dancers rehearse at the Fernando Alonso National Ballet School in Old Havana. On the wall is a photo of the school's founder, Fernando Alonso (José Luis's uncle), who was married to Alicia Alonso, the prima ballerina of Cuba and the founder of the Cuban National Ballet.*

say, "Guess what you're going to eat today?" And without being able to guess my grandmother's invention of the day, I sat hungry and full of curiosity while she cooked and told me her stories.

My grandmother Elena, who came from the Asturias region of northern Spain, often made dishes with a Spanish origin or influence, such as paella. My grandmother Rosa, born and raised in Cuba, cooked dishes with a more tropical flair, using citrus to marinate. Specially prepared black beans and rice were the ubiquitous side dishes to the tender meat or fresh fish of the day and were accompanied by a colorful root vegetable, such as a boniato, a type of sweet potato common in the Caribbean islands that is similar to a yam, or plantains that had been fried and sprinkled with salt to become tostones or sautéed to become sweet maduros. If there were beans and rice left over, they were mixed together for the next meal and called *Moros y Cristianos* (Moors and Christians), a reference to when Moors from North Africa battled Christians for control of medieval Spain.

For decades, sugar was one of Cuba's major crops, and it is used in dishes with French and Spanish influences from the country's original colonizers. My grandmothers often made flan and custards, in addition to using the island's abundance of coconuts and other tropical

Right: *José Luis as a child in Cuba.*

fruits, such as mango, papaya, and guava, in a variety of ways. Some Cubans use these fruits to make fresh drinks, fruit cocktails, pastes, or jams.

Today, due to a shortage of resources, many Cuban households have more than one nuclear family. Grandparents, aunts, uncles, cousins, and children may share a home, and even beds, bedrooms, and bathrooms. In these situations, one family member is usually responsible for the household food and gets ingredients from the local market or *dulcería* (which in Cuba is a bakery), where freshly made bread can be bought in the morning, and from private vendors who go from home to home with their eggs, meat, or special food sale of the day. This family member also cooks the meals and has them ready when kids come home from school and adults come home from work. If the designated chef has children, the rest of the family helps take care of them so he or she can cook. In Cuba, food helps keep families close, as conflicts are often resolved in the kitchen while preparing the food, or after, when eating together.

In Cuba it is most common to eat meals at home. Yet, recent government-issued economic reforms, which encourage private business, have brought sweeping changes, including numerous new food and beverage options—all made and sold by Cuba's new entrepreneurs, known as *cuentapropistas*.

Unchangeable, however, is that the ultimate Cuban recipe consists of fresh ingredients, family, friends, and music combined with the Cuban joys of sharing, living, and loving, all mixed with a generous portion of laughter.

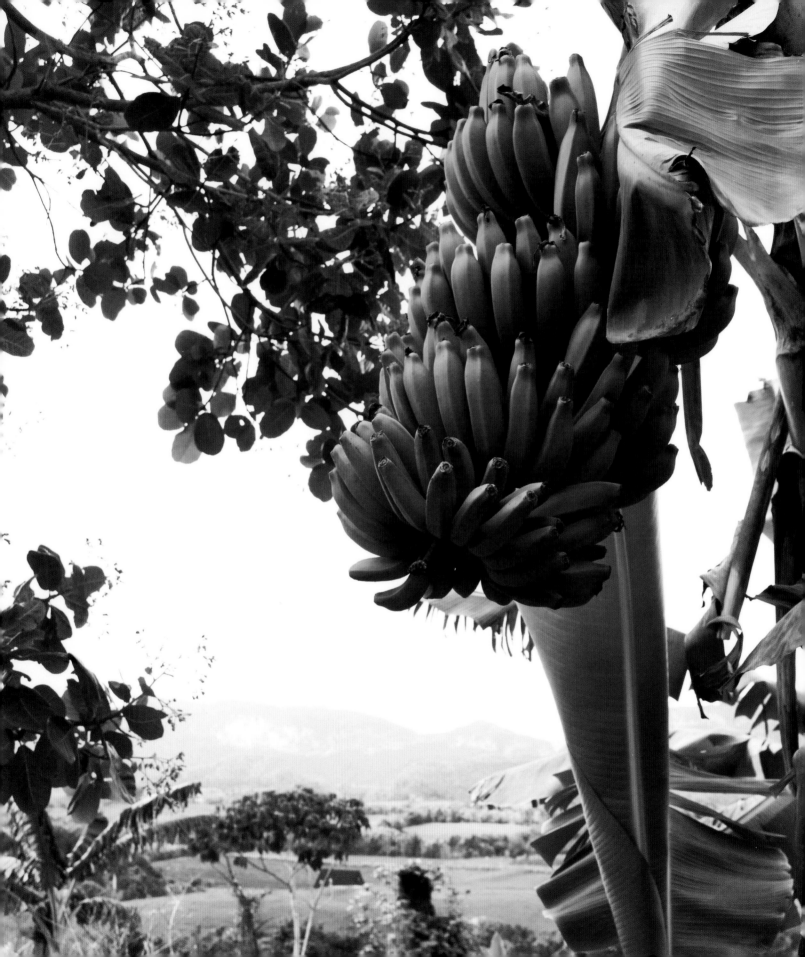

THE TEST KITCHEN AND
THE CUBAN PANTRY

BY VALERIE FEIGEN

All cooking can be summed up by a simple equation: ingredients + process = final dish. The trick to learning to cook the cuisine of a foreign country, particularly a country isolated by trade barriers, is to learn how to substitute ingredients and to understand the chefs' techniques.

Our first challenge after carefully selecting the paladares and restaurants was to personally speak to each chef to request their recipes. Most of these recipes had never been written down—oral tradition prevailed, passed down from generation to generation—and while the chefs were thrilled to have their favorite dishes recorded in a cookbook, the process of interpreting years of experience and habits into simple-to-follow recipes was very difficult. It was our job to understand and translate, not just Spanish into English, or metric into American measurements, or local Cuban ingredients into those available in the United States, but to really decode each chef's process and passion, while recording it clearly and faithfully.

As we cooked, questions arose. We called repeatedly, and each chef, paladar manager, or owner would stop doing what he or she was doing in order to speak with us. Always generous with their time, the creators of the dishes tried to explain their processes; but sometimes, "We use a scoop or a capful, a mug or a handful" was the best instruction we could gather. Some recipes omitted key ingredients, such as olive oil, tomatoes, onions, or salt, because their inclusion was assumed. A common phrase in many recipes was "make a *sofrito*," with no further instruction. A Cuban sofrito is the base of many dishes and is almost always composed of tomatoes and onions caramelized over low heat until soft, with salt added to taste. We often had to draw on our personal knowledge of cooking techniques and experience with the chemistry of ingredients to discover what the chefs intended for each special dish.

Opposite: *Plantains growing on a tree at Finca Agroecologica el Paraiso in Viñales.*

We learned that complex techniques paired with simple ingredients are a hallmark of the cooking at the unique Cuban paladares and restaurants we chose for this book. We realized early on that we mustn't be deceived by the seeming simplicity of the cuisine. It is definitely not all "rice and beans," though white rice and black beans are the main staples of every Cuban meal and accompany many paladar dishes. What Cubans lack in ingredients they make up for in time, dedication, focus, and curiosity. They choose harder techniques to achieve improvements in flavor and appearance. For example, flans are baked in a bain-marie to avoid cracked surfaces, and the buttercream of a vanilla cake is often an Italian or Swiss buttercream made in the classic European tradition with cooked meringue and whipped butter instead of a fast and easy mixture of butter and powdered sugar. In the case of the buttercream, we had to interpret the chef's intention from a simple statement to "make a meringue and add the butter."

Despite the lack of ready information, we remained committed to recreating each chef's specific dishes. We never substituted similar recipes. We relied on our cooking expertise and an exhaustive but unflagging repetition of each dish until we replicated what the paladar serves in Cuba. We added measurements and substituted ingredients only when none could be ascertained. We were fortunate to have a coterie of experts who had eaten at every paladar and restaurant included in this project, to reflect on the authenticity of each iteration.

There are certain key local Cuban ingredients that we learned to replace with more readily available American ingredients. All ingredients used in Cuba are fresh and pungent. In order to succeed in making these dishes, it is necessary to buy the freshest spices and food of the highest quality. For example, cumin is ubiquitous and must always be fresh and strong.

The measurements we've given reflect the quantities necessary for American versions of spices, which tend to be much milder than Cuban versions. A spice like Cuban oregano used at the quantity we've given would be overpowering.

The sizes of Cuban ingredients are often very different from the sizes of the same ingredients in other countries. In the United States, our chickens lay enormous eggs and those are what you find in the supermarket. Smaller eggs are typically used in Cuba, so we often had to adjust the quantities of eggs in recipes that included them as an ingredient. We recommend using large size eggs for all the recipes in this book. Cuban tomatoes are two to three inches in diameter: the size of medium tomatoes in the United States.

Butter is also different in Cuba. When possible, we recommend using salted cultured butter instead of sweet butter. Because we used salted butter in all of our recipe testing, additional salt should always be added as needed and to each individual's taste. We recommend using sea salt, not table salt; coarse salt is fine for these recipes, except for the desserts,

Opposite: Garlic and onions being sold by the strand from a private cart in Old Havana.

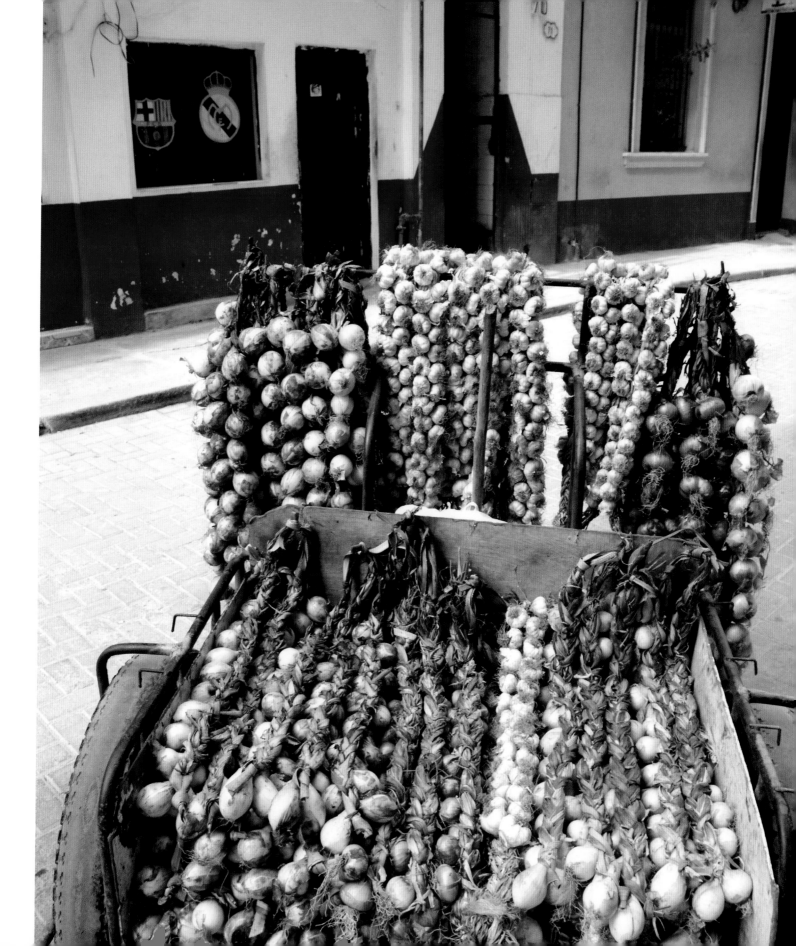

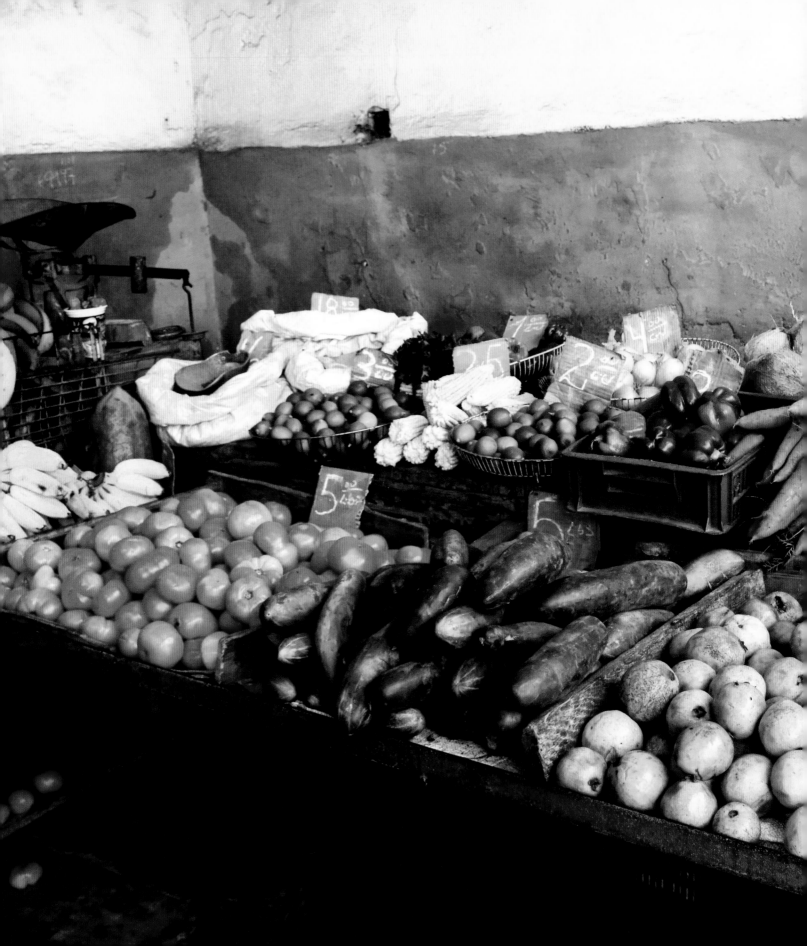

where finely granulated salt is needed to keep the measurements accurate. All references to pepper are for finely ground black pepper unless otherwise specified. The flour is all-purpose white flour and the sugar is granulated white sugar unless otherwise noted.

In Cuba, unripe fruits and vegetables have different uses from ripe ones. Ripe fruits are enjoyed fresh. Unripe ones are cooked. A *fruta bomba* (the Cuban word for "papaya") is often cooked in simple syrup when green to make delicious desserts, or used when yellow and ripe to make *batidos* (smoothies). Plantains are as ubiquitous in Cuba as potatoes are in the United States. Unripe plantains are starchy and best prepared deep-fried. They can be used to make chips for dips or cut into fries. When twice-fried and smashed, they are called tostones and appear on many menus. Ripe plantains are sweet and when pan-fried in light oil, they are called maduros. Unripe sour oranges are used for juice and zest, where we would use lemons.

Below is a list of substitutions for hard-to-find Cuban ingredients:

CUBA	UNITED STATES
Sour oranges	Lemons
Yerba buena	Fresh mint
Cuban pumpkin	Butternut squash
Ají peppers	Jalapeño peppers
Cachucha peppers	Green and red bell peppers
Cassava (yuca)	Parsnips or turnips
Malanga (taro)	Parsnips or turnips
Boniato	Sweet potato (not to be used for deep-frying; for deep-frying, use a yam)
Spiny lobster (Caribbean, without claws)	Frozen lobster tails or Maine lobster
Vino seco	Medium-bodied, good red wine

Left: *Produce at a farmers market in Old Havana.*

Cuba's cattle stock has become scarce and highly regulated by the state. Red meat and milk are therefore limited, expensive, and treated preciously in Cuba. The least expensive cuts of meat offer the best flavor when slowly cooked in savory liquids. Cubans mostly use imported powdered milk, when Americans would use liquid milk. However, there is not a one-for-one substitution; so we used different substitutions for each recipe.

Pork legs, which are readily available in Cuba, are hard to find in the United States. We used Boston butt pork shoulder. For *ropa vieja*, we always used the first cut of the brisket.

After assembling the recipes and ingredients, our final challenge was the techniques. In order to recreate the chefs' techniques, we needed to acquire certain equipment. We relied on sharp knives, a mandoline for slicing food very thin, an electric mixer, a food processor, a large Dutch oven, cast-iron frying pans, large saucepans for deep-frying, a pressure cooker (Cuban ovens are usually charcoal-powered; home cooks and chefs usually rely on pressure cookers to do much of their cooking and even baking), and a wood mortar and pestle for crushing garlic, mint, and other ingredients.

Once we recreated the food to our satisfaction, we learned to plate the dishes as the chefs had done and as the accompanying photographs beautifully and faithfully record. Beauty is paramount in Cuban dishes as Cuban cuisine is its own art form. The food in the featured paladares and restaurants is always arranged in specific and visually appealing tableaus.

A critical component of restaurant cooking is timing. Since every dish is made to order, most of the recipes in this book create dishes meant to be served and enjoyed immediately. We note which dishes can be set aside and served later and which require immediate consumption.

It has been a pleasure to get to know the artistry of these talented chefs and entrepreneurial business owners, to appreciate their passion, patience, attention to detail, and devotion to creating pleasure through food. We encourage everyone to experience Cuba through the recipes in this book and to use each recipe as a guide and a window into the adventure of Cuban culture.

The photographs in this book will take you on a journey through Cuba. The recipes will bring Cuban cooking into your home. We hope this book provides you with a taste of Cuban magic.

Right: *A man on horseback near a private vegetable cart in Trinidad.*

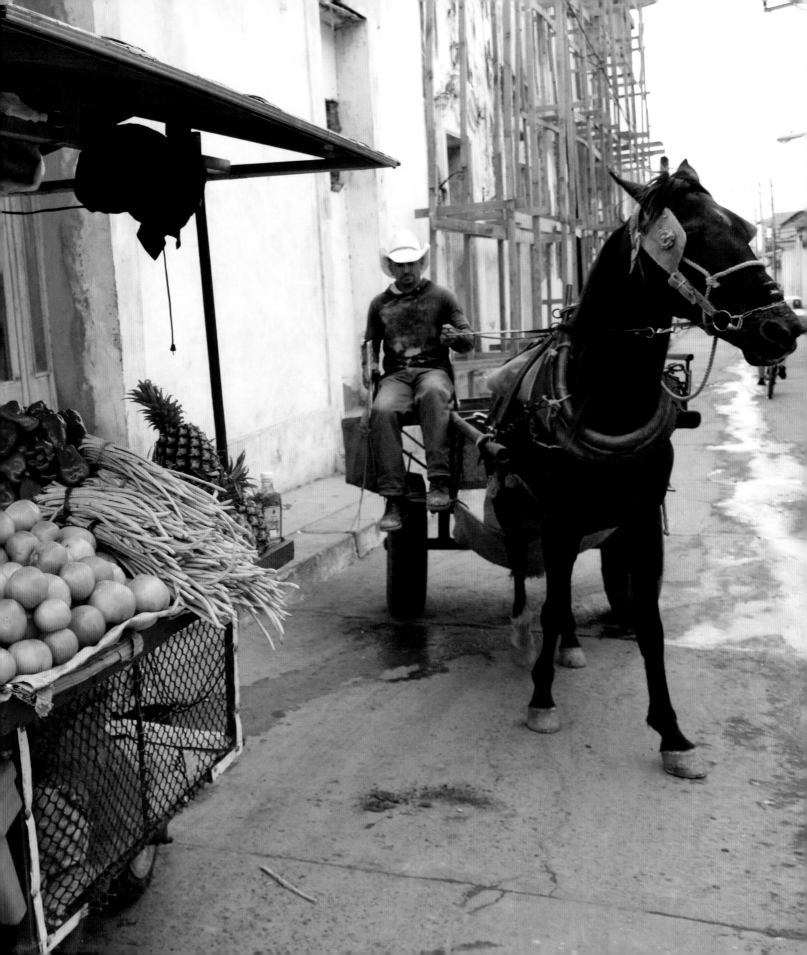

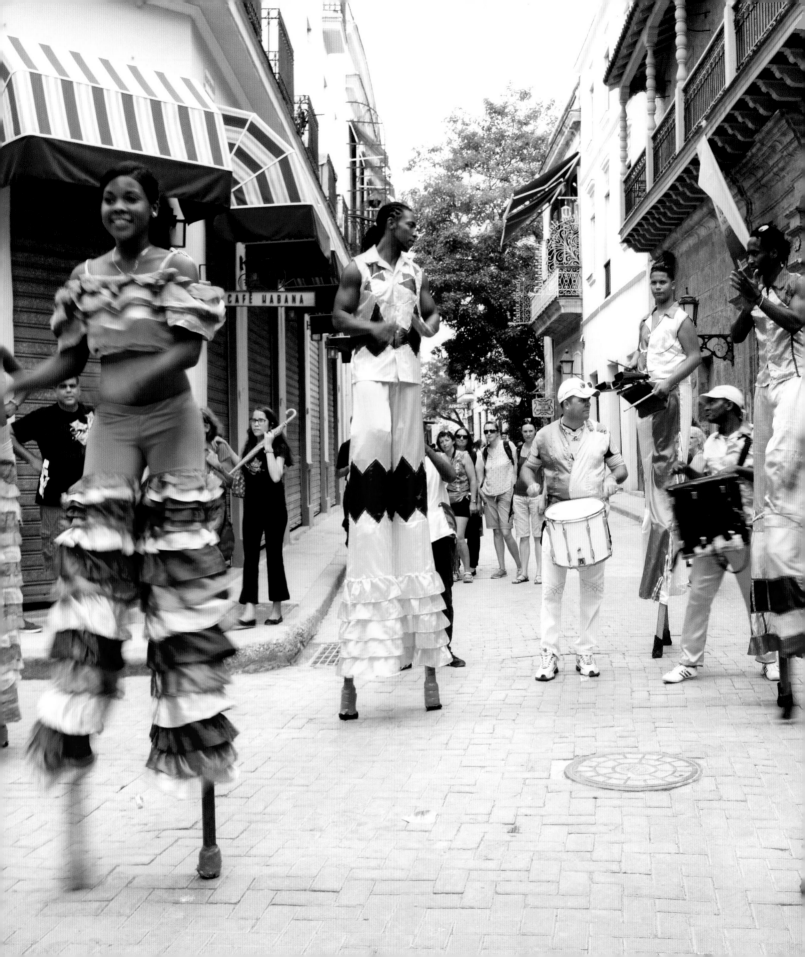

OLD HAVANA

Walking around Old Havana feels like a mysterious and timeless walk through centuries past. Every street has been the setting for life and love, struggle and art—the varied stories of leaders, celebrities, and countless others who have flocked to this remarkable historical area. Havana was founded by the Spanish in 1519, and the city's sheltered harbor, formed by the Bay of Havana, was a strategic nexus for treasure-seeking Europeans in the West Indies. As a result, in 1553, the city of Havana, located in the western part of Cuba, became the de facto capital of Cuba; it would officially be declared the capital in 1607, taking the role from Santiago de Cuba, on Cuba's eastern coast. In the late sixteenth century, the Spaniards built the Morro Castle, a fortress guarding the Bay of Havana, to protect the city from pirates and other foreign invaders. From 1674 to 1740, a sea wall was built along the northern shore of Havana to further protect against invasion.

Today the city has a sea wall known as the Malecón, which begins in Old Havana at the mouth of the Havana Harbor and stretches for five miles. Its esplanade is a lively site for the local Cuban social scene; there are group gatherings and romantic couples enjoying the fresh ocean breeze while wandering musicians serenade them and fishermen cast their rods. Walking the path beside the Malecón, one hears the soothing sounds of the Caribbean waves and sees Cuba's surreal mix of modern tour buses, motorcycles, and bicitaxis with classic old American cars, vintage Russian Ladas, BMWs, and Mercedes-Benzes turned into taxis. The port of Havana hosts large cruise ships bringing tourists from

around the world, and is still one of Cuba's main ports for trade. Since 1818, Cuba has been exporting sugar, rum, tobacco, and coffee from this port.

In 1977, the Cuban government named Old Havana a national monument, and in 1982, the United Nations Educational, Scientific, and Cultural Organization (UNESCO) declared it a World Heritage Site. Old Havana is now home to more than nine hundred buildings of historical importance. The older ones were originally built in baroque and neoclassical styles, while more modern buildings are art deco structures. This eclectic combination of architectural styles from eras past is a great part of the city's charm and allure. Sadly, however, decades of neglect and a lack of resources have led many buildings to decay and deteriorate, even collapse. What's promising, however, is that work is being done to rebuild and prevent further decline of the city. In 1981, Cuba developed a restoration plan for Old Havana under the guidance of Eusebio Leal, the city's official historian, and since then many city buildings have been repaired and revived to their original states. The restoration movement

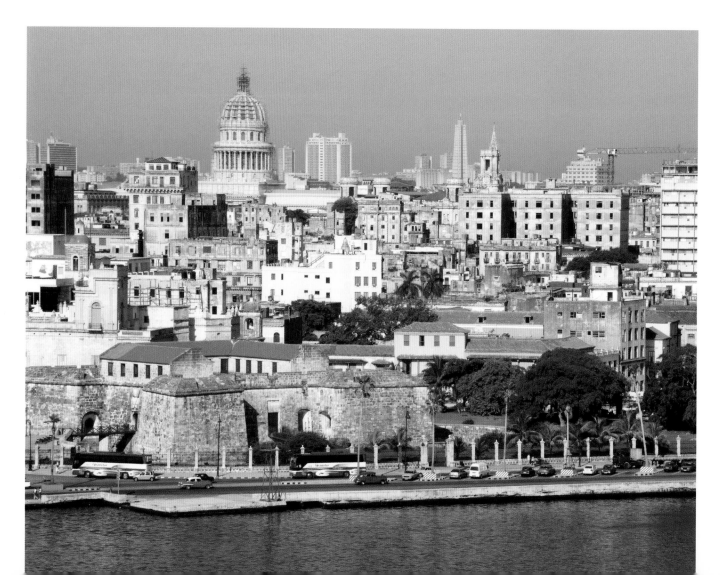

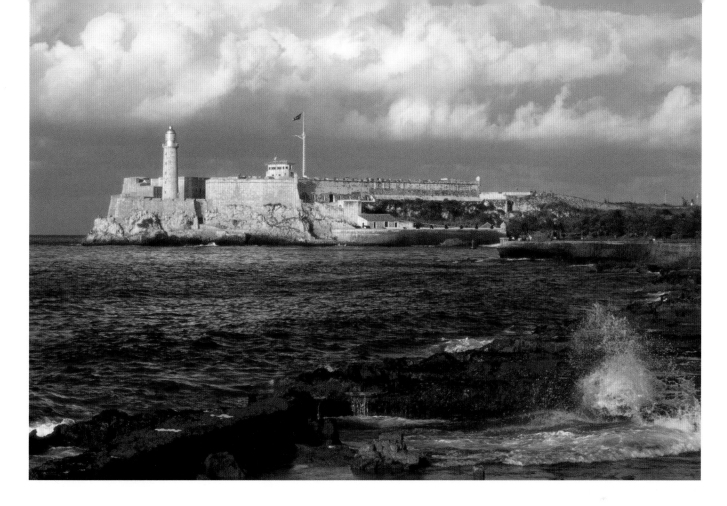

Above: *Castle of the Three Kings of the Morro (Castillo de los Tres Reyes del Morro).*

has been described as "an integral restoration," meaning not only a physical renovation but also one that revitalizes all aspects of Cuban life and culture in the area. There are still many buildings crumbling, with peeling paint, rubble, and strewn garbage that become an obstacle course for people walking on streets that lack caution signs or barriers. Yet many hotels, museums, cultural institutions, plazas, and other buildings are being restored to their original grandeur. The Alicia Alonso Grand Theater of Havana, home to Cuba's National Ballet, has been transformed into one of the city's most magnificent and ornate buildings, with marble imported from Italy. It is one of the best places to see Cuba's world-renowned dance, theater, and music performances. Private businesses, run by self-employed Cubans known as cuentapropistas, are also increasingly visible. New privately-owned galleries, clothing stores, and souvenir and food vendors are becoming ubiquitous.

There are five main plazas in Old Havana: Plaza Vieja, Plaza de San Francisco de Asís, Plaza del Cristo, Plaza de Armas, and Plaza de la Catedral. Each one has its own character and historical relevance. If visiting Old Havana, be sure to look up at the newly-restored ceilings; look down to watch your step among the disarray of rubble; and look around to see the city's beautifully restored windows, columns, balconies, and arches built around

courtyards decorated with tropical flowers and foliage. National monuments, statues that honor heroes such as José Martí, and tributes to revolutionary icons, such as Che Guevara, are omnipresent. Also, take time to enjoy the city's art and performances; to listen to the pulsating sounds of its musicians playing classic Cuban rhythms mixed with contemporary Latin jazz, salsa, timba, and rap; and to shop the newsstands and stalls of private vendors selling T-shirts, art, jewelry, and handmade crafts. As you wander the streets, you will notice the farmers' markets (known as *mercado agropecuario, agromercados,* or just *agro*) and street carts selling garlic, herbs, vegetables, and homemade snacks to local residents. Most of all, be sure to eat in one of the numerous paladares serving delicious meals, each in a unique and remarkable style.

Below: *Cars in front of Cuba's Capitol Building and the Alicia Alonso Grand Theater.*

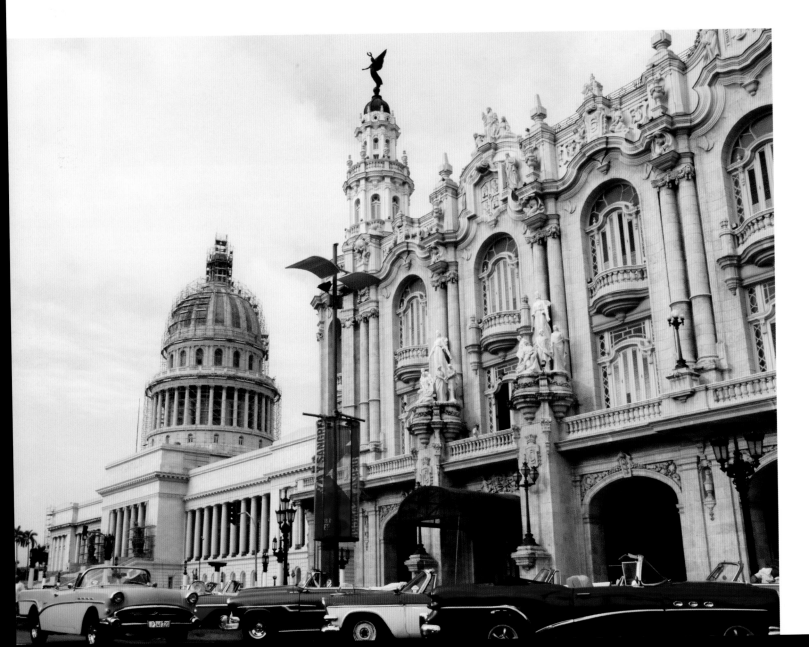

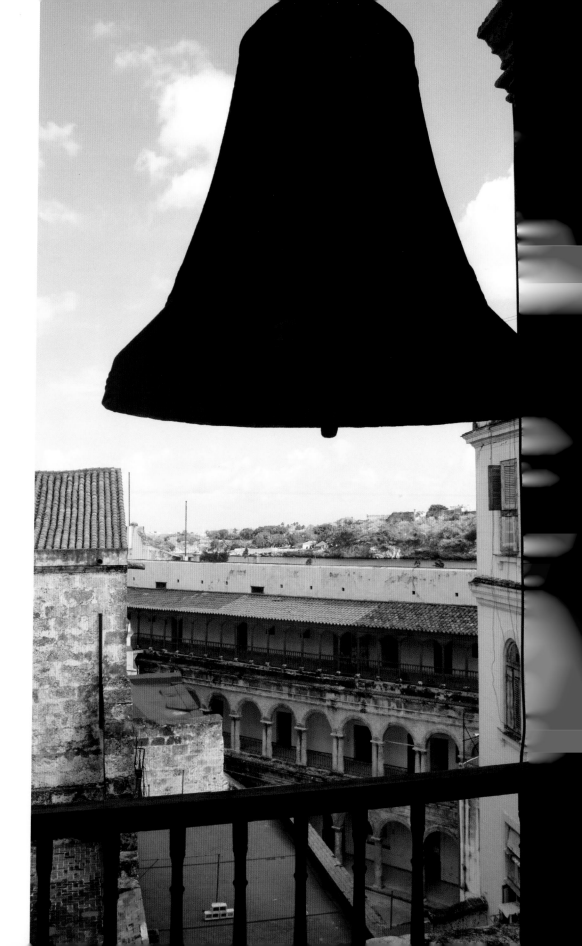

Right: *The Bell Tower of the Cathedral in Old Havana.*

Page 32: *One of the lion sculptures along the Prado.*

Page 33: *Plaza Vieja.*

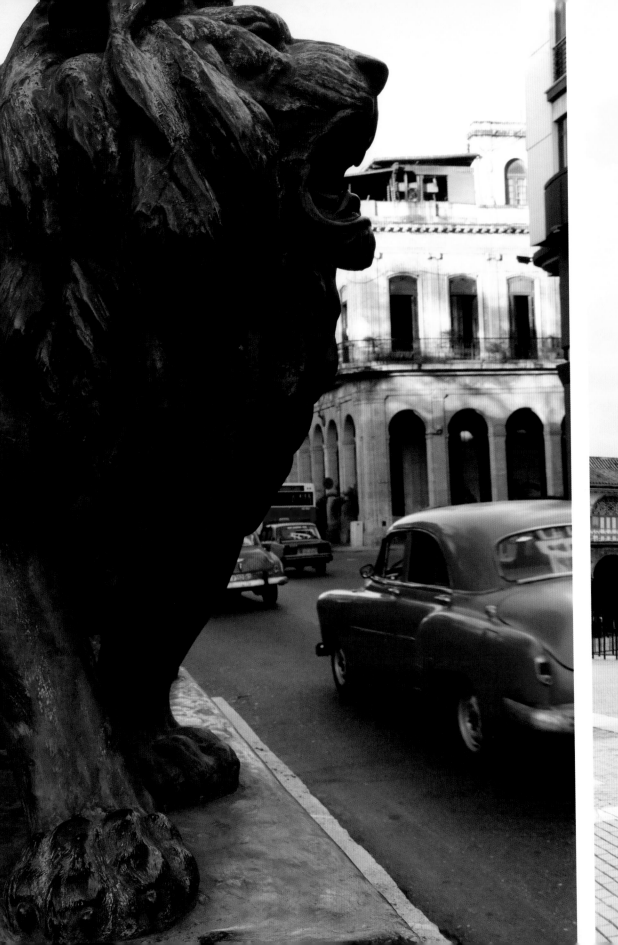

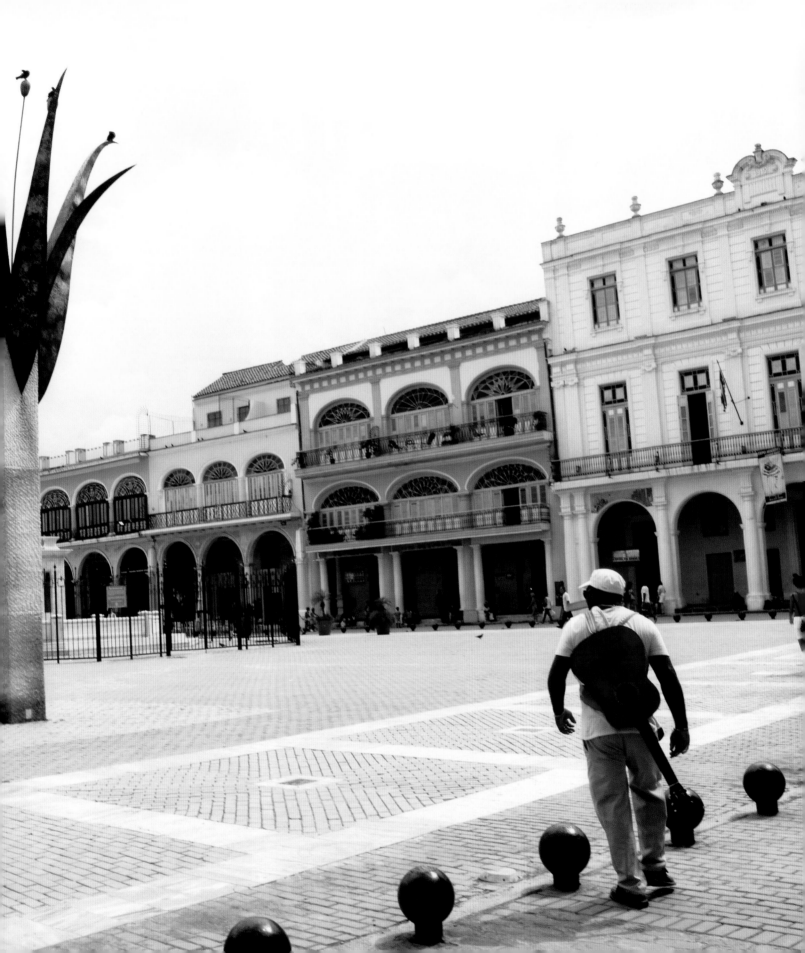

IVÁN CHEFS JUSTO

ESQUINA AGUACATE Y CHACÓN

Located in Old Havana near the Museum of the Revolution and the National Museum of Fine Arts is a home built in 1766, that houses two restaurants owned and run by Chef Iván Rodriguez and his business partner, Chef Justo Perez. Iván Chefs Justo is upstairs, and Al Carbon is below.

Chef Iván originally rented the upstairs to run Iván Chefs Justo restaurant. After great success with this first eatery, Iván was able to buy the whole building. He then opened Al Carbon downstairs, with a separate entrance around the corner. Both restaurants are decorated with antique objects and iconic photographs of famous American actors, such as Marilyn Monroe and Audrey Hepburn, displayed with photos of Cuban stars from the first half of the twentieth century. A collection of old clocks and phonographs covers every inch of wall space. Iván said the clocks "reflect the stuff, noise, people, activity, and energy of the outside world."

Iván Chefs Justo is a cozy and chic restaurant where celebrity guests, such as Mick Jagger, have come to dine. All of the chefs at Iván Chefs Justo are dedicated to authentically preparing Iván's recipes. The bartenders stylishly prepare drinks in front of classic photographs of Cuba's legendary singer Benny Moré. The menu is handwritten on a chalkboard, so offerings can be easily erased and replaced, since they change based on the availability of ingredients at the local market.

Iván is always busy. His days are filled with cooking, buying ingredients, and calling suppliers. The historic house he converted into a restaurant has very little storage space, with no room to store food in bulk, so Iván must be in constant

contact with his food suppliers. He says these frequent orders have helped him build his relationships with local farmers.

Iván says that one of the secrets to his success is how many fresh ingredients he uses in his dishes—some are even grown only for his restaurants. In addition to running two successful restaurants, Iván also caters large parties, such as weddings and other events. He proudly tells of his travels to New York City, where he was flown in to cook and prepare food for a large private event. He loved his time in New York and explained, "It felt like Havana, with wonderful people and energy."

Right: *Chef Oscar Perez Mallet.*

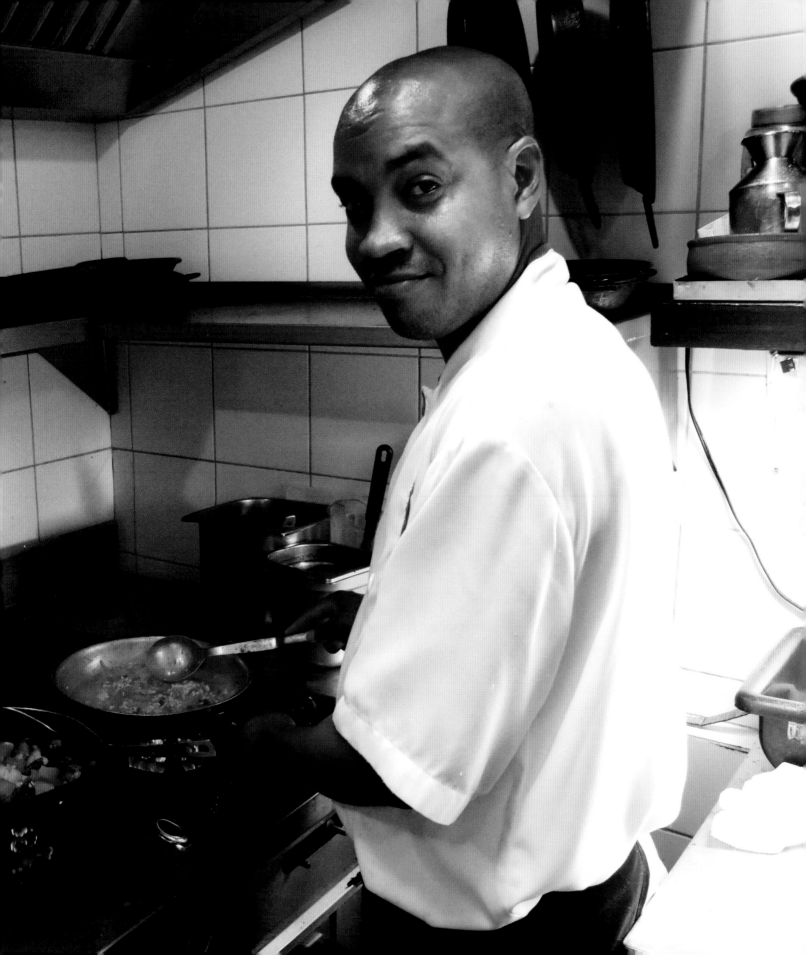

FISH CROQUETTES WITH PLANTAINS

Croquetas de Pescado con Plátanos

Court Bouillon

2 onions, halved

1 head garlic, peeled and
 separated into cloves

1 tablespoon salt

1 bay leaf

 Pinch of nutmeg (optional)

8 ounces dorado fish fillet or other
 white fish fillet, 1 inch thick

Enchilada

½ pound (2 sticks) salted butter, melted

2 cups flour

2 onions, finely chopped

1 clove garlic, minced

1 tablespoon finely chopped
 fresh parsley

1 teaspoon salt

 Pinch of ground nutmeg (optional)

2 eggs, beaten

1 cup finely crushed
 breadcrumbs or panko

 Vegetable oil

4 ripe yellow plantains, peeled

To make the court bouillon, bring 2 cups water to a boil in a stockpot then add the onions, garlic, salt, bay leaf, and nutmeg, if using. Reduce the heat to low and add the fish. Cook at a low simmer until the fish is cooked, about 10 minutes. Do not overcook; if it is too flaky, it will fall apart in the water.

Remove the fish fillets while still whole and set aside. Strain the court bouillon, discard the solids, and set aside ½ cup of the liquid. Flake the fish when it is cool enough to handle; set aside.

To make the enchilada filling, melt the butter in a large saucepan over low heat. Add 1 cup of the flour and stir continuously for about 3 minutes; stop when the flour is completely absorbed and the pastiness is cooked out. Set aside.

In a bowl, combine the onions, garlic, parsley, salt, and nutmeg, if using. Add the butter mixture and up to 2 tablespoons of the court bouillon, then add the flaked fish. The mixture should be moist, but hold together. If it's too loose, add more flour. If it's too stiff, add more of the reserved court bouillon, a little at a time.

Roll the mixture into 1-inch round balls and set aside.

Beat the eggs in a small bowl. Fill another small bowl with the remaining 1 cup flour, and fill a third small bowl with the breadcrumbs. Dip each ball in the flour, then the beaten eggs, and then the breadcrumbs, and then set them aside on a single layer without them touching.

Fill a large saucepan with 3 inches of vegetable oil and heat the oil to 350°F. Add the croquettes to the oil in batches and cook for approximately 5 minutes, until browned. Do not overcrowd the saucepan. If they are browning too quickly, lower the heat to 325°F. Remove the fried croquettes from the oil with a slotted spoon and place on a layer of paper towels to absorb excess oil, then transfer to a serving dish. Reserve the cooking oil in the saucepan.

Slice the plantains ½ inch thick on the diagonal. Return the oil to 350°F, add the plantains, and cook for 5 minutes, turning to cook evenly until medium-brown on all sides. Transfer to paper towels to absorb excess oil and then to the serving dish. Serve the croquettes and plantains immediately.

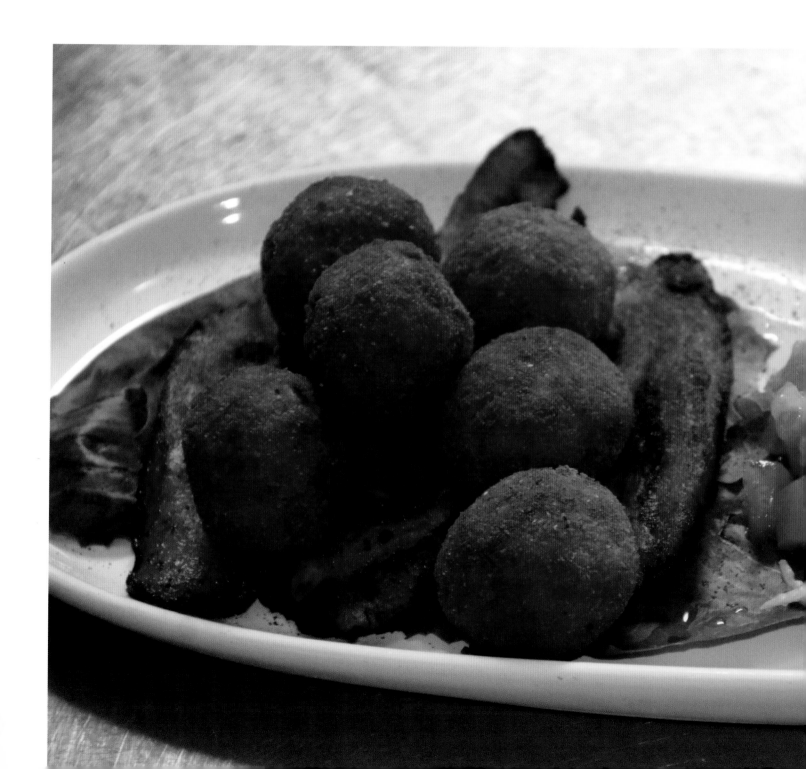

FISH FILET OVER CHICKPEAS

Pescado Sobre Garbanzo

1 cup dried or canned chickpeas

4 tablespoons olive oil

1 large white onion, finely chopped

2 red bell peppers, finely chopped

1 cup chopped tomato

2 ounces chorizo, chopped

5 cloves garlic, crushed

5 threads saffron

8 ounces white fish fillet
 (such as dorado or cod)

1 teaspoon salt

½ teaspoon pepper

 Fresh parsley, pinch of
 chopped or sprig of flat

If using dried chickpeas, rinse several times, then soak in 4 cups cold water at room temperature for at least 12 hours, or refrigerate overnight.

Drain the softened chickpeas and combine with 2 cups fresh water in a pressure cooker or a pot with a lid. If using a pressure cooker, cook for 45 to 50 minutes on the setting for beans or medium. To cook on the stovetop, bring to a simmer and cook, covered, for 1 ½ to 2 hours, depending on desired texture. Drain and set aside. Skip these steps if using canned chickpeas.

To make the sauce, a sofrito, heat 2 tablespoons of the olive oil in a large cast-iron pan over medium heat. Add the onion, red peppers, tomatoes, chorizo, 4 cloves of the garlic, and the saffron and sauté for 10 minutes, until well combined. The onion pieces should retain firmness, but not be hard. Add the chickpeas and cook, stirring to combine well, for 5 minutes over medium heat.

Meanwhile, season the fish with salt and pepper. Heat the remaining 2 tablespoons of olive oil in a frying pan over medium heat. Add the remaining clove of garlic, but be careful not to brown the garlic. Add the fish. Cook one side of the fish for 3 to 5 minutes until brown and then flip to cook the other side for 3 minutes. Fillets that are ½ inch thick will cook in 5 minutes, thicker fillets will take longer. Once the fish is cooked, divide the chickpeas onto two plates, place the fish on top, garnish with parsley, and serve immediately.

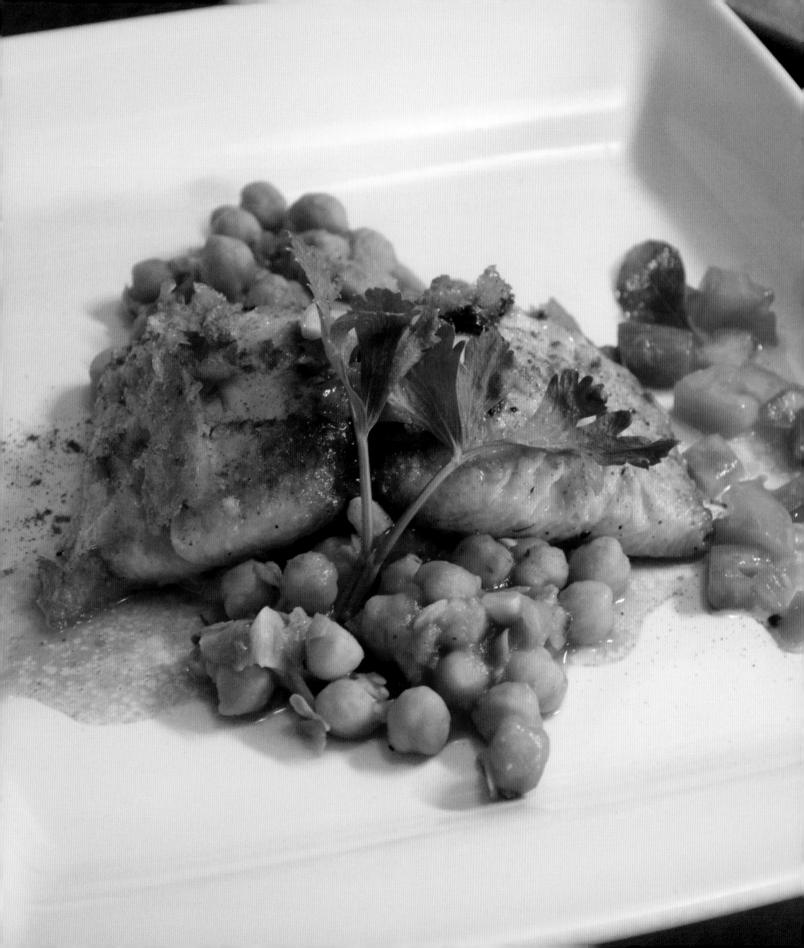

FISH CEVICHE

Ceviche de Pescado

8 ounces white fish fillet (such as dorado, cod, or other firm, fresh white fish)

¼ cup freshly squeezed lemon juice

1 teaspoon salt

¼ teaspoon pepper

¼ cup olive oil

⅔ cup finely chopped onion

2 ají peppers or jalapeño peppers, chopped, or to taste

⅓ cup sweet corn kernels (optional)

2 cups micro salad greens (optional)

Carefully remove any bones, skin, or gristle from the fish, then finely dice it and put it in a deep bowl. Add the lemon juice, salt, and pepper and refrigerate for at least 20 minutes, or up to several hours.

Add the olive oil, onion, peppers, and corn kernels, if using, and stir until well combined. Serve the ceviche alone or, if desired, on top of a green salad. (You can use a small bowl as a mold to create uniform mounds of ceviche.)

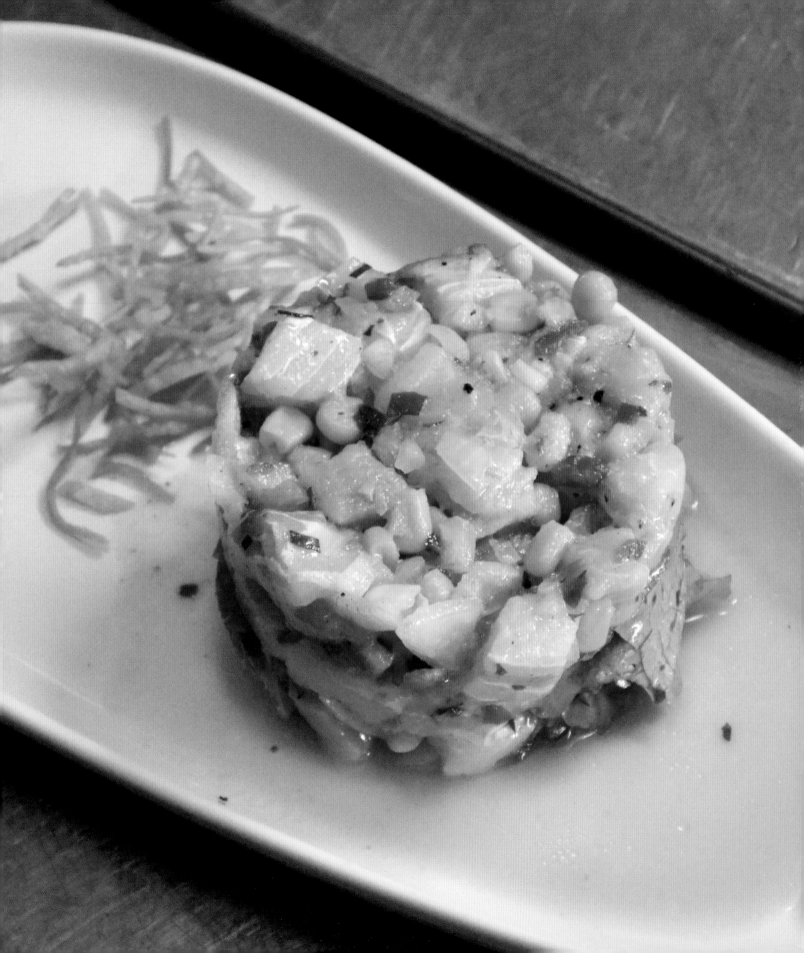

AL CARBON

ESQUINA AGUACATE Y CHACÓN

Downstairs and around the corner from Iván Chefs Justo is the main entrance to Al Carbon. It has a more spacious layout than Iván Chefs Justo and has an open kitchen that features a wood oven, where many of the restaurant's traditional Cuban dishes are cooked over charcoal. The cooks and waitstaff are fun, friendly, and welcoming. The cooks share a modesty about their skills, which adds to their charm. When I asked cook Luis Molina how he made his Grilled Chicken al Carbon, he said, "Oh it's easy, you just get a chicken and cook it!" Another chef told me, "Most of our recipes come from our heads or our family, like our grandmothers. They've never been written down!" So I pulled out my pens and paper, items that even today are often hard to find in Cuba, and we began writing.

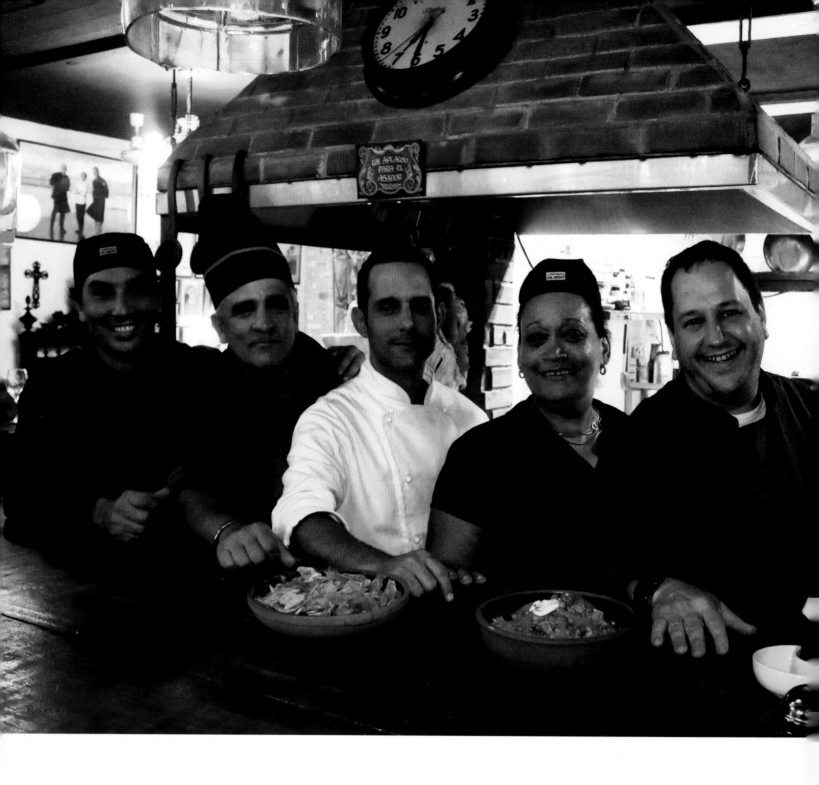

Above: *Owner and Chef Iván Rodriguez (second from right) poses with staff. From left: Denis, Ciro, Luis (head chef), Iliana, Iván, and Rafa.*

GRILLED AL CARBON CHICKEN

Pollo Al Carbon

One 2 to 3-pound chicken, quartered

1 cup olive oil

1 tablespoon freshly squeezed sour orange or lemon juice

1 small head garlic, peeled and separated into cloves

1 tablespoon sweet paprika

1 bay leaf

2 teaspoons salt

Sauce (*Mojo*)

1 cup olive oil

⅓ cup red wine vinegar

½ yellow onion, finely diced

1 teaspoon sweet paprika

Salt and pepper, to taste

Pierce the chicken all over with a fork, then combine the olive oil, citrus juice, garlic, paprika, bay leaf, and salt to create a marinade. Pour the marinade over the chicken, refrigerate and let it saturate for at least half an hour and up to 24 hours. (Piercing the chicken will allow the marinade to penetrate it.)

Preheat the grill to high, place the chicken on the grill, and immediately lower the grill temperature to medium. If the chicken starts to burn, move its pieces to the cooler sections of the grill as needed. Cook for about 10 to 15 minutes, then turn and cook on the other side for about 10 to 15 minutes more, until the juices of the chicken run clear when it is pierced with a knife.

To make the sauce, whisk all the ingredients together in a small bowl. Serve the chicken immediately with the sauce spooned on top and spilling over the sides.

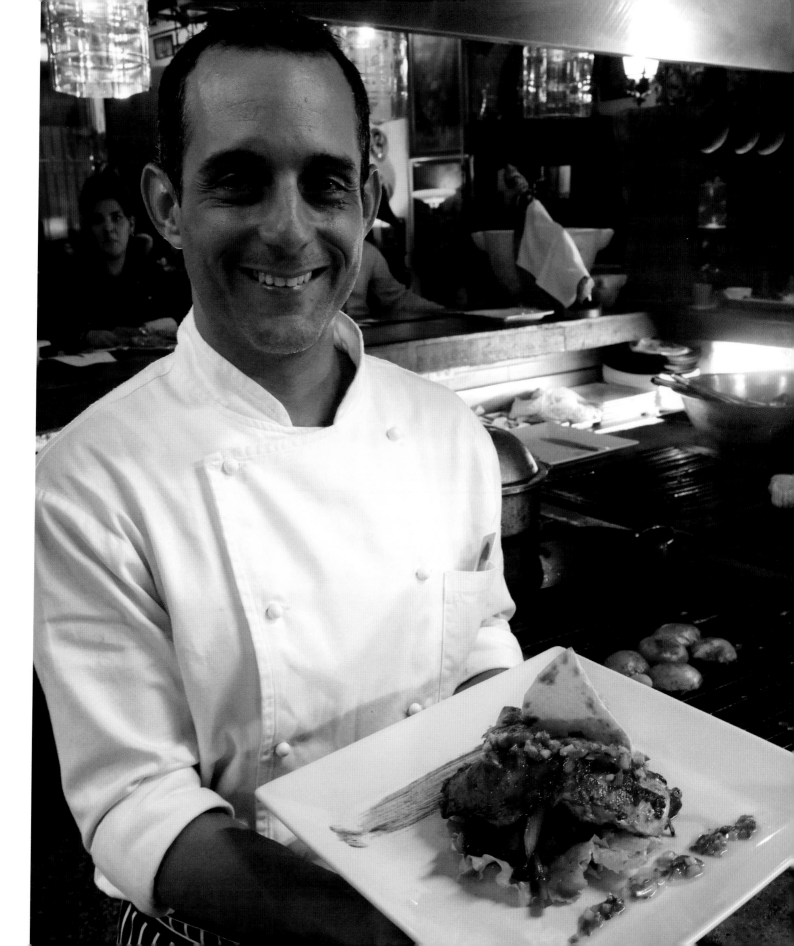

CHICKEN WITH RICE
Arroz con Pollo

6 ounces boneless skinless
 chicken breasts

1 teaspoon salt

¼ teaspoon pepper

½ cup olive oil

½ yellow onion, chopped

¼ cup chopped cachucha or red bell
 pepper, plus additional for garnish

1 ají or ¼ jalapeño pepper, chopped

1 clove garlic, minced

½ cup plus 2 tablespoons arborio
 rice or short-grain white rice

2 teaspoons dry white wine

¼ teaspoon ground cumin

¼ teaspoon saffron threads

3 cups chicken broth

2 tablespoons ketchup

 Dash of light beer

1 tablespoon chopped fresh
 parsley, for garnish

2 tablespoons cooked
 peas, for garnish

 Hard-boiled egg slices, for garnish

Cut the chicken into ½-inch pieces and season with the salt and pepper. Heat the olive oil in a large frying pan over high heat for 1 minute. Add the chicken and sear over high heat, turning the pieces until they are brown on all sides.

Lower the heat to medium and add the onion, cachucha and ají peppers, and garlic. Sauté for 3 to 5 minutes, then add the rice, wine, cumin, and saffron, and stir well. Add the hot chicken broth and ketchup and stir. Cook until the broth is absorbed, about 20 to 30 minutes, and the rice is soft or at the desired consistency, stirring occasionally.

Add the beer and continue to cook, without stirring, until it is absorbed, about 5 minutes. Garnish with the parsley, peas, egg slices, and cachucha pepper, and serve immediately.

NOTE: A homemade chicken broth is recommended for a rich flavor.

YUCA WITH GARLIC SAUCE

Yuca con Mojo

1 yuca (Cuban yuca, if possible—
 they are longer and narrower
 than other yuca roots)

⅓ cup olive oil

2 cloves garlic, minced

¼ cup finely chopped onion

1 teaspoon freshly squeezed
 sour orange or lemon juice

 Salt, to taste

Fill a saucepan with cold water. Rinse the yuca, then peel it: begin by cutting the ends off the root. With the skin still on, use a very strong kitchen knife to cut the yuca into 2-inch logs. With a paring knife, carefully peel the skin off each log, either by standing the logs on a cutting board cut side down and peeling them, or by holding them and peeling them like an orange. Next, cut each piece lengthwise down the middle, so that each piece is quartered. Add all the pieces to the saucepan and make sure there is enough water to submerge the yuca. Cover and bring the water to a boil over high heat. As soon as it boils, immediately decrease the heat to low and simmer, covered, for 20 minutes, or until tender but not mushy.

Remove the yuca from the heat and drain and discard the cooking water. Let the yuca cool slightly and remove the string core that is attached to the center of each piece.

Heat the olive oil in the saucepan over medium heat. Add the garlic and onion and sauté 2 to 3 minutes, but do not brown. Combine the mixture with the yuca and sour orange juice, and then add salt. Serve warm.

MERINGUE COOKIES

Galletas de Merengue

3 large egg whites, at
 room temperature

¾ cup sugar (superfine is preferred,
 but granulated sugar is all
 that is available in Cuba)

Preheat the oven to 200°F (see Note). Line 2 baking sheets with parchment paper.

Make sure there is no egg yolk in the egg whites (see Note), and then beat the egg whites with an electric mixer on medium to high speed until frothy. Once frothy, slowly add the sugar, while continuing to beat at medium to high speed. Stop beating when the whites create stiff peaks but are still glossy.

Transfer the meringue to a pastry bag with a ½-inch flower tip, and pipe small rosettes onto the baking sheets about an inch apart. Transfer to the oven and bake for 2 hours.

Remove the cookies from the oven and place on a wire rack to cool. The cookies can be stored for several days in a closed tin once they are completely cool. To serve these as they do at the restaurant, serve alongside a shot of espresso.

NOTE: If you have more time, you can also preheat the oven to 350°F, and when ready to bake the meringue, place the baking sheets in the oven and immediately turn off the heat. Leave the cookies in the oven for 6 to 8 hours or overnight.

It is easiest to separate the whites from the yolks when the eggs are cold. Cracking the eggs on a counter and not on the edge of a bowl helps get a clean break. The yolks can be saved for a pastry cream like the one on page 56.

Al Carbon serves its meringue cookies atop a glass jar of espresso.

FOUR-MILK CAKE

Cuatro Leches

Genoise Cake

10 large eggs

2 cups sugar

2 cups flour

2 teaspoons baking powder

¼ teaspoon salt

Pastry Cream

2 ½ cups whole milk

3 large egg yolks

½ cup sugar (see Note)

¼ cup cornstarch

2 tablespoons salted butter

¼ teaspoon lemon zest

Dulce de Leche (page 58)

Makes 14 ounces

To make the genoise cake, preheat the oven to 350°F. Line 2 half-sheet professional baking pans or jelly roll pans (approximately 17 by 12-inches) with parchment paper. Do not grease. The cake needs to cling to the paper when it rises.

Beat the eggs with an electric mixer at high speed for 1 minute. Add the sugar and beat for 8 more minutes, or until the eggs are a pale lemon-yellow color and thick.

While the eggs are beating, stir the flour, baking powder, and salt together in a separate bowl. Turn off the beater and sift a third of the flour mixture at a time into the fluffy egg mixture, using a spatula to fold it in. Keep adding a third of the flour at a time and folding very gently until there are no flour streaks remaining in the batter. Do not overmix or the batter will deflate.

Pour the batter into the lined pans and transfer to the oven immediately. Bake for about 15 minutes, or until a knife inserted in the center of the cake comes out clean. Wet two clean dishtowels and wring them out, then lay them out on two wire racks. Flip the cakes immediately onto the wet towels on the racks to cool. Peel off the parchment paper carefully.

Once the cakes are cool, place on a cutting board and use a 2-inch round cookie cutter to cut 12 small, round cakes out of each sheet cake. (Al Carbon uses the empty can from the dulce de leche recipe as a cookie cutter. It is a 2-inch round.) Store the cooled cakes in a sealed container for up to two days at room temperature.

To make the pastry cream, heat the milk in a 2-quart saucepan until it's just barely at a boil. In a separate bowl, whisk the egg yolks with the sugar and cornstarch until well blended. Slowly add the hot milk to the egg yolk mixture while beating briskly to prevent the milk from cooking the yolks. Once it is fully blended, pour the mixture back into the saucepan and cook over low to medium heat, stirring continuously, until the pastry cream coats the back of a metal spoon and thickens, about 5 minutes.

Strain and then stir in the butter and lemon zest. Let cool and refrigerate for up to two days, or until ready to use. Stir thoroughly before using.

To assemble the cakes, Al Carbon uses empty cans, but you can also assemble them in small bowls or one large bowl. To assemble, top a round of cake with 2 tablespoons pastry cream, another round of cake, and 2 more tablespoons pastry cream. Repeat to layer all the cakes with pastry cream. Top each cake with a layer of dulce de leche and serve immediately. (The genoise could also be made in round cake pans or square pans and assembled as a larger cake with a single layer or multiple layers.)

NOTE: The bakers at Al Carbon use powdered milk mixed with water in place of whole milk. Because the powdered milk is already sweetened, this recipe did not originally call for added sugar. We substituted whole milk for the water and powdered milk, and added sugar for the required sweetness. Instead of 2 ½ cups whole milk, the restaurant's baker uses 2 ½ cups water and ½ cup powdered milk.

DULCE DE LECHE

MAKES 14 OUNCES

1 can (400 g) sweetened condensed milk

Remove the label from the can and place the sealed can in a 2-quart or larger saucepan with a tight-fitting lid. Fill the saucepan with cold water and make sure the can is on its side and fully submerged in the water. There should be at least 1 inch of water above the top of the can at all times.

Bring to a boil, then lower the heat and simmer, covered, for 2 to 3 hours, checking every half hour to make sure the water still covers the can by at least 1 inch and adding water if necessary. Simmering for 2 hours will achieve a lighter color and runnier consistency, while a full 3 hours of cooking will bring the normally-white condensed milk to a rich caramel color with a thick consistency.

Turn off the heat after 3 hours and let the can cool in the water. Refrigerate the sealed or opened can for up to two days, until ready to use the dulce de leche that is now inside it.

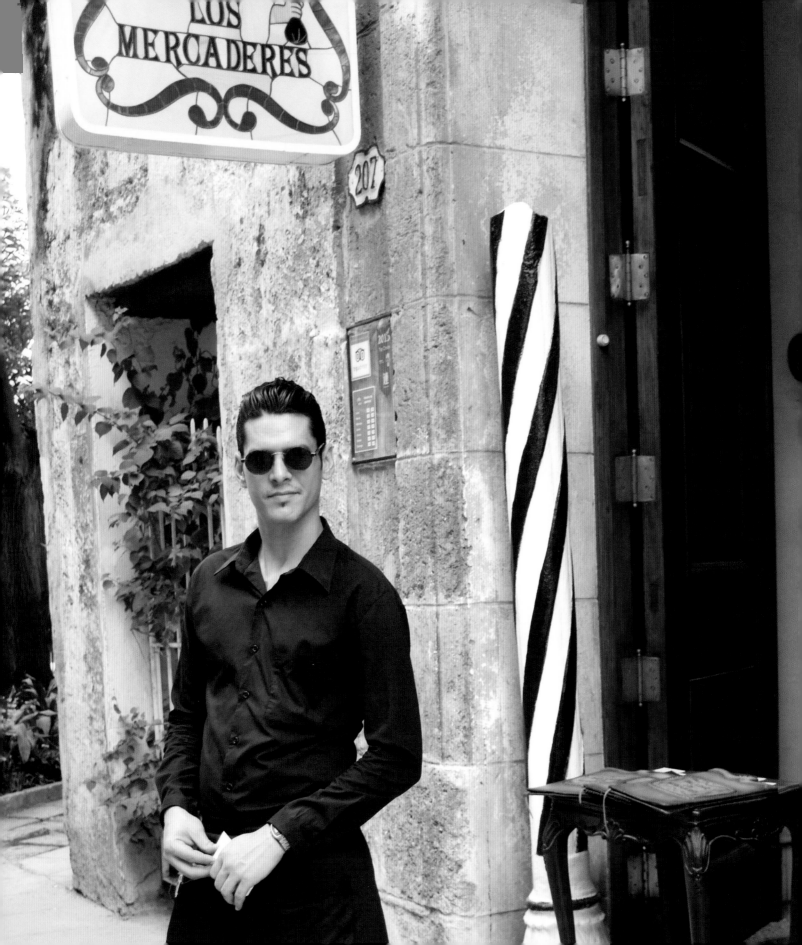

LOS MERCADERES

CALLE MERCADERES NO. 207

Several years ago, Yamil Alvarez Torres and his family decided to transform their high-ceilinged Spanish-style home in Old Havana to reflect the old-fashioned charm of their neighborhood. They dreamed of opening a paladar, and after three years of renovation, they opened Los Mercaderes in 2012 within the walls of their former home. A piece of the building's original wall stands intact so that visitors can see the transformation.

Yamil wanted the construction of the paladar to be a "family project." His daughter's room became the kitchen, and the living room and master bedroom became a distinguished space for more than fifty guests to dine. Yamil proudly explains, "Our daughter, Lorena Alvarez Flores, is the inspiration for everything we make."

Yamil and his family are also now the proud owners of a nearby organic farm, where they have employed eleven farmer families, in the countryside just outside Old Havana. All the fresh vegetables, meat, and other ingredients for the dishes on the menu are grown and raised on Yamil's family farm. It is the essence of farm to table," right in Havana. Sometimes Yamil, who likes to fish, even serves his fresh catch of the day. In addition to running the paladar, Yamil also offers hospitality training and profit sharing to his staff, who are notably attentive, friendly, and service-oriented.

Upon your arrival at the main entrance of the building on the ground level, a handsome young man welcomes you and rings a vintage brass bell to notify

Page 60: *An employee of Los Mercaderes stands ready to welcome guests and check reservations. Behind him is the bell he rings to alert restaurant staff that guests are coming.*

the staff upstairs of your arrival. Musicians can be heard as you climb the marble staircase, strewn with rose petals, to the second floor. You are then seated inside, among antique furniture, with either a view of a courtyard decorated with pastel floral tiles, or a view onto the street, where you might see stilt walkers pass by the large open paladar windows.

The menu at Los Mercaderes is a mix of traditional Cuban dishes that are served in exotic sauces formerly created and planned by Yamil and a chef from Spain, and now planned exclusively by Yamil and his wife, Layren Flores Vazquez.

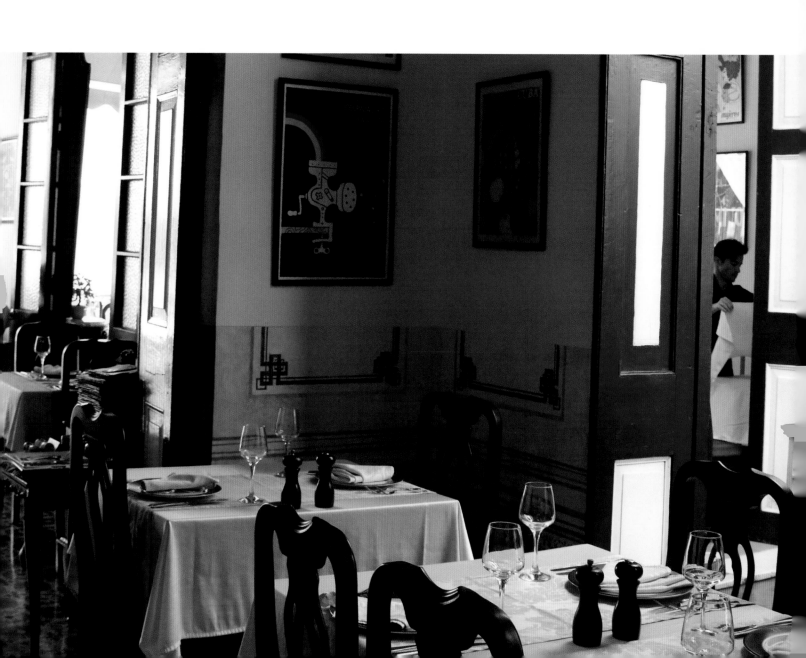

LOBSTER WITH PINEAPPLE

Langosta con Piña

1 large raw lobster tail, shell
 removed and meat cubed

¼ teaspoon salt

⅛ teaspoon pepper

2 tablespoons olive oil

⅓ cup chopped white onion

2 teaspoons pineapple liqueur
 or pineapple juice

2 teaspoons rum (preferably
 seven-year-old Havana rum)

¼ cup finely chopped pineapple

1 teaspoon prepared brown mustard

¼ cup heavy cream

1 tablespoon salted butter

Season the lobster with salt and pepper. Heat the olive oil in a large cast-iron pan over high heat, add the lobster, and cook, stirring occasionally, for 2 minutes to sear. Add the onions, lower the heat to medium, and cook without stirring for 5 minutes.

Add the pineapple liqueur, rum, pineapple pieces, mustard, and heavy cream and cook 3 to 5 minutes more, until the sauce thickens and the lobster is no longer translucent. Do not overcook the lobster or it will become tough.

Add the butter and more salt and pepper to taste, and serve immediately.

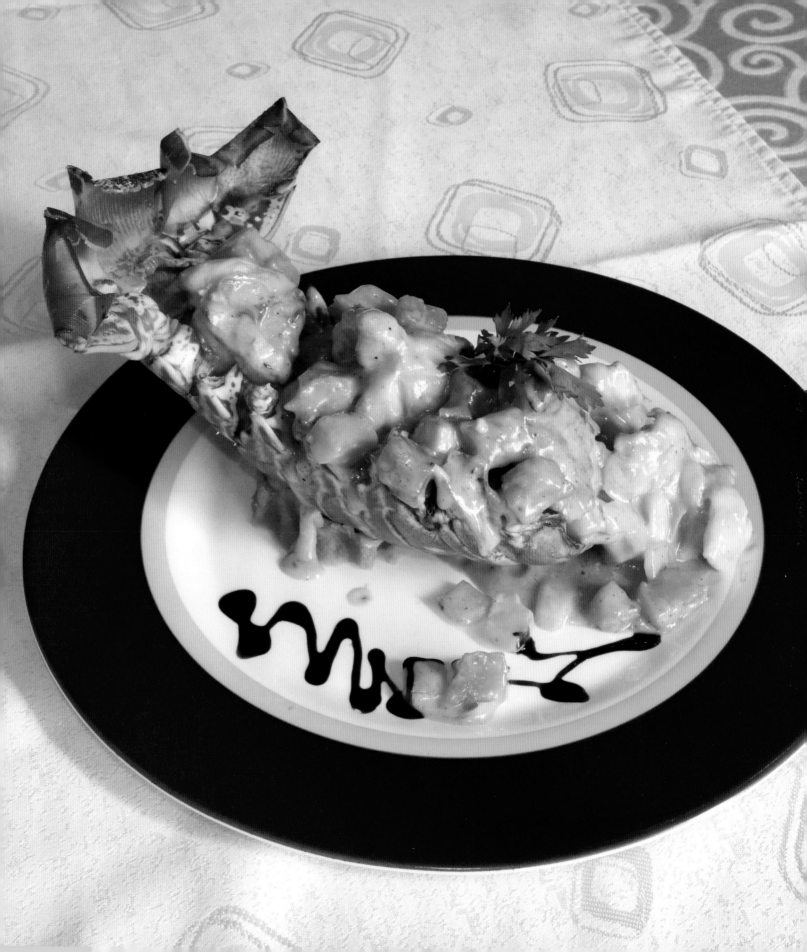

HOTEL SARATOGA

PASEO DEL PRADO No. 603

One of Havana's most historic avenues is the European-style Paseo del Prado, where many of Cuba's most important buildings are located, including the Capitol Building, the Alicia Alonso Grand Theater, several prominent hotels, cinemas, and historic mansions, as well as the famous Parque Central (Central Park), where men gather daily to discuss baseball and play competitive chess games. Originally built to create a boulevard as splendid as those in Paris, Madrid, and Barcelona, the Prado was the first paved street in Havana. It divides the neighborhoods of Old Havana and Central Havana.

In the middle of the Prado's two major thoroughfares, with their substantial traffic going in both directions, is a promenade that was landscaped in 1920 by a team of French and Cuban designers. On completion, the designers added marble benches, iron lampposts, majestic bronze lion statues, and trees that are kept well-groomed and provide shade from the harsh Caribbean sun. In the early decades of the twentieth century, the wealthy elite of Havana used to dress up and stroll the promenade passageways.

Today people walk the Prado to admire the slice-of-life views, enjoy the breeze, and see some of Cuba's talented artists displaying and selling their work. Just south of the Capitol building is the Hotel Saratoga, a favorite destination since the 1930s for artists, socialites, and celebrities from around the world. Beyoncé, Jay-Z, and Mick Jagger have all been guests.

Hotel Saratoga is a lovely place to stop for coffee or a drink in either their downstairs or upstairs bar. One of the hotel's best offerings is its scrumptious sugar cookie, which may accompany a coffee order. The hotel's very talented former baker, Olga Sanchez, was pleased and proud when we asked her to share her recipe. The Hotel Saratoga calls the delicious cookies "Olga's Cookies," in homage to Olga. They are similar to the classic cookie known in Spanish as *Torticas de Morón*.

OLGA'S BUTTER COOKIES
Galletas de Mantequilla de Olga

1 stick and 6 tablespoons cold sweet butter (14 tablespoons total)

1 scant cup of sugar

1 tablespoon vanilla extract

2 ½ cups flour

¼ teaspoon salt

1 medium egg, beaten

Preheat the oven to 350°F. Layer two baking sheets with parchment paper and set aside.

Beat the butter, sugar, and vanilla extract with an electric mixer on medium speed until lightly creamed, 1 to 3 minutes. Remove bowl from mixer.

Slowly add the flour and salt and combine with a large fork or spoon until just barely combined. Do not overmix the dough after adding the flour, as this would activate the gluten in the flour and toughen the cookies (see Note).

Stir in half the beaten egg, and discard the remaining half. Place the barely combined dough onto a lightly-floured counter, or between two pieces of parchment or wax paper. At this point, the dough should not be holding together. Use your hands or the wax paper to carefully combine the dough into a mass, and then using a rolling pin, roll the dough into a ½-inch-thick slab. Do not overwork the dough.

Using a 1-inch cookie cutter, cut rounds from the dough and carefully place them 1 inch apart on the parchment-lined baking sheets. Reroll the remaining dough and cut more rounds. Transfer the baking sheets to the oven and bake the cookies until lightly browned, 13 to 15 minutes, rotating the baking sheets from top to bottom and front to back halfway through the baking time. Do not overbake.

NOTE: The flour in Cuba has less gluten and creates a more tender crumb than we can achieve with American flour.

Olga said she sometimes creates an indentation in each cookie before baking and adds a dollop of berry jam or dark chocolate.

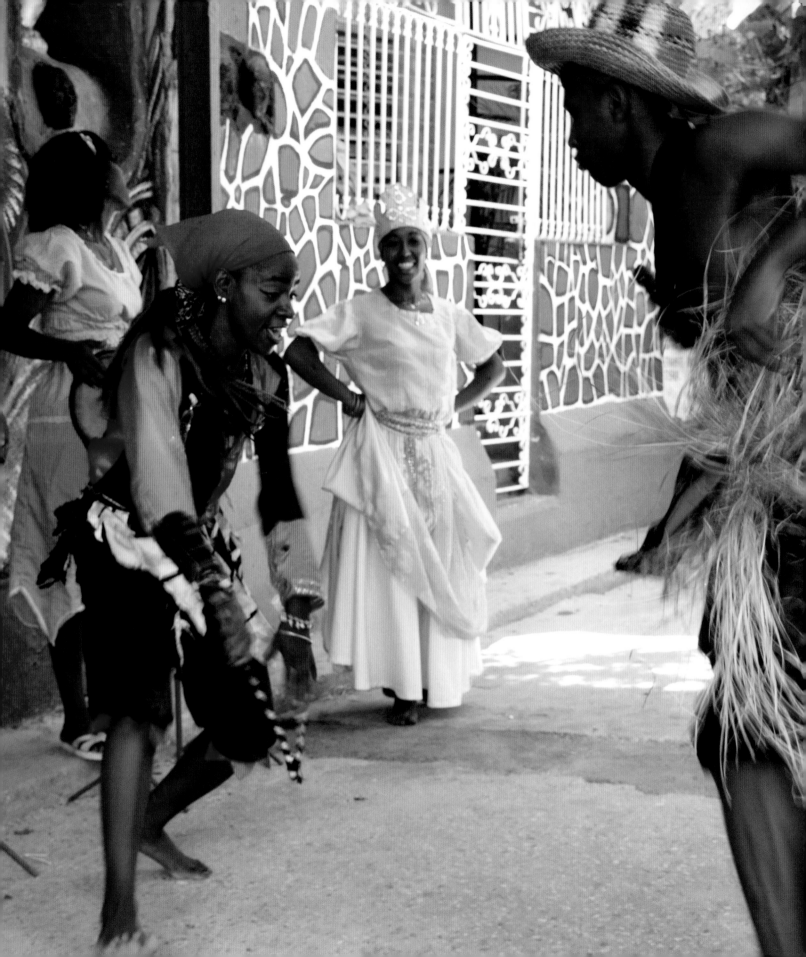

CENTRAL HAVANA

As Old Havana thrived and became more crowded in the early 1800s, the city expanded to the west, and in 1863 the neighborhood of Central Havana was developed. During the colonial period when slaves were brought over from western Africa, they brought their customs, traditions, and religious practices, which are still prevalent in Cuba, particularly in Central Havana. As trade between Cuba and North America developed, Havana flourished and became known as the "Paris of the Antilles," becoming culturally enriched and more fashionable. Central Havana was referred to as the "heart of Havana," with a prestigious shopping district where wealthy women purchased their couture clothing from designers such as Christian Dior. El Encanto department store on Calle Galiano (now called Avenida de Italia, although many Cubans still refer to it as Calle Galiano) featured clothing from a variety of top designers. However, a fire destroyed the building in 1961. The next several decades of economic and political change in Cuba altered the neighborhood's once opulent and glamorous character.

Today Central Havana, the most densely populated neighborhood in Havana, is mostly residential. The neighborhood, which lacks noteworthy historical sites, has received less public funding for renovations than other neighborhoods, such as Old Havana. Thus, many of Central Havana's concrete buildings are collapsing, peeling paint and hanging wires are more obvious than trees or greenery, and the stench of uncollected garbage is pervasive. Yet, the neighborhood is full of life, energy, and music. The street life exudes a sense of community, as people socialize on front stoops and kids play with dolls and pets in their home doorways.

A growing private industry of hair and nail salons, as well as privately-run food markets, is busy tending to residents, who mostly ignore passing foreigners.

One of Central Havana's more captivating streets is Callejón de Hamel (Hamel's Alley), where Cuban painter and muralist Salvador Gonzáles Escalona lives and runs a community project: a constantly changing and growing artistic celebration and expression of Afro-Cuban culture. The work, a sociocultural project, is a vibrant display of sculptures, paintings, and murals—a mix of cubism, surrealism, and abstraction—that Salvador began working on in 1990. His inspiration comes from his African heritage and much of the art represents the symbols and stories of the African-based Santeria and Palo Monte religions, as well as the Afro-Cuban men's group Abakuá, a secret society. Salvador welcomes other artists and neighbors to collaborate with him to expand the art project. Visitors can enjoy the visual artwork as well as midday performances by traditional folkloric dancers, who share and teach the dances of Cuban orishas (the gods and goddesses of the Santeria traditions that originated with the Yoruba, an ethnic group in Nigeria and Benin, and are now practiced throughout Cuba). Salvador's project has created a place where the local community can socialize, perform their Afro-Cuban music, and dance with foreigners who come to experience Cuba's spirit, music, talent, and traditions.

Two of Cuba's best paladares are located in Central Havana: La Guarida and San Cristóbal. They're known for their excellent food and unique atmospheres.

Page 70: *Folkloric dancers perform in Callejón de Hamel.*

Below: *People buying produce at a market.*

Opposite: *A vintage American car on Calle Galiano.*

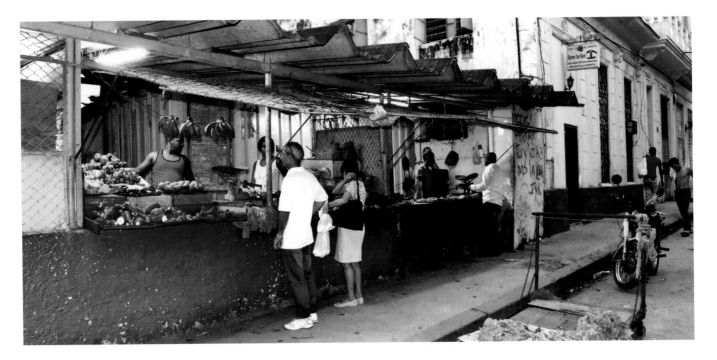

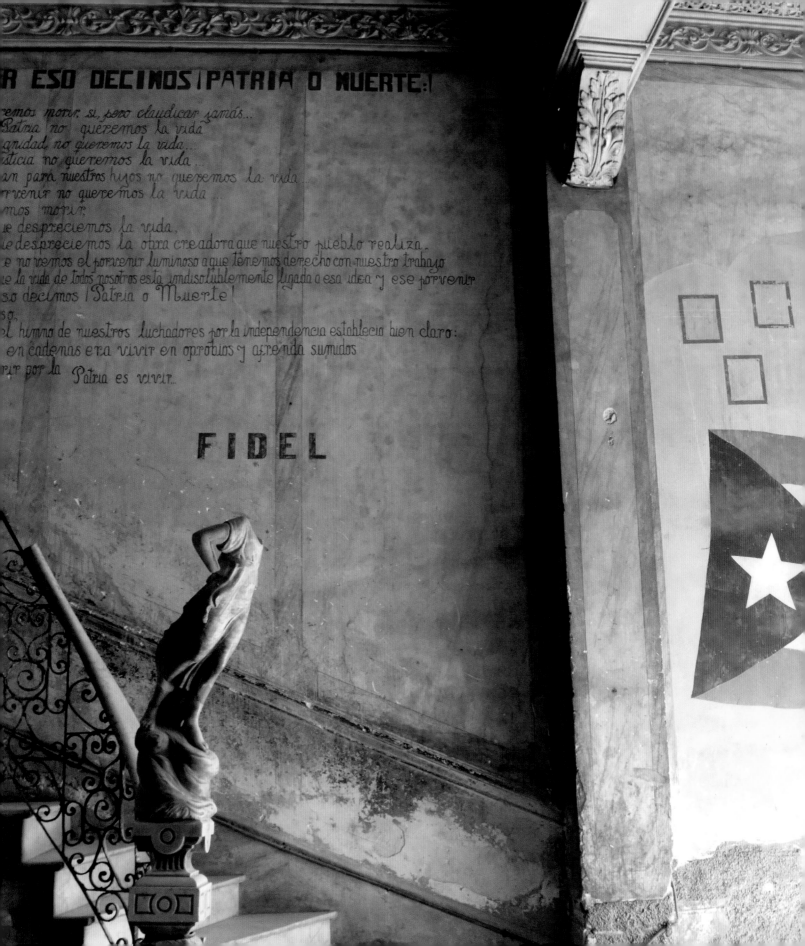

LA GUARIDA

CONCORDIA NO. 418

La Guarida is located in a residential, multifamily building that was built as a mansion in the early part of the twentieth century. Guests arrive at this ornate building through a towering, yet welcoming, open wooden entrance door, which leads to a dimly lit and mysterious inner courtyard where murals of Revolutionary leaders and the Cuban flag decorate the walls. An iconic marble statue of a headless figure enigmatically welcomes guests to climb a marble staircase. A high ceiling looms above the tall columns, marble floors, and vast space, and balconies provide views of hanging laundry and the daily life of neighbors. What awaits guests at the top of the staircase is one of Cuba's finest and first paladares.

The story of how La Guarida became a paladar is as enchanting as its setting. Owners Enrique and Odeisys Nuñez explained, "In 1993, during the very difficult time of the 'special period' in Cuba, the legendary Cuban film directors Tomás Gutiérrez Alea [known as Titón] and Juan Carlos Tabío decided to make their film *Fresa y Chocolate* (*Strawberry and Chocolate*) in our home at Concordia No. 418." Titón once described the film by saying, "It was a story that sought to motivate reflection on intolerance, discrepancy, and, in short, misunderstanding of everything it means to be and think differently." The film reflected the intolerances of the time and went on to transcend the social and political borders of the country. Distributed worldwide, *Fresa y Chocolate* won numerous international accolades, prizes, and even a nomination for an Academy Award. The film inspired foreigners to experience the place where it was made, but when they arrived,

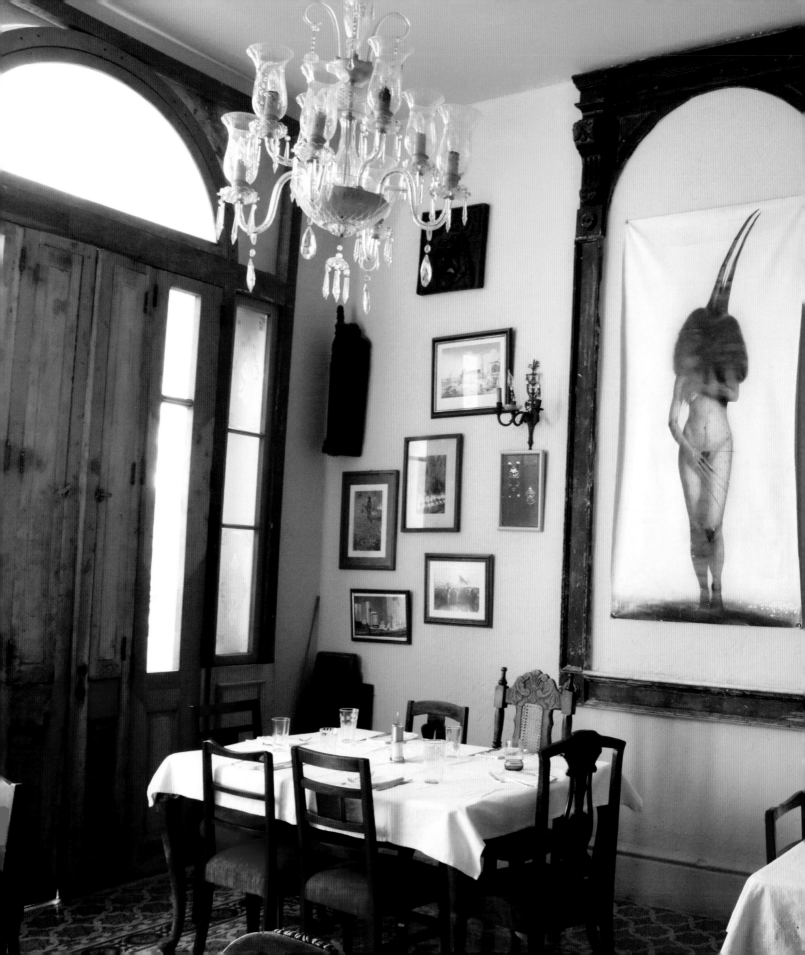

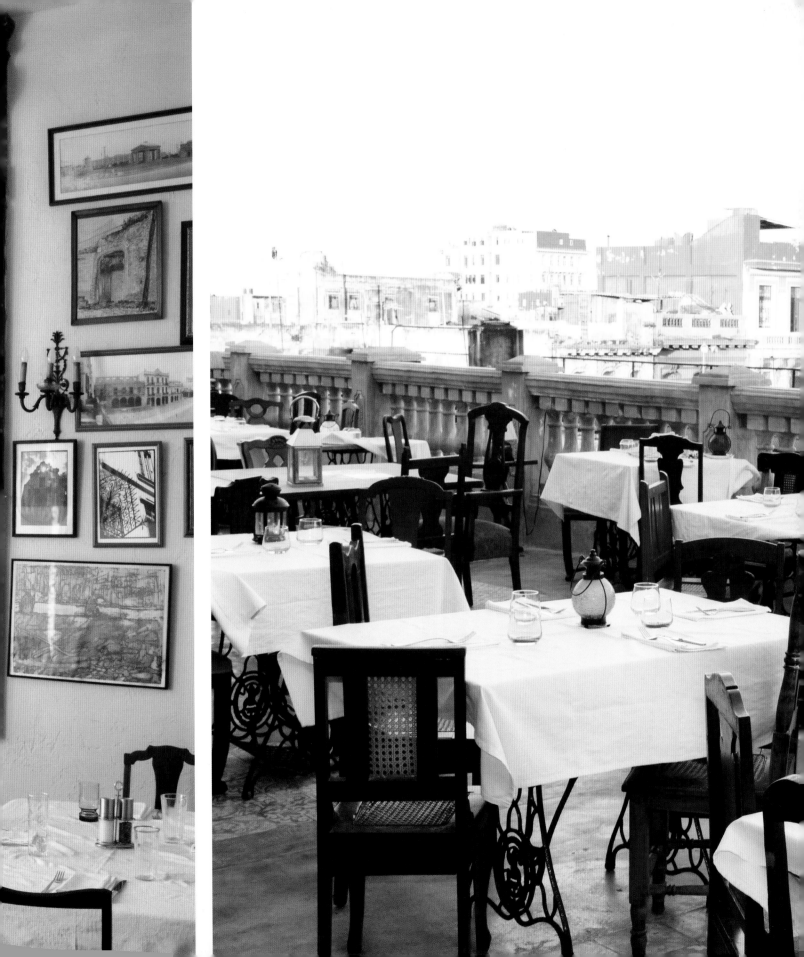

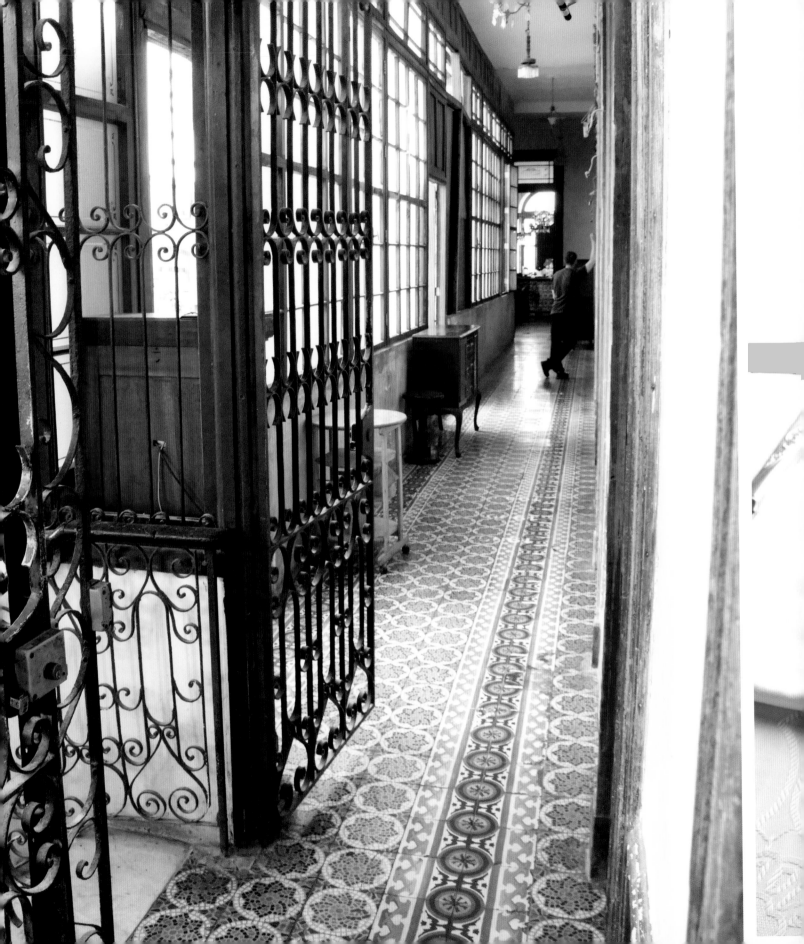

visitors found a regular residential building, not the baroque site full of symbolism that the film's main character, Diego, had as his home. Eventually, Enrique and Odeisys realized they wanted to do something to "keep the story of the film alive" and fulfill the expectations of those who came to experience the magic of the reality behind the art. In the mid-1990s, when the Cuban government legalized paladares, Enrique and Odeisys decided to change their lives, transform their home into a dream-like homage to the film, and open La Guarida, which they did in 1996. Since then, the paladar has expanded to include an additional outdoor seating area, as well as a rooftop bar offering panoramic views of neighborhood buildings, a piece of the ocean, and spectacular sunsets.

PUREE OF VEGETABLE SOUP

Chupito de Cortesía

4 cups starchy vegetables (such as yam, pumpkin, and sweet potato)

2 cloves garlic, minced

Salt and pepper, to taste

Sliced red bell pepper, for garnish

Fresh basil leaves, for garnish

Green Plantain Chips (page 224), for garnish

Mixed beans, cooked, for serving (optional)

Peel the root vegetables and chop into large chunks. Fill a large saucepan with water and bring to a boil, then add the vegetables and garlic. There should be enough water to just cover the vegetables. Lower heat to simmer and cook, covered, until the vegetables are soft. Transfer the vegetables to a blender, preserving ½ cup of cooking water. Add the salt and pepper to the vegetables, and puree, working in batches if necessary and adding cooking water as needed to reach the desired consistency.

Divide the soup among 16 shot glasses. Garnish each serving with a piece of red pepper, a basil leaf, and a Green Plantain Chip. Serve immediately while hot, with a side of mixed beans, if desired.

NOTE: This soup can also be made with vegetable or chicken stock in place of the water, and with a touch of cream for a richer, smoother finish.

La Guarida serves this soup as a small courtesy appetizer in a shot glass, which is why its Spanish name translates directly to "Courtesy Shot."

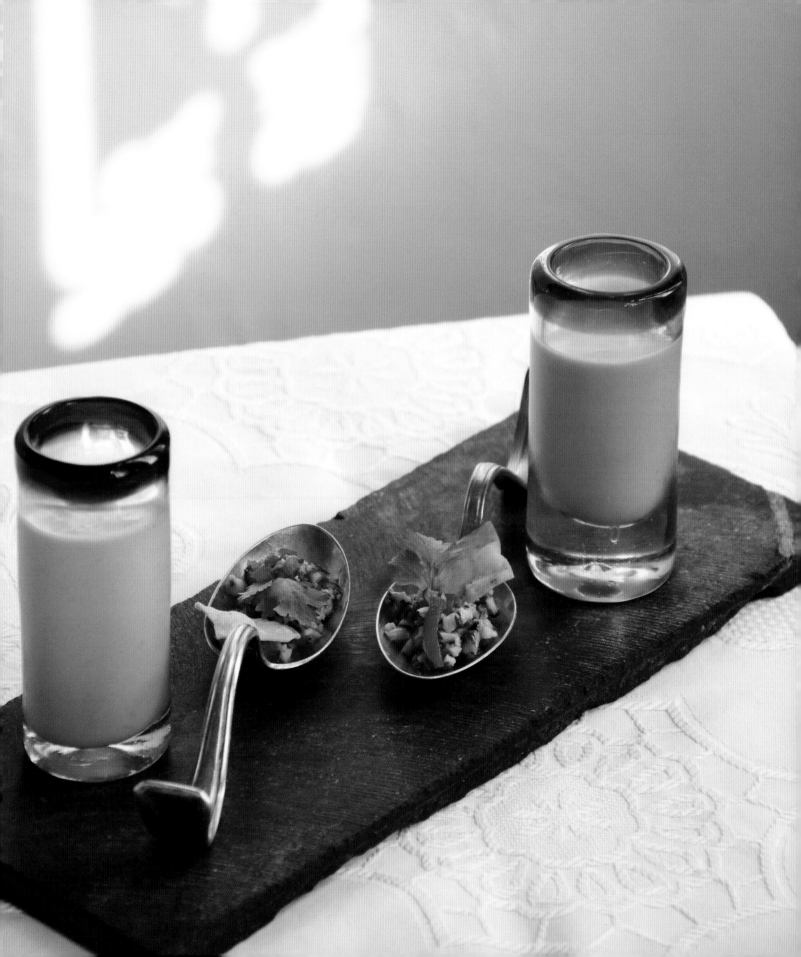

EGGPLANT CAVIAR IN TOMATO COULIS

SERVES 2

Caviar de Berenjena en Tomate Coulis

1 medium eggplant,
 washed and halved

6 tablespoons olive oil, plus
 additional for greasing the pan

½ teaspoon minced garlic

 Salt and pepper, to taste

2 tomatoes

1 ½ teaspoons freshly
 squeezed lemon juice

 Roasted red pepper
 slices, for garnish

 Cucumber, thinly sliced, for garnish

Preheat the oven to 450°F. Grease a baking pan with olive oil.

Place the eggplant skin-side down on the pan and bake for 40 minutes, or until soft. Remove from the oven and, when it is cool enough to handle, scrape out the seeds and cut the flesh from the skin. Discard the skin, and place the flesh in a strainer to drain for 30 minutes. Discard the juices.

Finely chop the eggplant flesh and, in a large bowl, combine it with 2 tablespoons of the olive oil and the minced garlic, salt, and pepper.

To prepare the tomato coulis, skin and seed the tomatoes and combine them in a blender with the remaining 4 tablespoons olive oil and the lemon juice, salt, and pepper. Blend until creamy, then strain and discard the solids, reserving only the liquid.

Serve the eggplant warm or at room temperature topped with the tomato coulis and garnished with the roasted red pepper and cucumber. At La Guarida, the chef serves the eggplant puree molded on a plate with a generous layer of tomato coulis, roasted red pepper, and paper-thin cucumber slices rolled into rosettes.

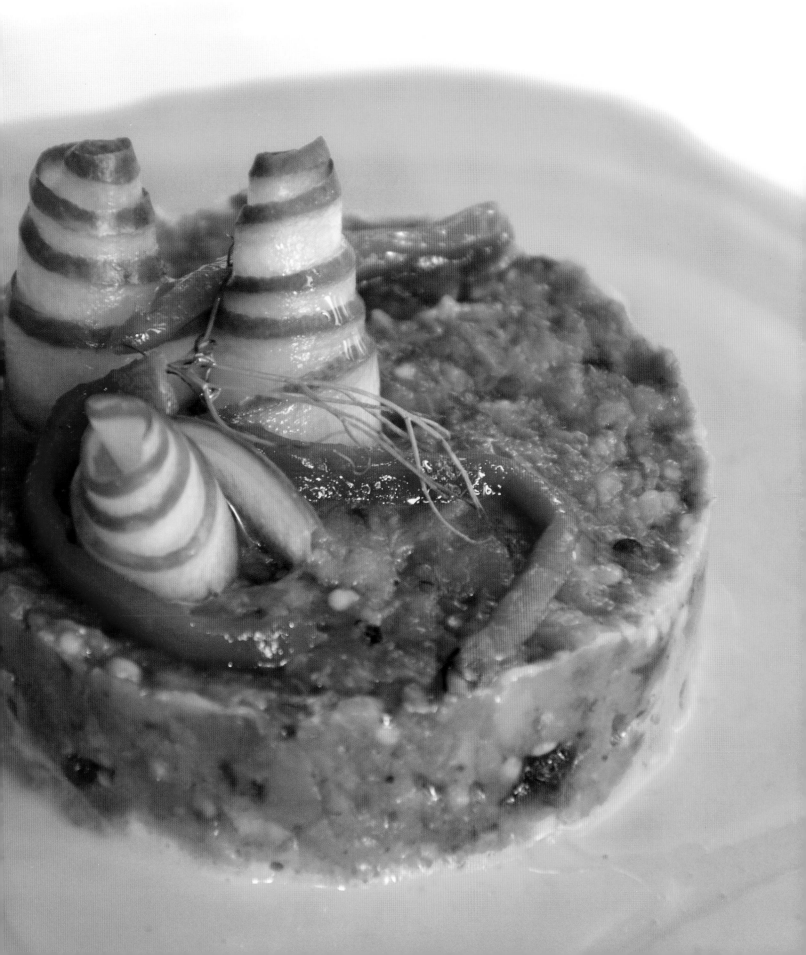

FISH TACOS WITH FRIED YAM TACO SHELLS

SERVES 5

Tacos de Pescado con Casco de Boniato

Taco Shells

Vegetable oil

1 large boniato (see Note)

Dressing

6 tablespoons mayonnaise

1 cup finely chopped yellow onion

½ cup finely chopped chives or green tops of scallions

¼ cup capers

Salt and pepper, to taste

Tabasco sauce, to taste

1 pound smoked whitefish, flaked (see Note)

Shredded lettuce, for garnish

Sliced red bell peppers, for garnish

To prepare the boniato taco shells, heat 4 inches of vegetable oil in a 2-quart or medium saucepan to 350°F. Use a mandoline to slice the boniato yam lengthwise into very thin and wide chip-like slices. Lower the yam slices into the oil four at a time and deep-fry until they brown, about 3 minutes. As they cook, use long tongs to shape and mold the slices into taco shell shapes. As they brown, they will get crispy and will hold the shape on their own. When they're crispy, remove from the oil and place on a paper towel to drain and cool. (In Cuba, they use a folded brown paper bag to absorb the grease because paper towels are not available).

To make the dressing, combine the mayonnaise, onion, chives, capers, salt, pepper, and Tabasco in a bowl. Mix the fish with the dressing. The whitefish mixed with the mayonnaise dressing can be kept for up to several hours in the refrigerator before filling the tacos, and the boniato taco shells can be kept at room temperature for several hours once they are cooled.

To assemble the tacos, spoon the fish mixture into the cooled boniato taco shells. Garnish with lettuce and red peppers and serve immediately.

NOTE: In lieu of a boniato, you may use a white, starchy yam, but not a sweet potato.

The chefs at La Guarida originally made this dish with steamed marlin. They changed the recipe to use smoked whitefish when a supplier of smoked fish became available nearby and smoked fish became a popular alternative ingredient in many dishes that had previously been made with cooked fish.

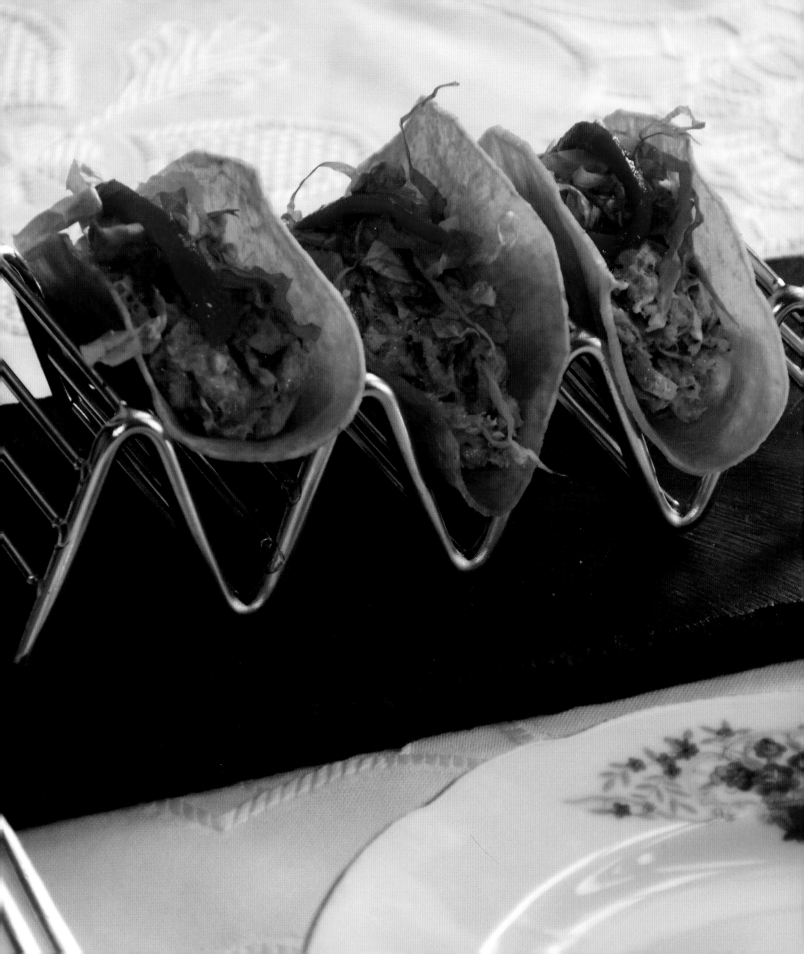

BONIATO AND PLANTAIN CHIPS
Boniato y Mariquitas de Plátano

1 boniato or yam, peeled

1 green plantain

Vegetable oil

Slice the boniato and green plantain into very thin slices using a mandoline. Fill a large saucepan with 3 inches of vegetable oil and heat to 350°F. Add the boniato and green plantain slices to the oil and deep fry until brown, about 3 minutes. Remove with a slotted spoon and transfer to a bed of paper towels to absorb the excess oil. Let the chips cool completely and then mix with cooled green plantain chips. Break all chips into small pieces before serving.

SERVES 4

GRILLED FISH
Pescado Asado

2 tablespoons olive oil

2 cloves garlic, crushed

½ teaspoon salt

Four 4-ounce firm flesh white fish fillets (such as sole, flounder, or dorado)

2 tomatoes, halved

Vegetable oil, for grilling

2 cups Boniato and Plantain Chips (above)

Combine the olive oil, garlic, and a pinch of salt in a small bowl. Use a brush to spread the mixture over both sides of the fish and the cut sides of the tomatoes. Let rest while preheating the grill to medium heat. Brush oil on the grill racks.

Grill the fish, turning only once, until opaque and just flaky; fish requires 5 minutes of cooking for every ½ inch of thickness. Grill the tomatoes cut-side down 3 to 5 minutes until soft. Remove the fish from the heat and place one fillet on each plate. Chop the grilled tomatoes and sprinkle with salt. Spread the chopped grilled tomatoes over the fish, sprinkle the fried Boniato and Plantain Chips on top, and serve immediately.

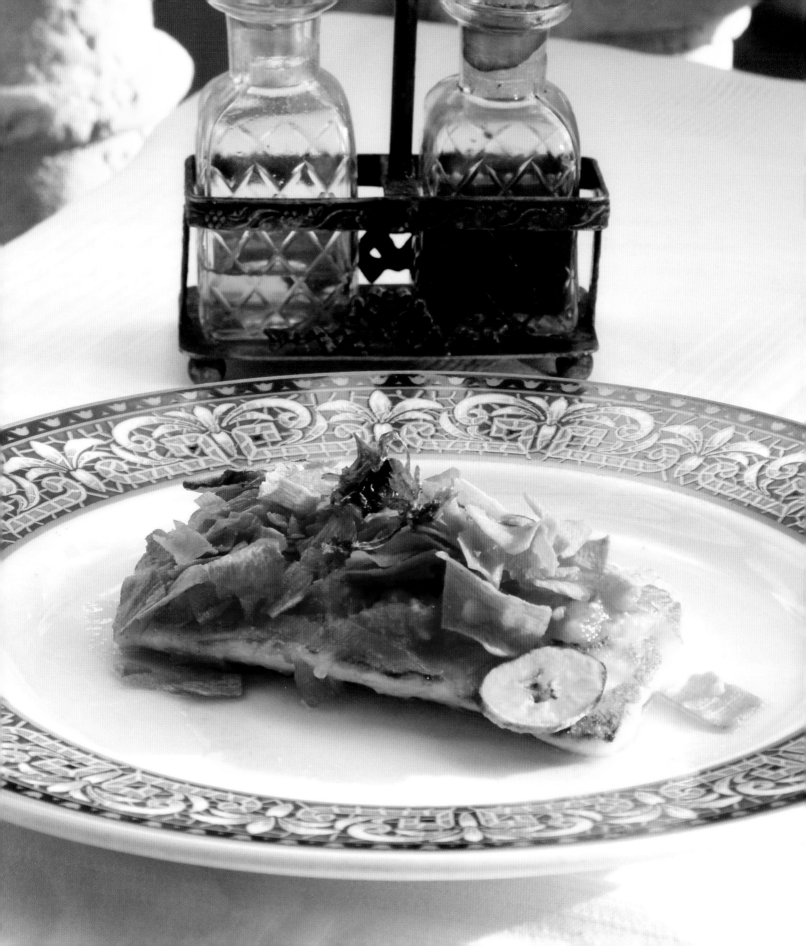

RAVIOLI
Ravioles

Homemade Pasta

2 ½ cups flour, or more as needed

5 large eggs (see Note)

2 tablespoons olive oil

1 teaspoon salt

Filling (Relleno)

½ cup goat cheese

¼ cup shredded Gouda cheese

2 tablespoons finely-chopped fresh basil

Salt and pepper, to taste

Pesto Sauce

2 cups fresh basil leaves

3 cloves garlic, minced

1 tablespoon pine nuts

½ cup olive oil

2 tablespoons Parmesan cheese

½ teaspoon salt

To make the pasta, place the flour in a mound on a clean countertop. Make a well in the middle of the flour and combine the eggs, olive oil, and salt in the well. Using a fork, beat together the eggs in the center and slowly begin to add the flour into the eggs, maintaining a wall of flour to hold the egg mixture in the center. As the dough forms, start to use the wall of flour, adding it slowly into the center mixture until you have incorporated all 2 ½ cups flour. Add more flour if needed to create a sticky dough.

Knead the dough by hand for 3 minutes, adding flour as needed to allow handling. The dough should be elastic and a little sticky. Knead for 3 more minutes, adding slight amounts of flour as needed to keep it from sticking to the board. Wrap the dough in plastic and let it rest for 30 minutes at room temperature. While the dough rests, prepare the filling and sauce.

To make the filling, combine the goat cheese, Gouda, basil, salt, and pepper in a small bowl and set aside.

To make the pesto sauce, combine the garlic, basil leaves, and pine nuts in a blender or food processor. Process to finely chop the mixture, then slowly add the olive oil until it becomes a paste. Add the Parmesan and salt and stir to blend. Set aside, or refrigerate if not using immediately. The pesto can be frozen for up to three months in a sealed container or a tight plastic bag.

Once the dough has rested, divide it into 8 balls. Keeping them covered with a clean kitchen cloth or a towel, roll each ball into a sheet ¹⁄₁₆ inch thick and 5 inches wide, using a rolling pin or a pasta maker. If using a pasta maker, reroll the dough several times until very thin sheets of pasta dough emerge. Crease each rectangle of dough lengthwise to create two 2 ½-inch-wide rectangles, then unfold to add the filling. Place tablespoonfuls of filling evenly spaced ½ inch apart down the length of one of the rectangles. Brush water along the edges and fold over the

other side of the dough to create a long rectangle 2 ½ inches wide with filling lumps evenly spaced inside. Press the dough gently in between each lump of filling to create individual ravioli. Cut out the ravioli using a fluted ravioli cutter or a knife. Repeat with the remaining dough rectangles and filling. (The ravioli can be frozen at this point, packaged airtight.)

Bring a large pot of water with a generous amount of coarse salt to a boil. Add 20 ravioli to the water and cook for 3 to 5 minutes. Remove the cooked ravioli with a slotted spoon and repeat with the remaining ravioli. Serve the ravioli immediately while hot, with a generous amount of warmed or room temperature pesto sauce.

NOTE: The chef's recipe used 10 eggs. Since Cuban eggs are very small, 5 large eggs, of the large kind found in the United States, work well as a replacement.

THREE-MILK DARK CHOCOLATE CAKE

Tres Leches Chocolat

Chocolate Sponge Cake

3 large eggs

½ cup sugar

½ cup flour, sifted

2 tablespoons cocoa powder

Three-Milk Sauce

2 cups powdered milk, or one
 14-ounce can evaporated milk

1 cup sweetened condensed milk

½ cup heavy cream

¼ cup cocoa powder

Chocolate Mousse

8 ounces bittersweet
 chocolate, chopped

½ cup sugar

4 tablespoons (½ stick) salted butter

½ ounce Cointreau or other liqueur

4 large egg yolks

¾ cup heavy cream

To make the sponge cake, preheat the oven to 350°F. Butter a 6-cup cupcake pan or an 8-inch square pan.

Separate the eggs. Beat the egg whites at high speed with an electric mixer until stiff. In a separate bowl, combine the sugar and egg yolks and beat on high speed for 3 minutes. Very gently fold in the flour and cocoa powder. Do not beat or stir vigorously. Gently fold the yolk and chocolate mixture into the stiff egg whites until just combined.

Pour the batter into the prepared pan and bake for about 12 minutes in the cupcake pan or about 15 minutes in the square pan, just until the cakes are cooked through and a knife or cake tester stuck into the center comes out clean. Release the cakes from the pan by running a knife along the sides. Let cool for 5 minutes in the pan, then remove the cakes and set aside to cool completely on a wire rack. These cakes can be kept for up to two days at room temperature in an airtight container.

To make the three-milk sauce, combine all ingredients into a blender and blend well. Strain and set aside. The mixture can be kept covered in the refrigerator for up to two days.

To make the chocolate mousse, melt the chocolate, sugar, butter, and Cointreau in the top of a double boiler, or in a heatproof bowl set over a pot of simmering water (be sure the bottom of the bowl does not touch the water). Once the mixture is melted, beat to combine by hand or on low speed using an electric mixer. Beat the egg yolks in a separate bowl by hand. Slowly add yolks, one teaspoon at a time, to the hot chocolate mixture, making sure to beat the mixture on medium speed while adding them to prevent the eggs from curdling. Cook for several minutes, until well combined, then remove from the heat. Refrigerate, uncovered, until cool.

Beat the heavy cream in a separate bowl until soft peaks are formed. When the chocolate is completely cool, fold the whipped cream into the chocolate mixture. Refrigerate, covered, for up to several hours until ready to use.

To assemble the cakes, place each cupcake-sized sponge cake in an individually-sized serving bowl or dessert plate. If the cake was baked in an 8-inch square pan, slice the cake into 6 pieces and place on a dessert plate. Pour the chocolate sauce over the cakes to drench them. Scoop the chocolate mousse into a pastry bag and pipe a large rosette of mousse onto the top of each cake using a flower tip. Serve immediately.

SAN CRISTÓBAL

CALLE SAN RAFAEL NO. 469

As guests arrive at the tall wood doors of San Cristóbal, handsome, friendly young men welcome and escort them into a magical and festive atmosphere. Before you even sit at your dining table, you can hear the whole-hearted laughter of the paladar's owner, head chef, and most genial host, Cristóbal Márquez Valdés, known to his friends as "Carlito." For decades, Carlito has been collecting antiques, and almost every inch of wall space throughout the restaurant, including the bathrooms, is an homage to Cuba's cultural history. Rooms are decorated with Carlito's vast vintage collection, including an eclectic mix of classic black-and-white photographs that glamorously portray famous Cuban and American actors, singers, athletes, and political heroes; antique, working wooden clocks; paintings of rural settings; handmade pottery; retro posters advertising Spanish movies and bull fights; and old American business signs from the 1940s and 1950s, such as ones for Coca-Cola and Standard Oil. Archways, molding, stained glass, and chandeliers reflect light from the high ceilings, casting a warm and celebratory glow. Tall marble columns separate the room where Carlito has built a shrine to the black Virgin Mary, also known in Cuba as Nuestra Señora de Regla (Our Lady of Regla). A few private rooms can be reserved for a more secluded experience, away from the energy and activity of the main passageway. President Barack Obama and his entourage dined at San Cristóbal for authentic Cuban creole during their historic visit to Havana in March 2016.

Carlito is a warm and generous man who frequently shares his joyous laughter with his staff, family, and visitors. He visits each guest at their table to make sure they are having a wonderful experience dining in his home. Each waiter is also

attentive and affable. Guests are offered a complimentary after-dinner drink and cigar, which is one of the ways Carlito likes to celebrate life and share its pleasures.

Carlito's mother was a cook for the wealthy in the 1950s, and she taught him how to make all the best traditional Cuban dishes, which are now on the menu at San Cristóbal. The secret to his dishes, he says, is that the ingredients are always fresh, and he personally handpicks the vegetables from a local farm. Carlito is proud of his hard-earned success and shares his happiness and enthusiasm for life with his guests through each one of his dishes.

San Cristóbal begins every dinner with a complimentary assortment of Spanish tapas on a platter to share family style. These can include ingredients such as fried malanga, black or green olives (natural or fried), ceviche, Serrano ham, fried plantain or yuca chips, pureed eggplant baked with olive oil, a Spanish tortilla omelet, smoked salmon, and shrimp salpicón (shrimp cooked with onion, tomato, garlic, hot pepper, and olive oil).

Opposite: *San Cristóbal's owner and chef, Cristóbal Márquez Valdés, known as "Carlos."*

Page 96: *A waiter holds a pepper mill grinder in the form of a baseball bat.*

Page 97: *The room at San Cristóbal where President Barack Obama and First Lady Michelle Obama dined during their visit to Cuba in March 2016.*

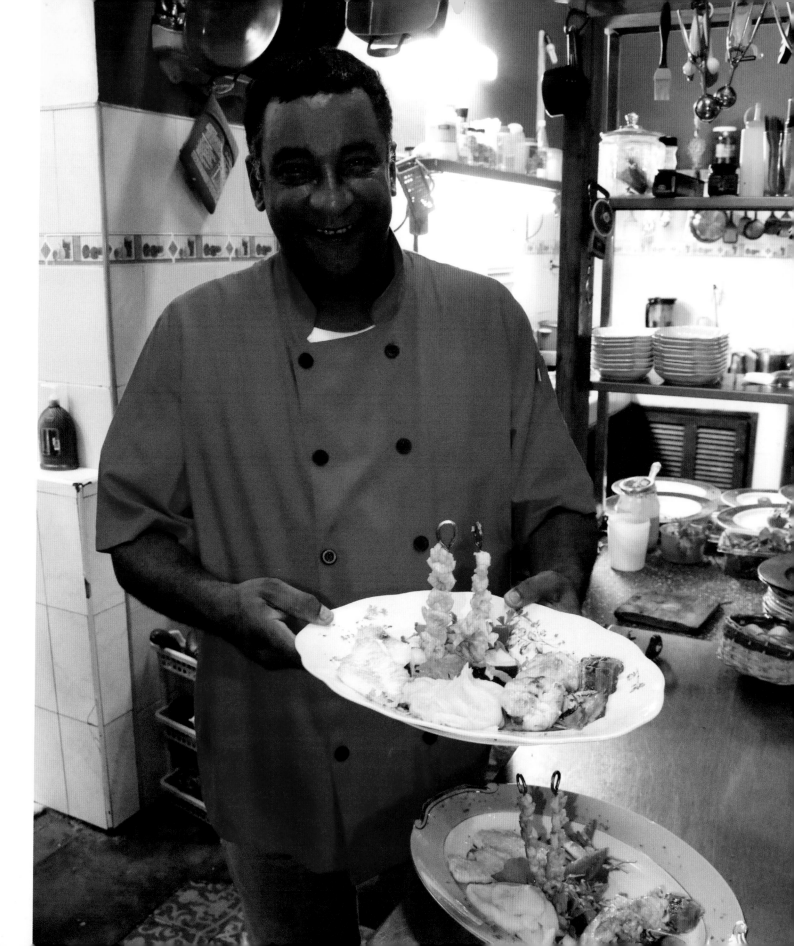

GRILLED CHICKEN WITH WHITE RICE, BLACK BEANS, AND SWEET PLANTAINS

SERVES 4

Pollo a la Plancha, Arroz Blanco,
Frijoles Negros y Maduros

12 ounces dried or canned black beans

1 cup white rice

4 tablespoons coarse salt

1 red bell pepper, finely chopped

2 cloves garlic, minced

16 green olives, pitted and chopped

1 tablespoon red wine vinegar

¼ teaspoon ground hot red pepper or red pepper flakes

Pepper, to taste

2 ripe plantains, yellow-brown in color, peeled

Vegetable oil

1 pound boneless and skinless chicken breast, quartered

2 tablespoons olive oil

If using dried black beans, rinse the beans in water three times to remove grit and dirt, then soak submerged in water overnight at room temperature.

To prepare the rice, mix the rice, 1 tablespoon of the salt, and 2 cups cold water in a saucepan or rice cooker (if using a rice cooker, use only 1 cup of water). Bring to a boil, and then lower the heat to a simmer. Cook, covered, for about 20 minutes, until the rice is soft and the water is absorbed. (If using a rice cooker, cook the rice according to the manufacturer's instructions.)

To prepare the black beans, combine the beans, bell pepper, garlic, olives, red wine vinegar, ground red pepper, and 2 tablespoons of the salt in a saucepan. Add enough cold water to just cover the ingredients. Bring to a boil, then lower the heat and cook, covered, at a simmer until the beans are soft and fully cooked. If using canned beans, this will take 30 to 45 minutes; dried and soaked beans will need to cook for 1 ½ hours. Add salt and pepper to taste.

While the beans are cooking, prepare the sweet plantains and the chicken. Slice the plantains ¼ inch thick on the diagonal. Heat an inch of vegetable oil in a large frying pan over high heat. The oil is hot enough if the plantain slice immediately sizzles when placed in the oil but does not start to burn. Add the sliced plantains and fry on both sides, about 3 minutes a side, until cooked through.

Preheat the grill to high, or preheat a sandwich press suitable for grilling. Season the chicken with olive oil and the remaining 1 tablespoon of the salt. This is best

if allowed to sit tightly covered in the refrigerator for a minimum of 20 minutes and up to two days. When ready to cook, place the chicken on the grill and cook, flipping once, for 3 minutes on each side until it is no longer pink in the middle. If the breast is very thick, it might require a few more minutes of direct heat. Test by slicing through the thickest section to confirm it is just barely pink inside and mostly white. Remove from the heat and serve immediately.

Serve the chicken with a scoop of black beans, a scoop of white rice, and a serving of fried plantains. The beans and rice should be served separately on the plate in typical Cuban style. The plantains should be placed next to them.

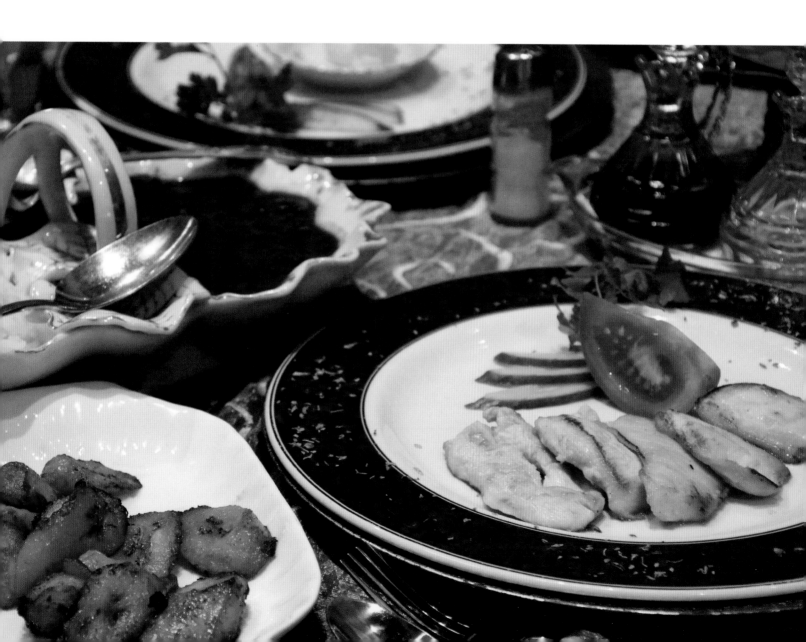

GRANDMOTHER'S GARDEN SALAD

SERVES 2

Ensalada del Huerto de Abuela

1 medium potato, peeled

Salt

2 eggs

2 small tomatoes

1 head of romaine lettuce

Handful of watercress leaves

6 ounces of canned or jarred high-quality tuna packed in olive oil

Ranch-Like Dressing (see Note)

¼ cup mayonnaise

¼ cup pineapple juice

¼ cup finely chopped white onion

1 clove garlic, minced

¼ teaspoon curry powder

Salt and pepper, to taste

Cube the potato into 1-inch chunks. Bring a pot of salted water to boil, then add the potato and lower the heat to a simmer. Simmer, covered, until the potato pierces easily with a sharp knife, about 15 minutes. Set aside and let cool. When cool, cut into smaller chunks if desired.

Place the eggs in a small saucepan and add just enough cold water to cover. Cover the pan and bring to a boil over high heat. Once the water boils, immediately lower the heat to a simmer and cook for exactly 12 minutes. Remove the eggs from the heat and run cold water over them or place them in ice water to cool. Peel the eggs and slice each into 4 slices.

Wash and dry the tomatoes, lettuce, and watercress. Quarter the tomatoes, tear the lettuce and watercress into pieces, and combine them in a bowl. Artfully arrange the drained tuna, hard-boiled egg slices, and potato chunks on top.

To make the dressing, combine the mayonnaise, pineapple juice, onion, garlic, and curry powder in a blender or food processor. Blend until smooth, then mix in the salt and pepper. Pour the dressing over the salad and serve immediately.

NOTE: The chef says the dressing is like a Florentine salad dressing. His use of it on a Niçoise-like salad is an idea that came from his grandmother. His wife, however, much prefers this salad with a vinaigrette. To make the vinaigrette dressing, whisk together 1 tablespoon Dijon mustard and 2 tablespoons red wine vinegar in a small bowl. Slowly add 6 tablespoons olive oil in a thin stream, whisking vigorously to emulsify, then add the salt.

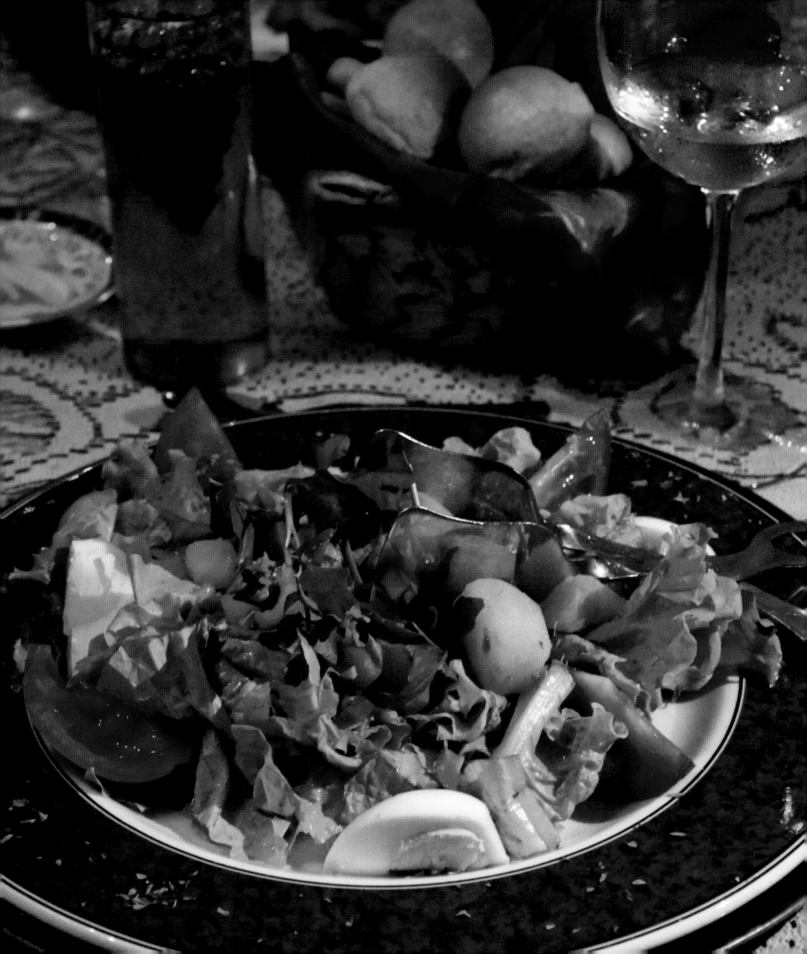

FILLET OF FISH FLORIDA WITH ORANGE SAUCE

SERVES 4

Filete de Pescado con Salsa de Naranja

Four 6-ounce fish fillets (such as tilapia, red snapper, sole, or flounder) each ½ inch thick

2 teaspoons salt

1 teaspoon pepper

2 tablespoons olive oil

½ tablespoon salted butter

1 cup freshly squeezed orange juice

Segments from 4 oranges, cut supreme (see Note)

Rinse the fish fillets and pat them dry with a paper towel. Season with salt and pepper. Heat the olive oil in a large skillet over medium heat. Once the oil is hot, add the fillets and cook until lightly browned on one side, then flip and cook until lightly browned on the other side, 2 to 3 minutes per side. If the fillets are thicker than ½ inch, they will need more cooking time.

Add the butter, orange juice, and orange segments to the pan and cook, not stirring, for 1 to 3 minutes. Remove fillets to a serving dish or serving plates and carefully add a layer of orange segments over each fillet. Drizzle a generous amount of orange sauce from the pan over each fillet and serve immediately.

NOTE: To supreme oranges, cut off the top and bottom ends of each orange and peel the oranges. Then, using a small paring knife, cut out the segments, carefully avoiding the membranes.

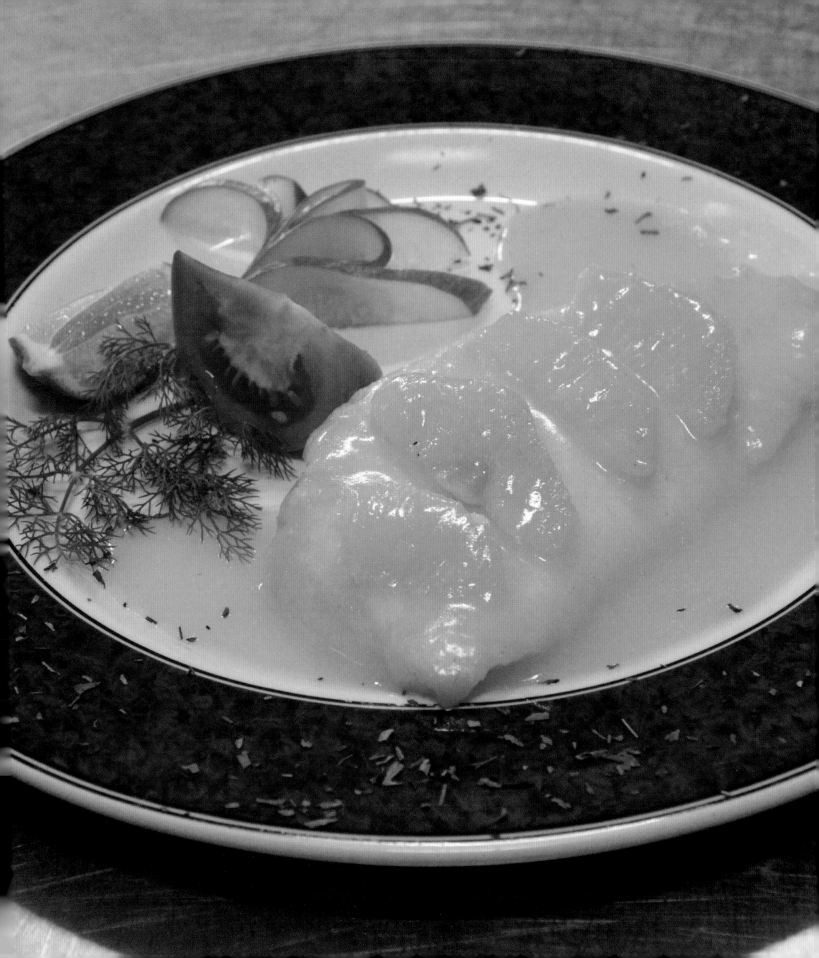

HAVANA TEMPTATION: STEAK STRIPS WITH GRANDMOTHER'S DEMI-GLACE SAUCE

SERVES 4

Tentación Habananera: Palillos de Filete con Salsa de Abuela

2 tablespoons olive oil

1 pound lean cut of meat (such as filet mignon, strip, or sirloin), cut 1 ½ inches thick,

1 tablespoon coarse salt

1 teaspoon pepper

2 yellow onions, finely julienned

4 cloves garlic, minced

1 ½ cups red wine

Preheat oven to 450°F. Heat the olive oil in a large Dutch oven or cast-iron pan over high heat. Sprinkle the meat with salt and pepper, add to the pan, and sear 2 minutes on each side, flipping only once. If you prefer the meat served rare, it can be served now or remain on the stove for another 2 minutes. If you prefer the meat served medium to well-done, transfer the pan, uncovered, to a very hot preheated oven and cook 5 more minutes or until the desired temperature is reached. (Make sure the kitchen is well vented). Remove the meat from the pan and set aside, allowing it to rest for up to 15 minutes.

Lower the heat to medium-low, add the onions and garlic, and cook, stirring gently and occasionally for 5 minutes. Add the red wine, and using a wooden spoon, scrape up all the brown bits clinging to the pan, and stir to combine. Reduce the heat to low and continue to cook, not stirring, until the sauce is thick and syrupy. This should take 10 to 15 minutes. Add additional salt and pepper to taste, and serve the steak immediately with the sauce spooned over the top.

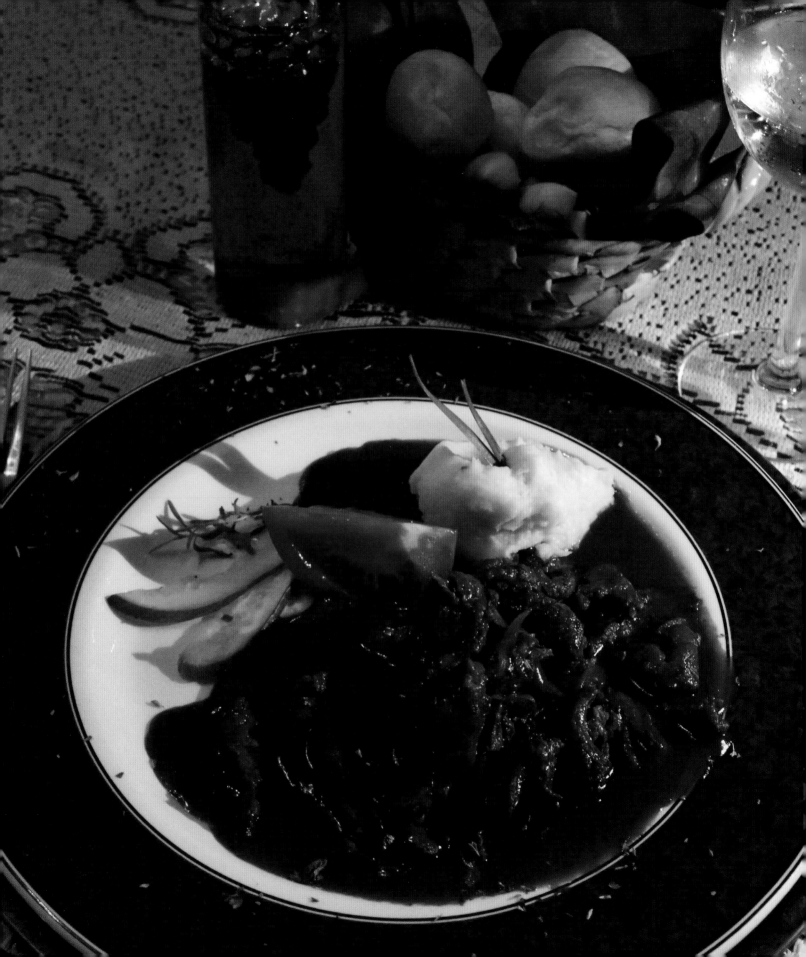

GREEN PAPAYA IN SIMPLE SYRUP WITH CHEESE

SERVES 4

Fruta Bomba con Queso

1 green papaya (fruta bomba), peeled

1 cup sugar

1 cup (8 ounces) firm white cheese or farmer cheese

Slice the papaya into ½-inch cubes. Combine the sugar and 1 cup cold water in a saucepan and bring to a boil, then add the papaya. Lower the heat to a simmer and cook, uncovered, until the papaya is soft, about 40 minutes. Strain and serve the papaya immediately with wedges of the white cheese.

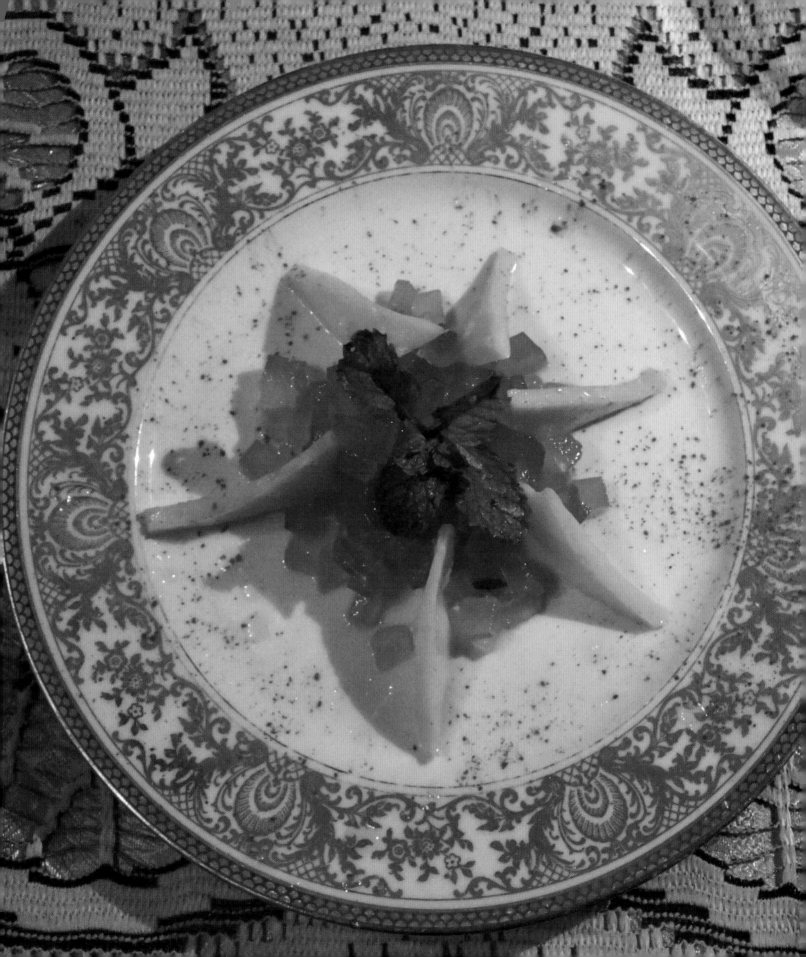

VEDADO

As you drive west from Central Havana to Vedado, the buildings you pass become taller and more modern, though several notorious buildings maintain the baroque and neoclassical style of Old Havana. Vedado, whose name translates to "private reserve" or "forbidden," was originally a forest reserve with a variety of trees protecting Havana city. Wood houses were first built in Vedado in the 1860s. In the beginning of the twentieth century, secluded and exclusive homes were constructed in the neighborhood. A wave of modern and architecturally innovative buildings and landmark hotels were built during the 1950s, when Havana was a chic destination for wealthy Americans. During this period of opulence and corruption, casinos were part of the lively scene, particularly the ones in the great dome of the Hotel Habana Riviera; the art deco, neoclassical-styled Hotel Nacional de Cuba (which hosted numerous well-known personalities such as film stars Frank Sinatra and Ava Gardner, scientist Alexander Fleming, and British Prime Minister Winston Churchill); the Hotel Capri; and the Habana Hilton (known then as the tallest and largest hotel in Latin America, with a Trader Vic's restaurant, supper club, pool, and rooftop bar with city views).

Following Fidel Castro's entry into Havana on January 8, 1959, during the Cuban Revolution, the casinos were shut down and the Habana Hilton became Fidel Castro's headquarters for three months while he also lived in one of the rooms. In 1960, after relations between Cuba and the United States soured, Castro renamed the notorious Habana Hilton hotel, designating it Habana Libre (Free Havana). At the nearby corner is the main avenue of Vedado, La Rampa (23rd Street), where Cubans come from far away and wait in long lines

to eat the famous ice cream at Coppelia or see a movie at the Yara cinema. Vedado is a busy neighborhood with large residential buildings mixed with many of Cuba's most prominent cultural venues, central government offices, embassies, and artist galleries. Vedado is also home to many of Havana's trendiest restaurants, paladares, and nightclubs, such as the exhilarating Fábrica de Arte Cubano (FAC), where both Cubans and foreigners enjoy multimedia art presentations that change frequently.

Tree-lined avenues and wide Parisian-style boulevards characterize Vedado's streets. Sculptures, monuments, and parks with Wi-Fi service abound. Also located in Vedado are the restored El Patronato synagogue and La Casa de la Comunidad Hebrea de Cuba (House of the Jewish Community in Cuba). Cuba's internationally renowned University of Havana, founded in 1728, is perched at

Page 108: *Vintage American cars on Calle 23.*

Below: *A girl with ice cream from Coppelia, the famous government-owned ice cream parlor in Vedado.*

the top of the hill with a statue of Alma Mater (Latin for "nourishing mother") welcoming students and visitors.

Near the university is Havana's expansive city square, which was conceived as a civic center by the French urban designer Jean-Claude Forestier in the 1920s. It has the same style as the sprawling Place Charles de Gaulle in Paris. President Fidel Castro renamed the square Plaza de la Revolución, and it now hosts the tallest building in Havana, the epicenter of Cuban government, with a giant José Martí monument proudly placed at the front entrance. Utilitarian-style buildings with large iconic images of revolutionary heroes surround this important plaza. Often the setting for political rallies, memorials, and revolutionary anniversary celebrations, Plaza de la Revolución has also become a point of interest for foreigners to visit; some even enjoy a ride in an old American car for a retro taxi experience.

Below: *Government-sponsored graffiti on Calle 23 with the slogan, "Viva Cuba Libre" (Long-live Free Cuba).*

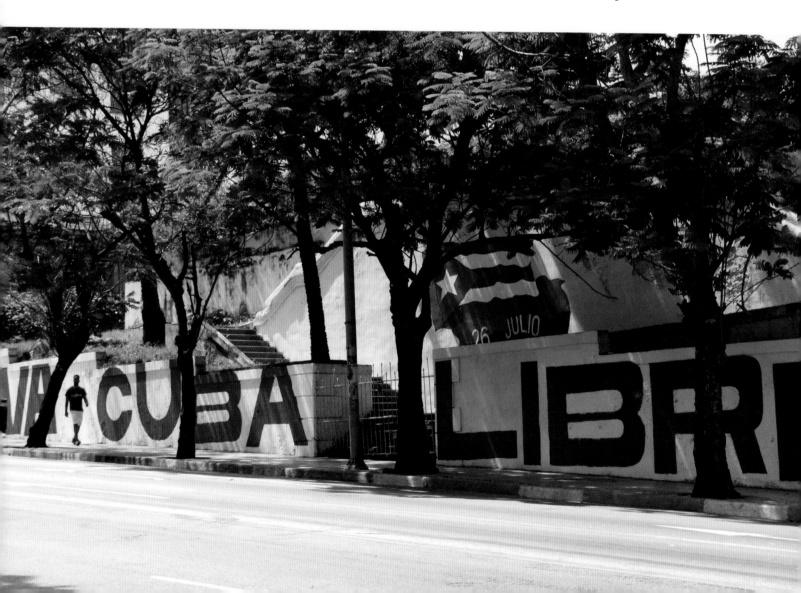

Left: *A crowd waiting to get into Fábrica de Arte Cubano.*

Above: *Lights form a heart shape outside the Tierra paladar located inside Fábrica de Arte Cubano.*

Above: *A statue of* La Milagrosa *(Miracle Worker) in the* Cementerio de Cristóbal Colon *(Christopher Columbus Cemetery).*

The *Cementerio de Cristóbal Colon* (Christopher Columbus Cemetery) is also in Vedado. It is home to mausoleums built with marble brought over from Italy, as well as the spiritually significant statue La Milagrosa (Miracle Worker). Cubans frequently visit La Milagrosa with flowers or marble plaques, praying for her to make a miracle happen or giving thanks for a relative's safe trip from Cuba to the United States. Located along the Malecón is the US embassy, an entity that in 2015 upgraded from being an interests section (taking care of American interests in Cuba) to being an official embassy, with more services and responsibilities, as a result of US President Barack Obama and Cuban President Raúl Castro's efforts toward normalizing relations between the United States and Cuba. Although politics in the United States have led to changes in American policy toward Cuba

since their historic announcement, there still still remains, as of the writing of this book, a US embassy in Havana.

Since 1992, Cuban laws have allowed farmers to sell their surplus produce at local farmers' markets. Since 2009, further economic reforms in Cuba pertaining to the privatization of land and farming have led to the opening of many more farmers' markets, known as agromercados (agriculture markets), where vendors sell fresh organic fruits, vegetables, beans, herbs, spices, and meats. There are several popular markets in the Vedado neighborhood that specialize in rare produce and herbs, and many paladar owners go there to buy their ingredients.

Near one of the larger agromercados, just a few blocks from the US embassy and next to Vedado's famous FOCSA residential building, the tallest building in Cuba, is one of the more trendy paladares, Café Laurent.

Below: *El Patronato synagogue and La Casa de la Comunidad Hebrea de Cuba (House of the Jewish Community in Cuba).*

Pages 116 and 117: *A farmers market for private vendors.*

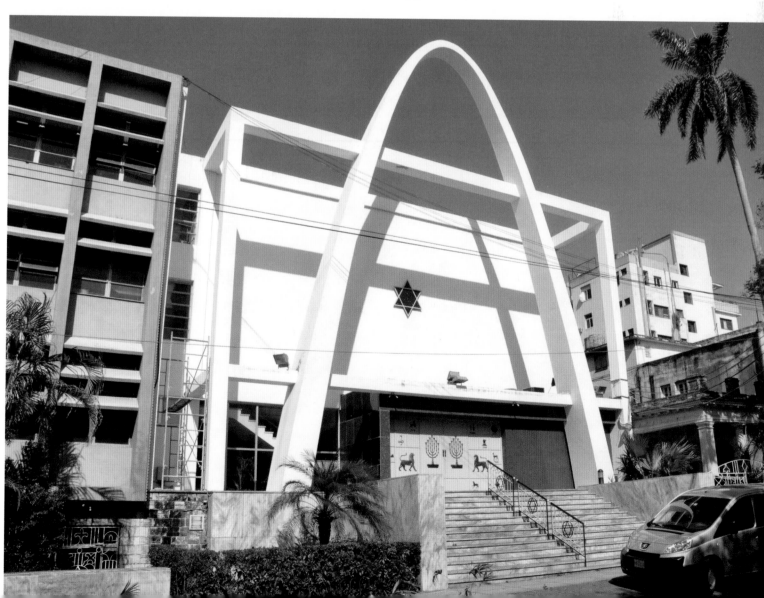

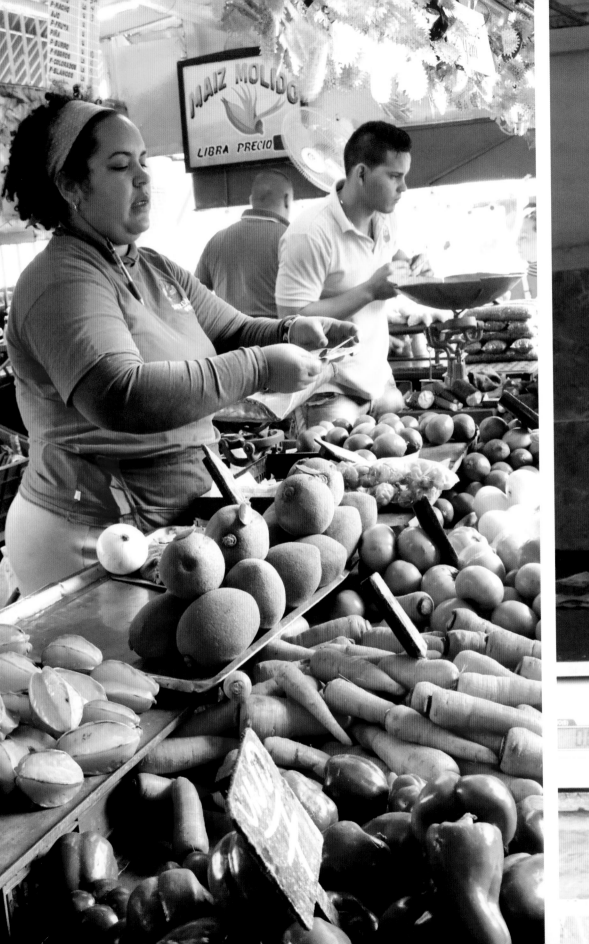

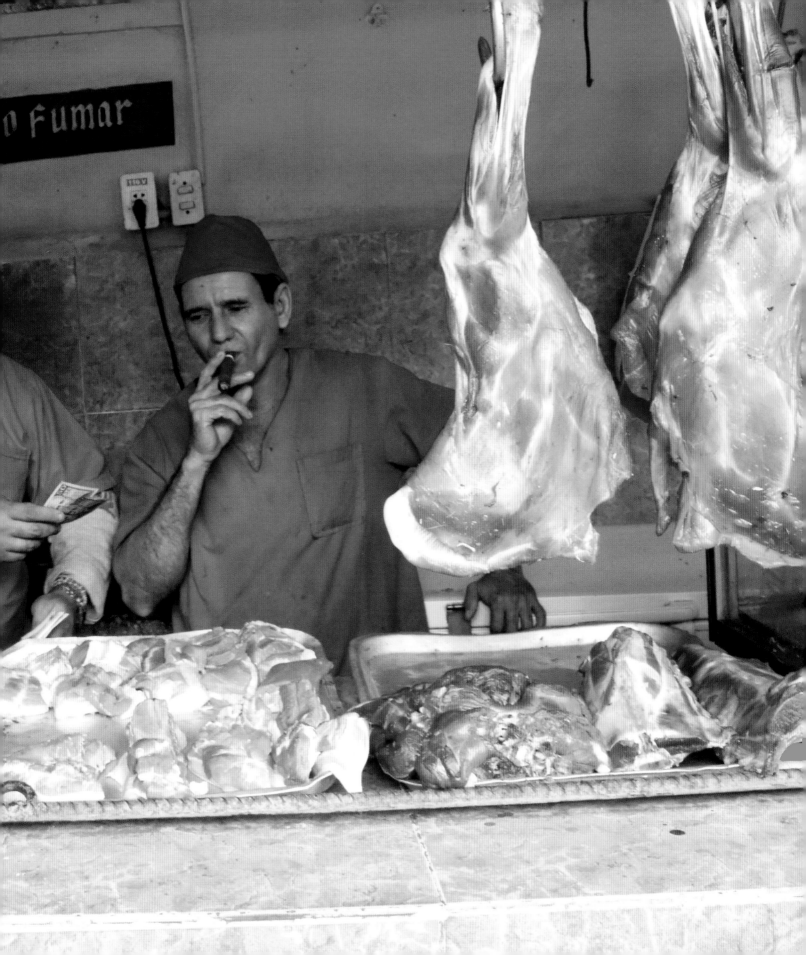

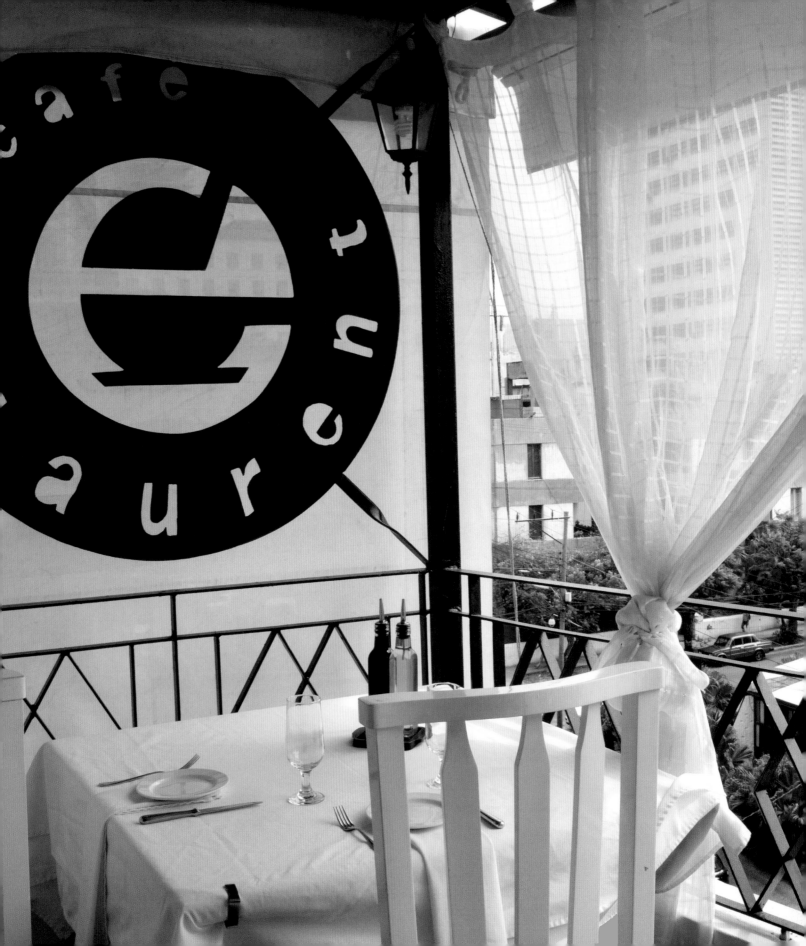

CAFÉ LAURENT

CALLE M No. 257, PENTHOUSE

Hidden among nondescript buildings is a black-and-white sign marking the tree-lined entrance path of a multifamily residential building. It was built in the 1950s, and movie memorabilia from the time lines the elevator that takes diners to the top floor, where a simple white door reveals a penthouse apartment that in 2011 was converted into the stylish Café Laurent. Contemporary furniture and starched white cotton tablecloths give the interior an air of sophistication and elegance. Walls covered floor to ceiling with retro newspapers and posters add a touch of nostalgia. White, laced drapes pulled back with bows decorate the windows of the outdoor balcony dining area. Guests seated by the windows are privy to ocean views combined with an urban landscape, including old American cars driving by homes and an up-close view of FOCSA. Built in 1956 and named after the contracting company, FOCSA is known as an engineering wonder since its tall, concrete, modern-style structure was built without the use of cranes.

Chef Victor Salgado works with a team in the Café Laurent kitchen, preparing dishes informed by his culinary education in Cuba, hospitality classes in Mexico, and experiences working in Cuba, Mexico, and the United States. The result is a fusion of tastes with a Cuban flair.

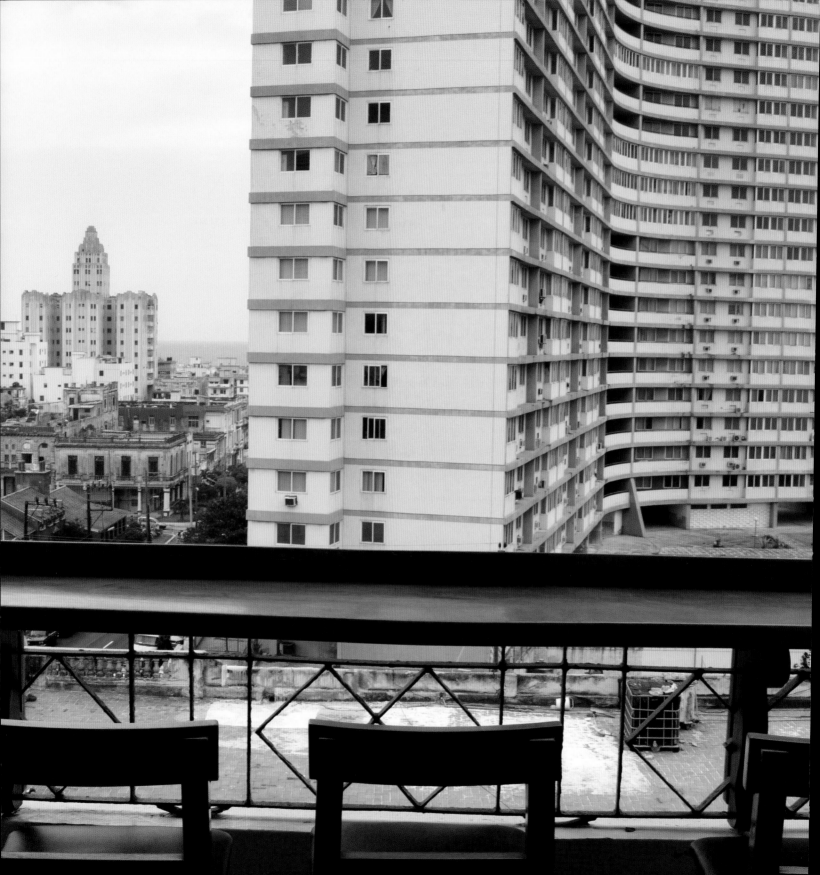

Left: *A view of the FOCSA building from the window seats of Café Laurent.*

Below: *Vintage advertising decorates the elevator that takes guests to Café Laurent, located on its building's penthouse level.*

Pages 124 and 125: *Head Chef Victor Salgado (third from right) poses with his staff.*

CAFÉ LAURENT—STYLE FRIED PLANTAINS

SERVES 6

Tostones Estilo Café Laurent

2 tablespoons diced ham

1 tablespoon diced pineapple

1 tablespoon diced onion

1 teaspoon mustard

1 teaspoon ketchup

½ teaspoon salt

½ teaspoon sugar

½ teaspoon balsamic vinegar

3 firm green plantains, peeled
Vegetable oil

6 tablespoons grated cheese (such as Swiss or Gouda)

Combine the ham, pineapple, and onion in a cast-iron frying pan over medium heat and sauté for 5 minutes over low to medium heat. Add the mustard, ketchup, salt, sugar, and balsamic vinegar, and stir to combine. Cook over medium heat until the mixture thickens to a chunky paste, about 5 minutes. Remove from the heat and set aside.

Slice the plantains vertically into ½-inch-thick lengths or slice on the bias into 12-inch-thick oval-shaped slices. Heat 3 inches of vegetable oil in a tall cast-iron saucepan until it reaches 350°F. Add the plantain slices and fry until they're golden brown, about 5 minutes. Use tongs to turn the pieces occasionally in the hot oil. Transfer the plantains with the tongs, being careful not to break them, to a layer of paper towels to absorb the excess oil and let cool. Reserve the cooking oil in the pan.

Once the plantains are cool, crush each slice with the back of a spoon, return the vegetable oil to 350°F, and briefly refry the plantains in the hot oil for about 1 minute. Remove the plantains from the oil and blot dry. To serve, sprinkle the hot fried plantain slices with grated cheese and cover with the chunky ham and pineapple paste.

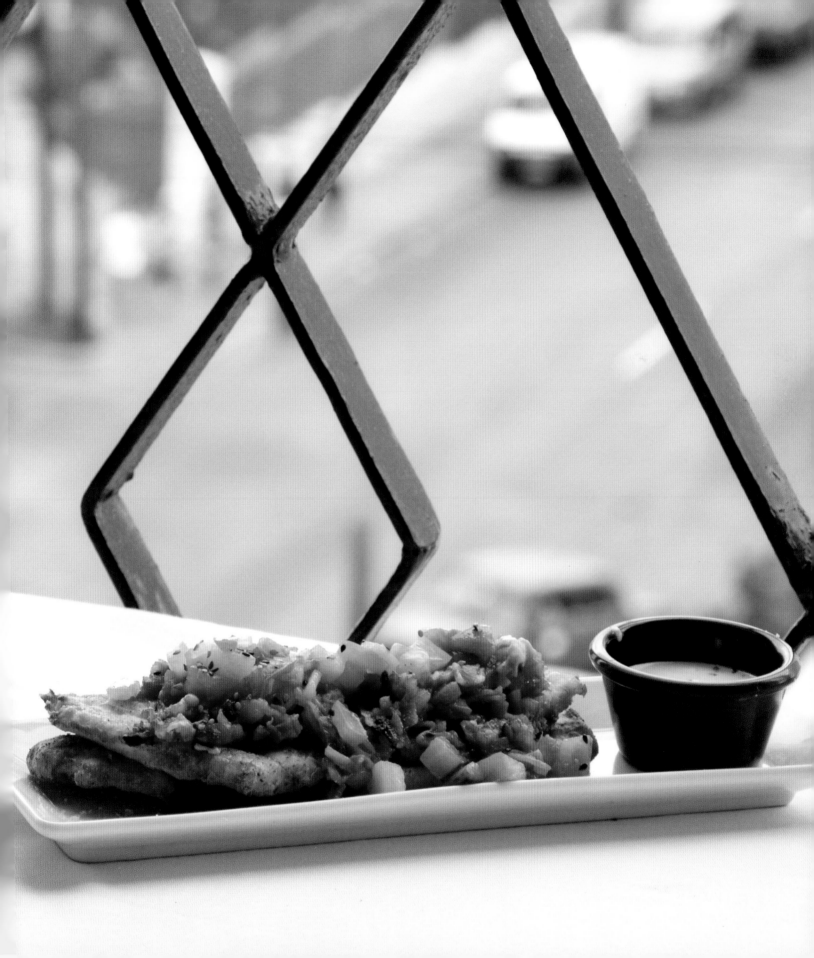

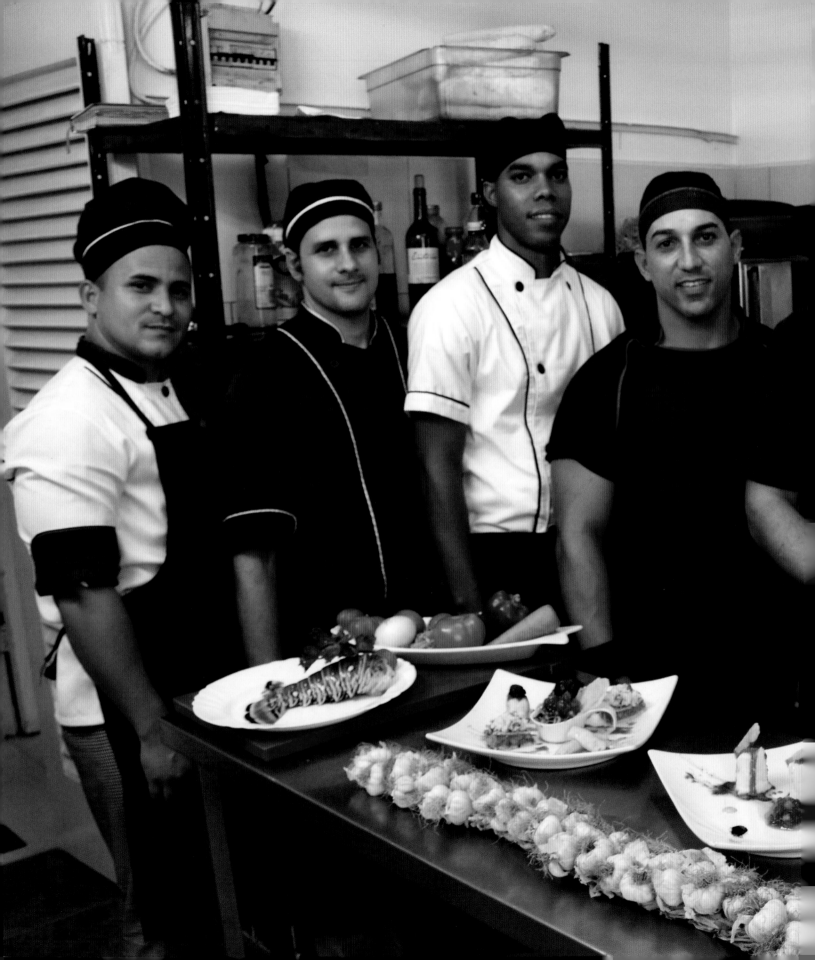

CARAMEL CAKE

Alfajor Cake con Dulce de Leche

2 cups cornstarch

1 ⅔ cups flour

2 teaspoons baking powder

½ pound (2 sticks) salted butter

¾ cup sugar

1 tablespoon brandy or cognac

Zest of 2 lemons

3 large egg yolks

2 cups softened Dulce de
Leche (page 58)

½ cup melted chocolate, for
serving (optional)

1 small scoop ice cream,
per serving (optional)

1 cookie per serving (optional)

In a bowl, sift together the cornstarch, flour, and baking powder. Set aside.

Beat the butter, sugar, brandy, and lemon zest together with an electric mixer on medium for 2 minutes, until the mixture turns a pale yellow and is light and fluffy. Add the egg yolks one at a time, beating on medium after each addition, until just combined. Add the lemon zest and beat on low until combined. Scrape down the sides of the bowl. Turn the mixer to low, slowly add the dry ingredients to the wet, and mix until just combined. To do not overbeat.

Scoop the dough onto a sheet of plastic wrap and roughly shape into a ball. Wrap and refrigerate the dough for 30 minutes or more.

Preheat the oven to 350°F. Line a baking sheet with parchment paper if making round cookies, or line a 9 by 13-inch baking pan if making square cookies. Grease the parchment paper.

Dust the counter and rolling pin with flour. To make round cookies, roll the dough out to ¼ inch thick, use a cookie cutter or the bottom of a 2-inch circular glass to cut out cookie shapes, and place them 2 inches apart on the prepared baking sheet. To make square cookies, roll the dough out to a 9 by 13-inch rectangle ¼ inch thick and place in the prepared baking pan. Transfer to the oven and bake for 15 minutes.

Remove from the oven and after 5 minutes transfer a wire rack and let cool. These cookies, unfilled, can be stored in a covered container at room temperature for up to two days.

Once ready to serve, for round cookies, spread a layer of dulce de leche on one round and top with another round to make a sandwich. For square cookies, cut the single layer in half and then cut into equal-size squares and create sandwiches with the dulce de leche. Serve each butter cake sandwich with a cookie and with a drizzle of melted chocolate and a small scoop of ice cream, if desired.

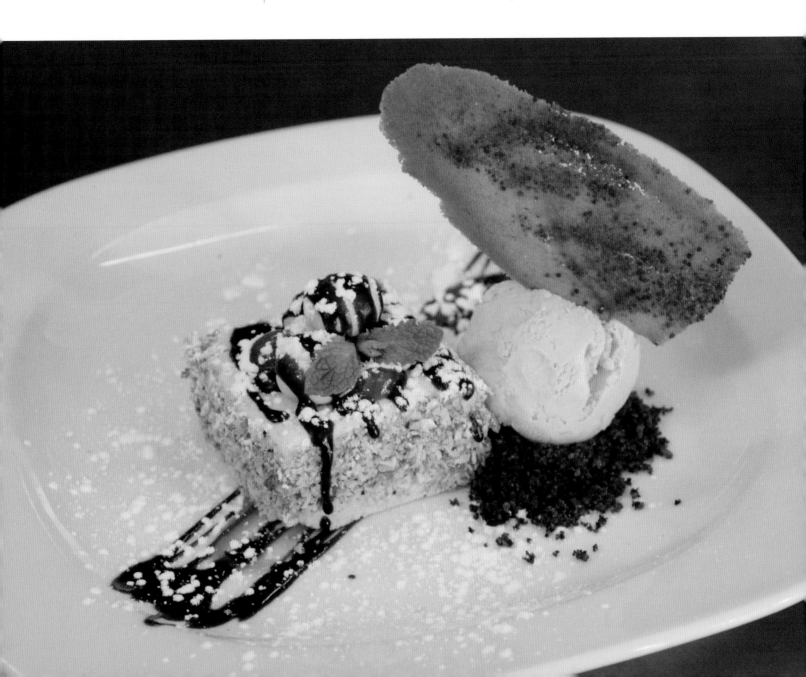

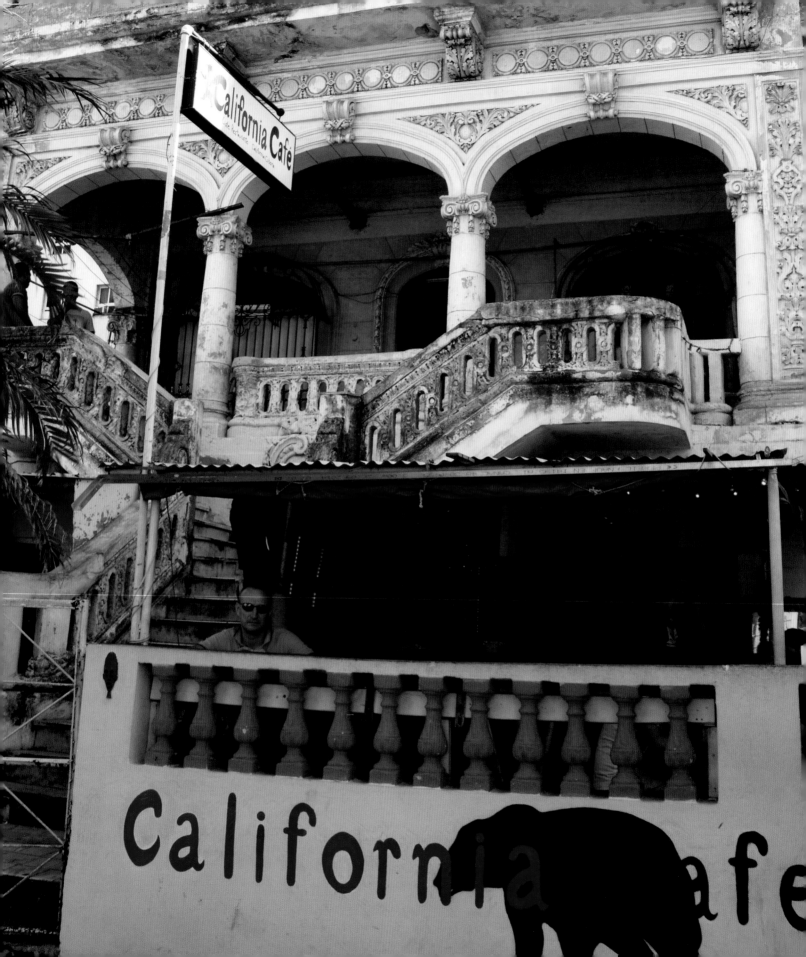

CALIFORNIA CAFÉ

CALLE 19 No. 3

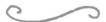

Located near the Hotel Nacional, just off the Malecón and in the heart of Vedado, is a festive and intimate paladar owned by an American woman from California who fell in love with a Cuban man in Havana. Together, Shona Baum and Paver Core Broche opened California Café in 2015. They work together with manager and copartner William Gonzalez Marti to offer food that is a fusion of Californian and Cuban dishes, always made with local and sustainable ingredients. Shona says, "In Cuba, everything is 'farm to table.' However, most Cuban cuisine, although delicious, can be plain." So Shona has made bottles of hot sauce, which are placed on every table, to add additional flavor.

The space has a fun, tropical vibe, and plates come adorned with both a Cuban flag and the Bear Flag of California, which matches the large illustrated cartoon bear painted in front of the café and inside on the pastel-colored walls. Their vegetarian options are flavorful, and their Cuban sandwich is especially impressive.

CUBAN SANDWICH
Sándwich Cubano

1 loaf crusty French bread (baguette) cut in half, or 2 hero rolls

3 tablespoons whole grain or Dijon mustard

3 tablespoons mayonnaise

2 ounces ham, thinly sliced

2 ounces porchetta or pork leg, thinly sliced

2 ounces Swiss or Gouda cheese, thinly sliced

2 large dill pickles, sliced ¼ inch thick

2 tablespoons salted butter

Slice each piece of bread lengthwise so that there are four pieces of bread, two pieces for each sandwich. Spread half the mustard on the bottom slice of each sandwich and half the mayonnaise on the top slice. Split the ham, pork, cheese, and pickles between the two sandwiches, and layer them between the bread slices.

Spread the butter on the outside of the closed sandwiches and preheat a sandwich press, a grill, or a frying pan over medium heat. Press the sandwiches in the sandwich press, or place on the grill or frying pan and use another pan on top to press the sandwiches down, if desired. Cook until the cheese is melted and the bread is brown and crunchy. This takes about 5 minutes if the sandwich press is very hot, longer otherwise. The cheese should be runny. Serve immediately, while the sandwiches are hot and the cheese is still runny.

CHARD AND EGG STIR–FRY

Guiso de Acelga

10 large chard or spinach leaves

2 tablespoons salted butter

2 cups chopped tomatoes

1 cup chopped onion

1 cup chopped green and
red bell peppers

4 cloves garlic, minced

4 eggs, gently beaten

Salt and pepper, to taste

Slices of toasted bread, for serving

Cut the chard into strips and heat a saucepan of water to just below boiling. Add the chard to the pan and cook for 3 minutes, then drain and set aside. If using spinach instead of chard, shred the leaves but do not blanch in boiling water.

Melt the butter in a large saucepan over medium heat. Add the tomatoes, onion, peppers, and garlic and cook, stirring occasionally, for 3 minutes. Add the eggs and scramble. Just before the eggs become firm, add the chard or spinach. Add salt and pepper and serve immediately with toasted bread.

TROPICAL SHRIMP

Camarones Tropicales

¾ can (about 4 ounces) tomato paste

2 tablespoons salted butter

1 ½ cups medium shrimp, peeled, tails intact

2 ½ cups chopped onion

3 cloves garlic, sliced

2 teaspoons salt

1 teaspoon pepper

1 tablespoon freshly squeezed lime juice

2 ½ cups diced pineapple

Half of a pineapple, hollowed out for display (optional)

Combine the tomato paste in a bowl with 1 ½ cups water and stir well to dilute it. Set aside.

Melt the butter in a large frying pan over medium heat, add the shrimp, and sauté just until they start to turn pink, about 1 minute. Add the onions, garlic, salt, pepper, and lime juice and cook, stirring occasionally, for 2 minutes. Add the pineapple and the diluted tomato paste and cook for 4 more minutes. Serve immediately, in the hollowed-out pineapple shell if desired.

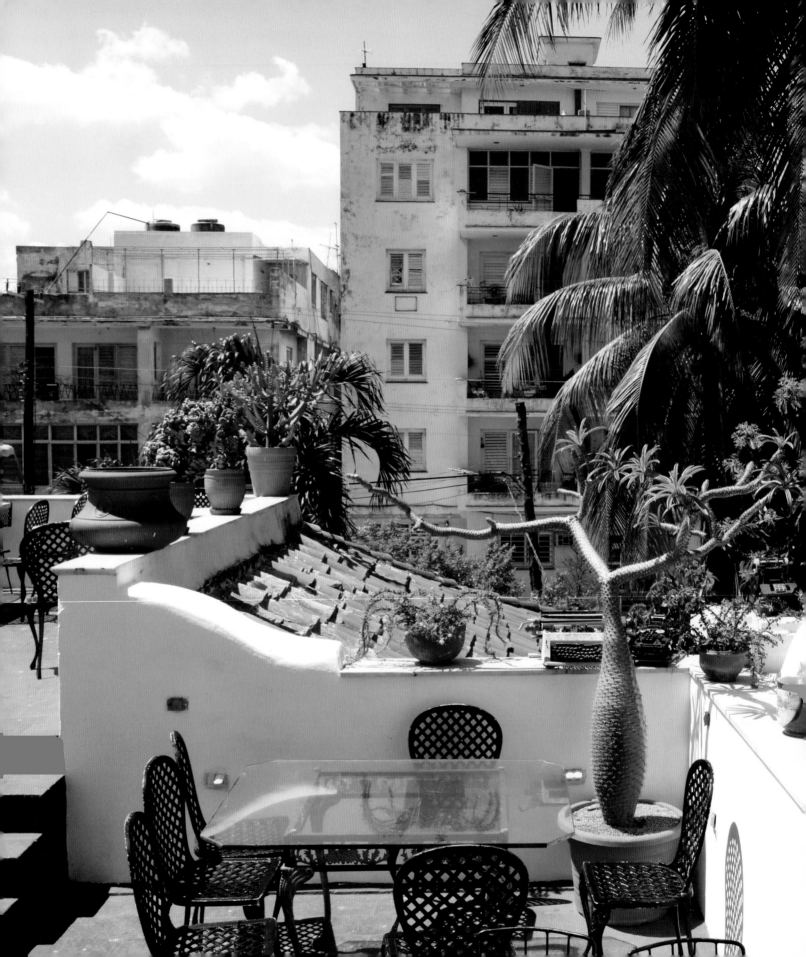

EL ATELIER

CALLE 5TA NO. 511 ALTOS

"A woman's place is in the House . . . and the Senate," read the sign once carefully placed on your way to the sprawling outdoor terrace of El Atelier. This paladar is located upstairs in a Spanish-style mansion built in the late 1800s. It is near the Melia Cohiba and Habana Riviera hotels, just off the illustrious Paseo Avenue. The paladar's successful entrepreneur owner, Niuris Higueras, is a vivacious woman who was one of a select few Cuban cuentapropistas (self-employed entrepreneurs) invited to President Barack Obama's town hall-style meeting during his visit to Cuba in March 2016. Although Niuris and her paladar were already highly regarded and well known before this historic presidential visit, when First Lady Michelle Obama dined with her mother and daughters at El Atelier, the paladar's reputation soared even higher.

A soft glow of candles and incandescent light in the evening create a romantic aura in El Atelier's main dining room. The space is decorated with contemporary furniture and Cuban art, which is for sale by the artists, and which seamlessly contrasts with the stunning antique china, glassware, table settings, and retro artifacts such as typewriters, sewing machines, and old-fashioned wooden cash registers. It's a combination of an elegant, vintage-chic ambiance with exciting, innovative cuisine.

Niuris created the unique menu with the paladar's former head chef, Michael Alejandro Calvo Oviedo (known to friends as Michel) and they nurtured each other's passion for creativity in the kitchen. Niuris calls her paladar an "experimental culinary workshop." The menu is always changing and its daily

offerings are handwritten symbolically on government-issued "ration card paper." Trained in France by famed chef Paul Bocuse, Chef Michel uses classic French gourmet cooking techniques to make dishes with Cuban ingredients. Dishes such as Duck à l'Orange, Ratatouille, and Leg of Lamb are very French and use French cooking techniques; but Chef Michel's recipes make tweaks like putting mango juice on the duck and sprinkling fried boniato chips on the leg of lamb that remind diners they are in Cuba. Michele says one of his secrets is to use cloves for color, or cinnamon for a sweet touch. The results are an unusual and spectacular gastronomic experience, served by a welcoming, highly attentive staff.

Below: *El Atelier's head chef, Michel, with Chef Alfredo.*

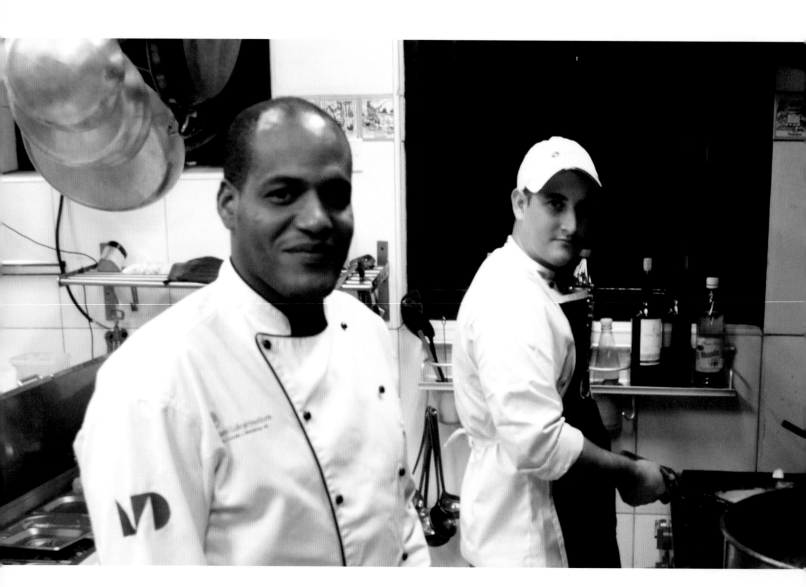

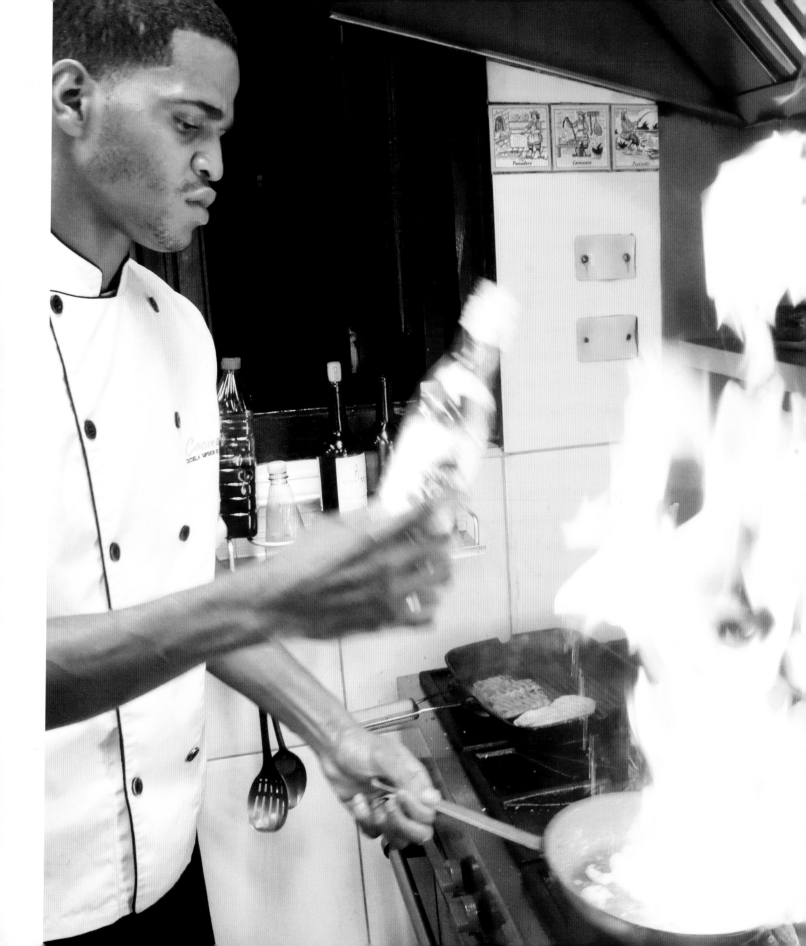

Below: *Paladar owner, chef, and entrepreneur Niuris Higeres Martinez.*

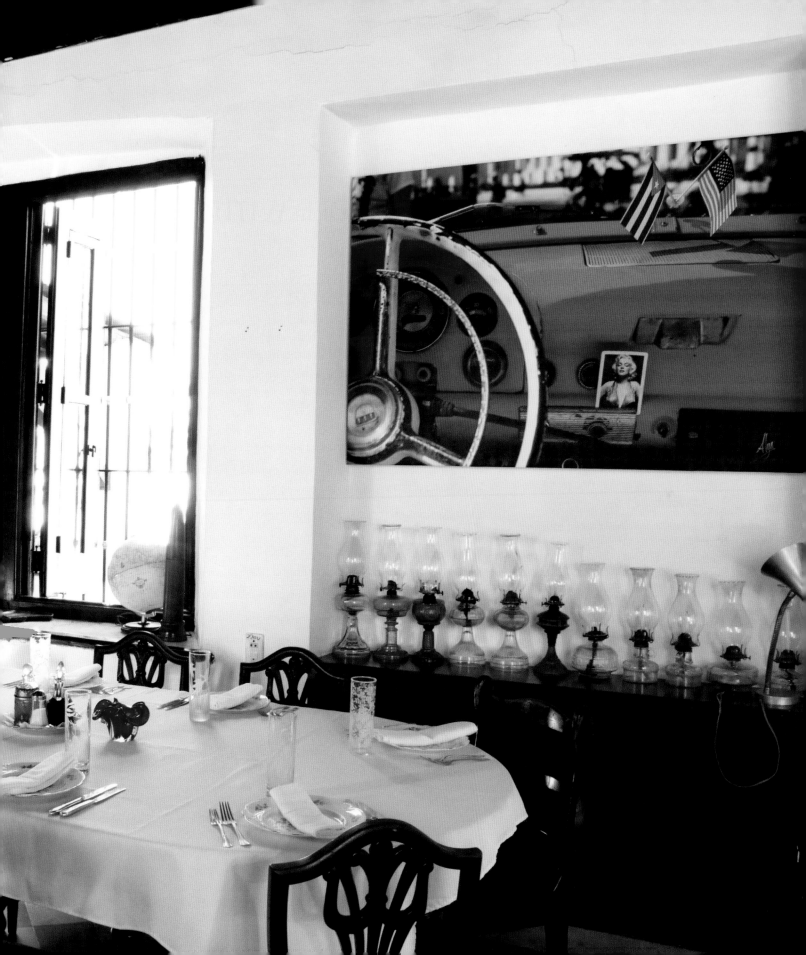

SALMON ROLL WITH EGGPLANT
Roll de Salmón con Berenjena

1 long, thin eggplant

1 tablespoon coarse salt, plus additional for sprinkling eggplant

1 tablespoon herbes de Provence

½ cup olive oil

4 ounces cream cheese

2 tablespoons Almond Pesto Sauce (page 146)

4 slices Norwegian smoked salmon

4 sprigs dill, for garnish

Slice the eggplant into four thin slices lengthwise with a mandoline or a very sharp knife. Sprinkle with salt and let sit for 20 minutes.

Preheat the oven to 350°F.

Rinse the eggplant slices well and place in an even layer in a casserole dish. Sprinkle with the herbes de Provence and the 1 teaspoon salt, and drizzle the olive oil over the top. Transfer to the oven and bake until the eggplant is tender, about 15 to 20 minutes. It may turn lightly brown. Transfer the eggplant slices to a paper towel and let cool.

Whip the cream cheese and the almond pesto sauce in a small bowl. Top each eggplant slice with a thin layer of the pesto cream cheese and a thin slice of smoked salmon. Roll the eggplant around the filling and tuck the ends underneath the roll. A toothpick can be used to seal each roll together. Garnish each serving with a dill sprig.

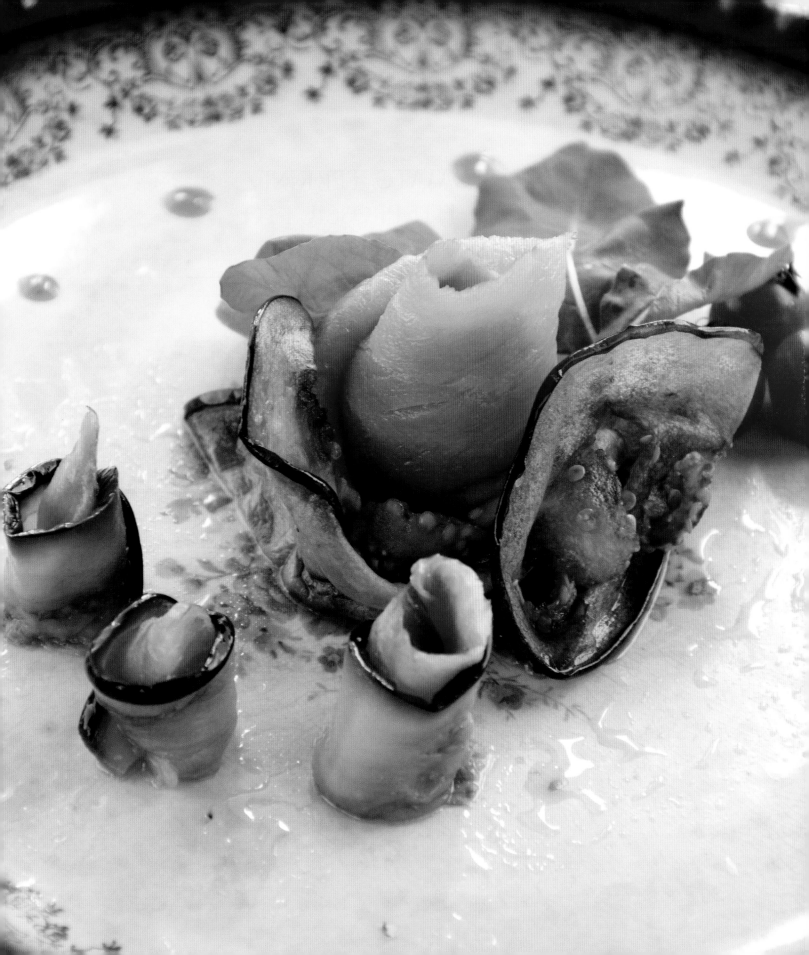

TOMATO TERRINE WITH PROSCIUTTO

SERVES 4

Terrina de Tomate con Prosciutto

1 large tomato, finely chopped

1 tablespoon chopped fresh parsley

½ teaspoon salt, or more to taste

2 tablespoons olive oil, plus additional for drizzling

4 ounces cream cheese

2 tablespoons Almond Pesto Sauce (page 146)

16 slices prosciutto, cut paper-thin

Combine the tomato, parsley, salt, and olive oil in a bowl. Let sit for 20 minutes, then drain off the tomato juice.

Meanwhile, combine the cream cheese and the almond pesto sauce in a small bowl.

On the edge of each of four small plates, mold the tomato mixture into a 2-inch round to make a small terrine. Arrange 4 prosciutto slices alongside each terrine, placed like the rays of the sun. Drizzle olive oil over the top of each plate and place a dollop almond pesto-cream cheese on top of each terrine to serve.

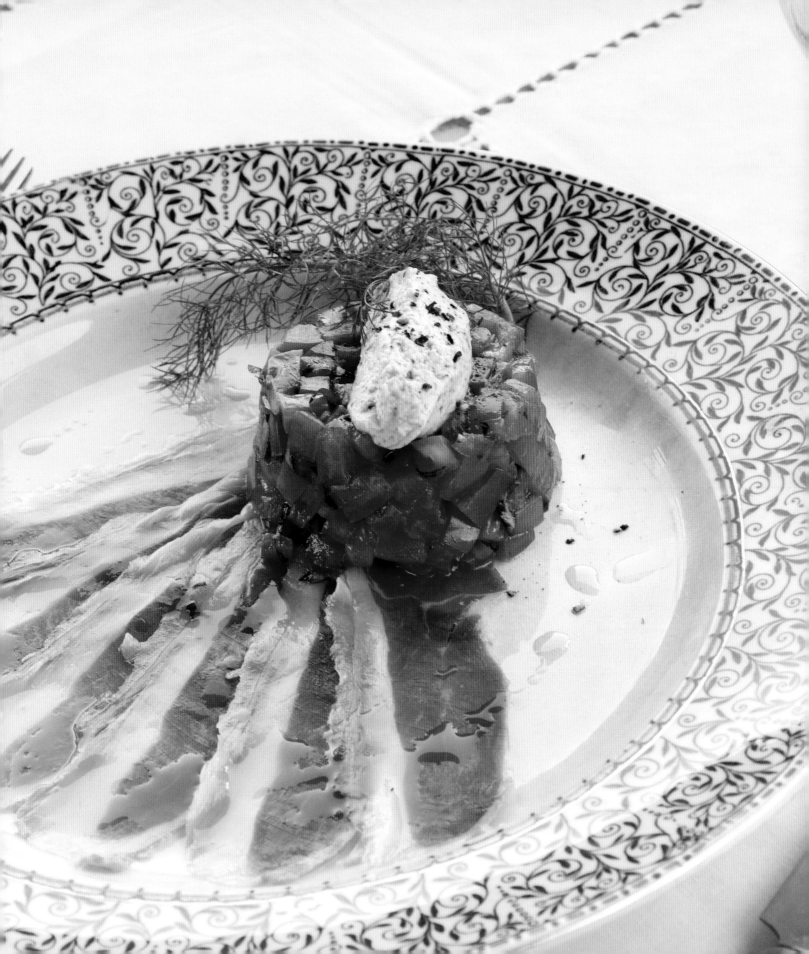

ALMOND PESTO SAUCE

Salsa de Pesto Almendra

3 cloves garlic, crushed

4 cups fresh basil leaves

½ cup toasted almonds

1 cup olive oil

 Salt, to taste

Chop the garlic in a food processor until finely chopped. Add the basil and almonds and chop well. Slowly drizzle in the olive oil, add the salt, and process to a smooth paste. Use immediately, refrigerate tightly covered for up to five days, or freeze for up to three months.

SMOKED SALMON WITH PESTO CREAM CHEESE

Salmón Ahumado con Queso Crema Pesto

4 ounces cream cheese

2 tablespoons Almond Pesto Sauce (above)

8 slices Norwegian smoked salmon

4 extra-large fresh basil leaves (optional)

2 tablespoons honey (optional; see Note)

 Pepper, to taste (optional; see Note)

Mix the cream cheese with the almond pesto sauce. In a 2-inch round mold (a glass will work), layer one slice of the salmon topped with a scoop of the almond pesto-cream cheese mix, and finish with another slice of salmon to create three layers per serving. Unmold onto a dish to serve. At the restaurant, the chef unmolds each portion onto an extra-large basil leaf and gives it a drizzle of honey and a sprinkling of pepper.

NOTE: The combination of sweet and pepper is a hallmark of Chef Michel.

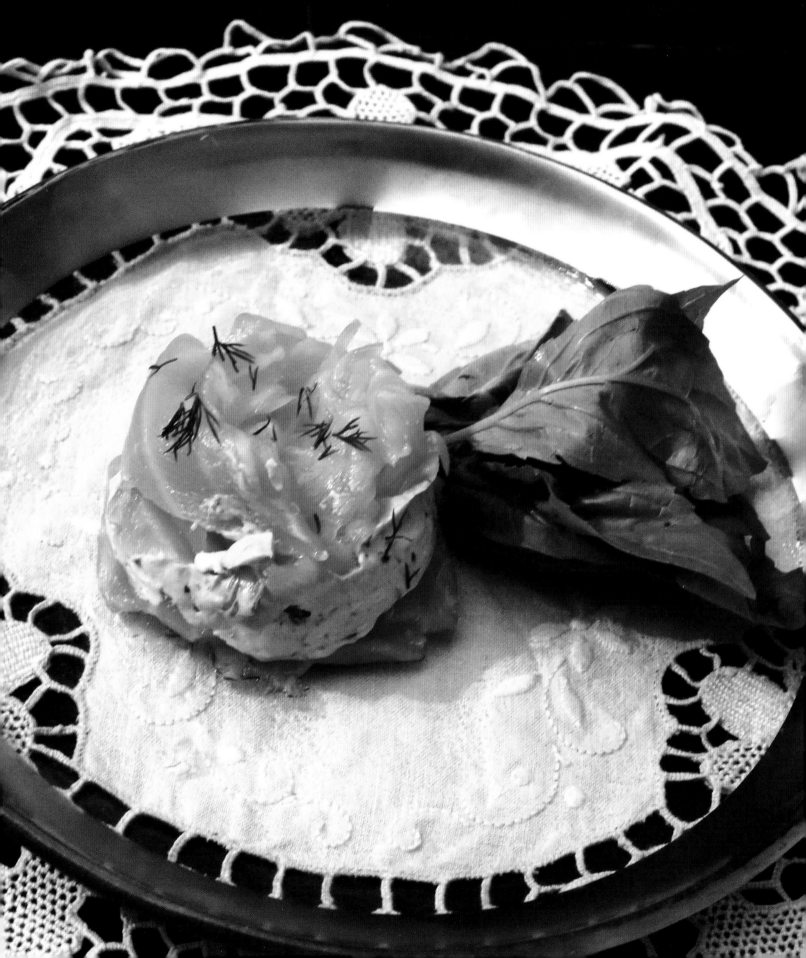

DUCK À L'ORANGE

Pato à l'Orange

4 duck legs

3 tablespoons olive oil

1 cup orange juice

1 cup mango juice

12 to 15 dried figs

12 to 15 dried apricots

1 cup sliced mushrooms

Salt, to taste

4 thin Boniato and Plantain Chips (page 86)

Clean the duck legs and remove any feather pieces that might still be adhering to the skin. Heat the olive oil in a large Dutch oven over high heat. Add the duck pieces and turn to sear on both sides. Add the orange juice, mango juice, figs, apricots, and mushrooms, and reduce the heat to low. Cook with the cover slightly ajar to allow the steam to escape and the sauce to cook down and intensify in flavor for about 1 ½ hours, until the meat is tender.

Near the end of the cooking time, preheat the oven to 400°F.

Remove the duck legs, reserving the cooking liquid, and place them in a baking dish. Transfer the duck to the oven and bake uncovered for 15 minutes, or until the outside is crispy. Meanwhile, strain the cooking liquid and move the fruit and mushrooms mixture to the dish containing the duck legs before it goes in the oven. Return the cooking liquid to low heat and simmer, uncovered, until the sauce is reduced to a syrupy texture, about another 10 to 15 minutes. Add salt to taste.

Pour the sauce over the duck legs, and then serve immediately with a sprinkle of boniato chips on top.

RATATOUILLE

2 cups chopped mixed vegetables, including eggplant, tomatoes, and squash

2 tablespoons mixed dried spices and herbs (equal parts dried basil, rosemary, cumin, parsley, and mint)

1 tablespoon coarse salt, or more to taste

2 tablespoons olive oil

Combine the vegetables, herb-spice mixture, salt, and olive oil in a small Dutch oven over medium heat, cook stirring for two minutes then lower the heat and cook for 20 to 30 minutes, stirring occasionally to prevent burning and sticking, until the vegetables are tender. This dish can be served warm or at room temperature, or can be kept covered in the refrigerator for up to two days and served cold.

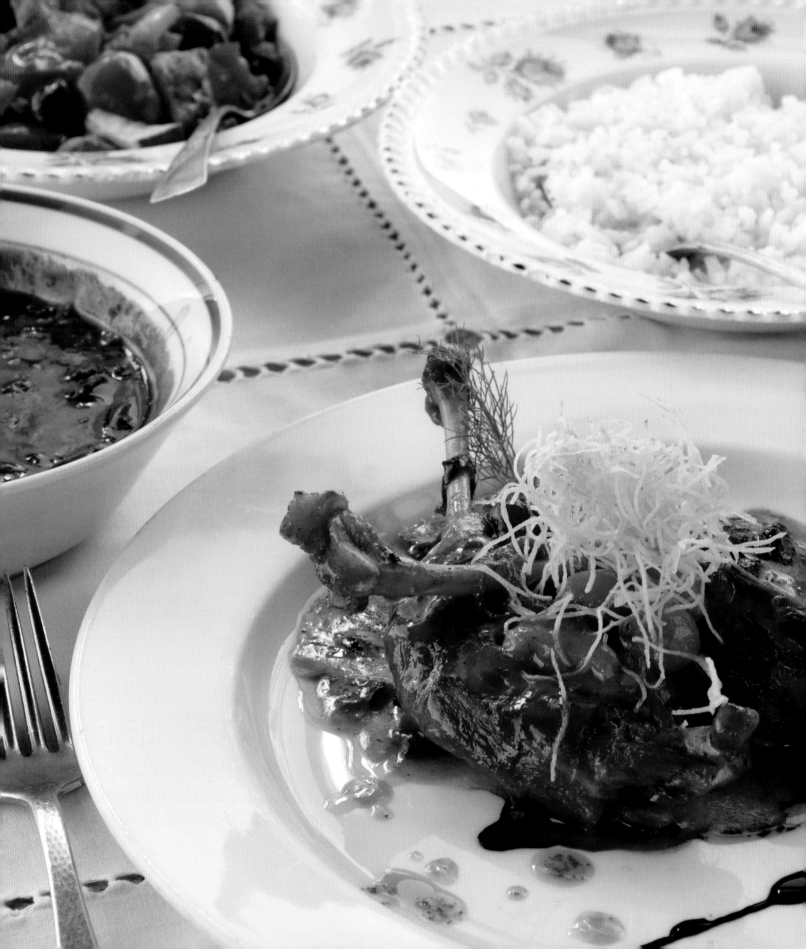

LEG OF LAMB
Pierna de Cordero

8 ounces leg of lamb

1 sprig fresh thyme leaves, finely chopped, or 1 teaspoon dried

1 sprig fresh oregano leaves, finely chopped, or 1 teaspoon dried

1 tablespoon coarse salt, plus additional for sprinkling on the eggplant

2 tablespoons olive oil

1 onion, thinly sliced

1 red bell pepper, cut in ½-inch cubes

2 carrots, cut in ¼-inch slices

1½ cups red wine

1 cup vino seco, or dry sherry or red wine

1 large eggplant

1 clove garlic, minced

1 teaspoon dried oregano

Season the lamb with the thyme, oregano, and salt. Heat 1 tablespoon of the olive oil in a Dutch oven, add the lamb, and sear, turning until it is browned on all sides. Add the onion, pepper, carrots, red wine, and vino seco. Scrape up all the drippings from the pan, bring to a boil over high heat, then cover and lower the heat to a simmer. Cook the lamb in the Dutch oven, completely covered, for 3 to 4 hours, until very tender.

Near the end of the cooking time, slice the eggplant in half lengthwise. Sprinkle the cut sides with 1 tablespoon of coarse salt and let sit for a half hour. Rinse eggplant thoroughly and pat dry with paper towels.

Preheat the oven to 400°F.

Place the eggplant cut side up in a baking dish and sprinkle with the remaining tablespoon of olive oil and the garlic and oregano. Transfer to the oven and bake 15 to 20 minutes, until the eggplant is soft. Remove from the oven, but leave the oven on.

Transfer the lamb to a baking dish and bake uncovered for 15 minutes. Heat the remaining sauce in the Dutch oven over medium heat, uncovered, until the sauce reduces by half and becomes syrupy.

When the eggplant is cool enough to handle, remove the flesh from its skin, and then puree the flesh. Serve the lamb immediately with sauce spooned on top and the eggplant puree on the side.

SERVES 2 # OCTOPUS SALAD
Ensalada de Pulpo

4 ounces raw octopus legs

2 tablespoons olive oil

2 scallions, chopped

½ onion, thinly sliced

1 tablespoon herbes de Provence

¾ cup white wine

¼ cup finely crumbled blue cheese

2 tablespoons balsamic vinegar, simmered over low heat until reduced in volume to 1 tablespoon

1 cup mixed baby greens

Heat a large pot of water to a boil and use large tongs to lower the octopus into the boiling water 3 separate times for 5 seconds each to blanch and seal the octopus. Chop the octopus into ½-inch pieces.

Heat the olive oil in a large saucepan over medium heat and add the chopped octopus, scallions, onion, herbes de Provence, and white wine. Cook, uncovered, until the octopus is fully cooked and no longer translucent, about 5 minutes. Add the blue cheese, drizzle with the thickened balsamic vinegar, and serve over a bed of mixed baby greens.

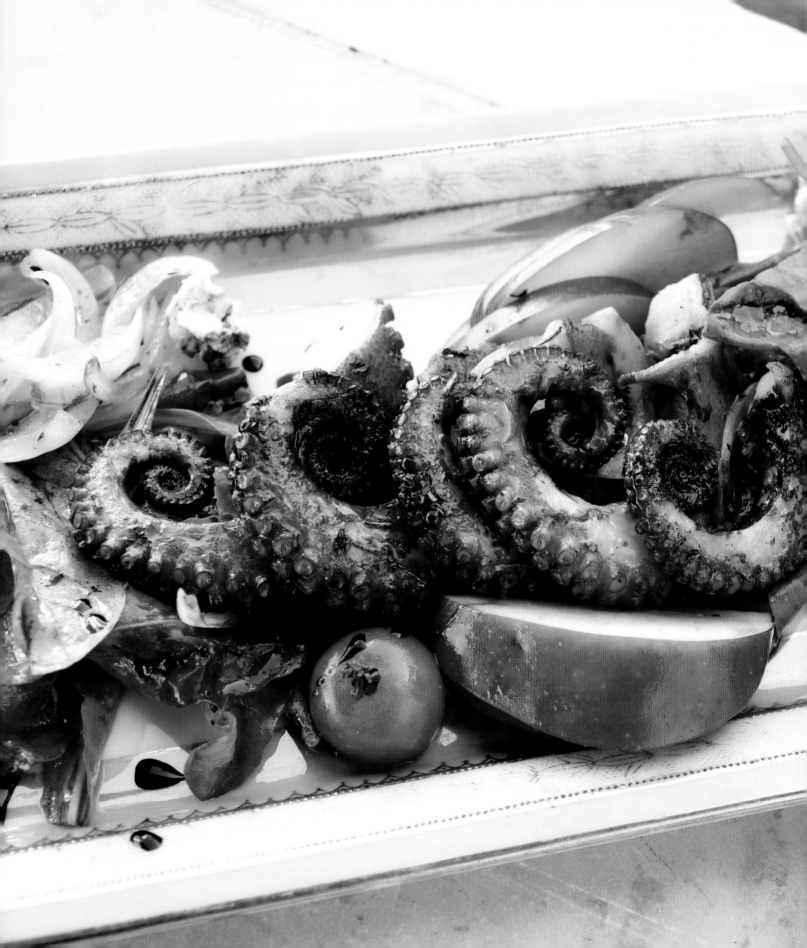

24 FRITTERS MALANGA FRITTERS

Fritos de Malanga

1 pound peeled and shredded
malanga (taro or yuca
can be substituted)

1 egg, beaten

5 cloves garlic, minced

1 teaspoon chopped fresh parsley

1 tablespoon salt

1 teaspoon pepper

Vegetable oil

Honey

Mix the malanga with the egg, garlic, parsley, salt, and pepper. Form the batter into small, ½-inch-thick and 2-inch-long oblong shapes. Heat 3 inches of vegetable oil in a large cast-iron saucepan or a deep fryer to 350°F, then add the fritters to the oil and deep-fry until they are brown and cooked through. Taste one to see if the inside is cooked through. The larger the fritter, the harder to get the inside cooked through without burning the outside. This should take 3 to 5 minutes. Remove from the oil, place on a layer of paper towels briefly to absorb the oil, and serve immediately, while still hot, with a side of honey for dipping.

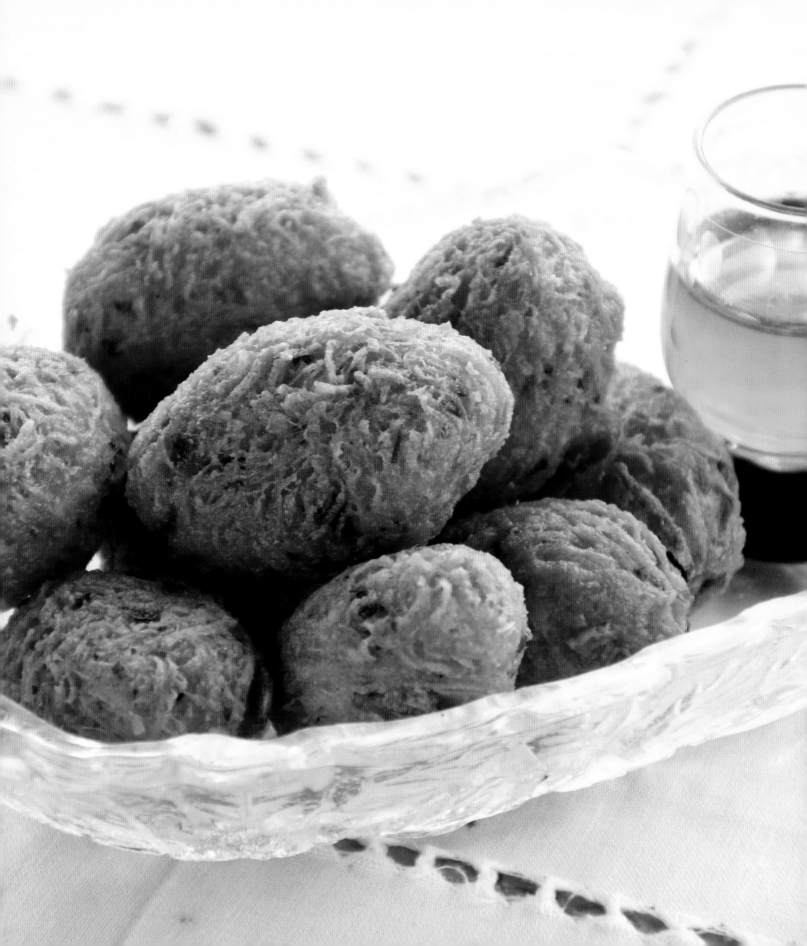

SURF AND TURF
Mar y Tierra

Olive oil for basting the grill

4 ounces red meat (the chef uses leg of lamb)

4 ounces boneless and skinless chicken breast

4 ounces deveined and peeled medium-size shrimp

1 lobster tail, shell removed

1 tablespoon coarse salt

1 teaspoon pepper

4 tablespoons (½ stick) salted butter, melted

4 cloves garlic, crushed

1 tablespoon finely chopped fresh parsley

Preheat the grill to medium-high heat and preheat the oven to 400°F.

Season the red meat, chicken, shrimp, and lobster with salt and pepper, then bathe them with a mix of the butter and garlic. Place on the grill and cook, turning until seared on all sides. Immediately remove the red meat and chicken, place on a baking pan, and transfer to the hot oven. While the meat bakes at a high heat, cook the shrimp and the lobster until they are no longer translucent, removing each piece immediately when it is done. Each piece is done when it turns completely opaque. Set aside.

Bake the red meat to your preferred degree of doneness: 5 minutes and 130°F for rare, 10 minutes and 140°F for medium rare, and 15 to 20 minutes and 160°F for well done. Bake the chicken at 165°F just until no longer pink inside the thickest part, about 20 to 25 minutes. Slice the meats and seafood, and serve immediately, sprinkled with the parsley.

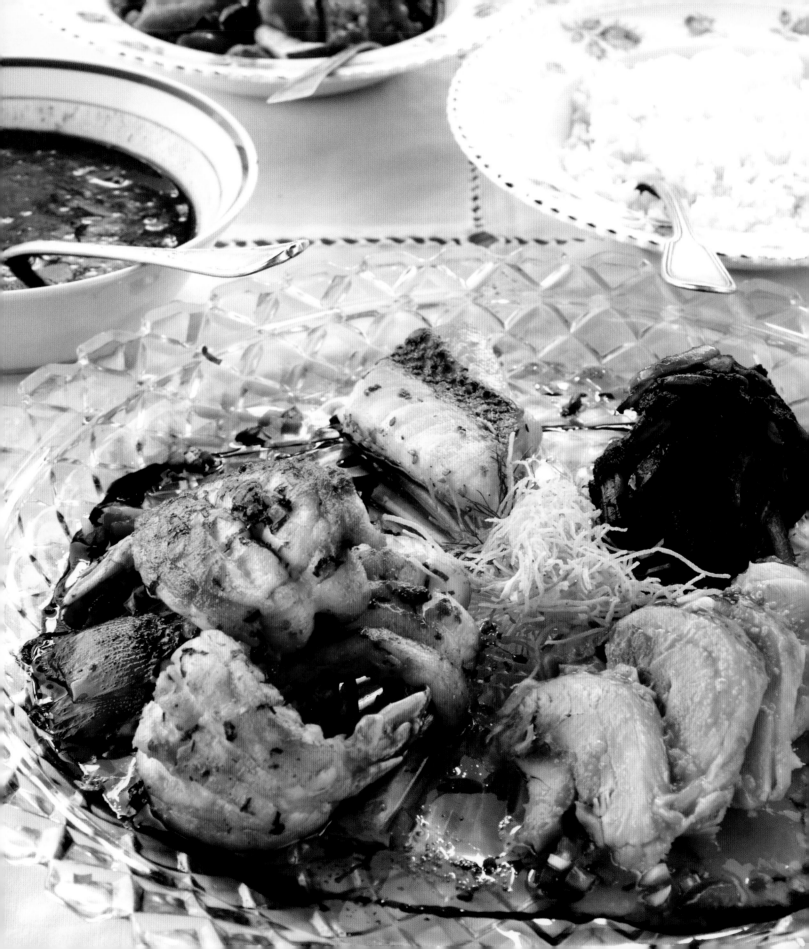

EL LITORAL

FORMERLY LOCATED AT MALECÓN 161

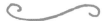

El *Litoral* means "the coast," and El Litoral paladar, formerly located facing the Malecón, had a picturesque ocean view that was mirrored with a maritime decor. Opened in January 2014, El Litoral was a modern-style paladar in a renovated neocolonial-style mansion. Although it was a popular eatery, Cuban authorities closed the paladar in June 2017, for supposed illegal business operations. It was the first paladar to offer a *mesa fría*, a cold appetizer salad bar with Spanish-style tapas, such as olives, locally-grown and imported sliced cheeses and meats, and a variety of mixed vegetables. The kitchen was an expansive modern space that had separate areas for preparing the hot main dishes and the cold main dishes. There was even a bakery for the delectable desserts, all of which were prepared on the premises. Former guests already miss the tasty croquettes and sweets.

SERRANO HAM CROQUETTES WITH FOUR–CHEESE SAUCE

Croquetas de Jamón Serrano con Salsa de Cuatro Quesos

1 pound serrano ham

1 large or 2 medium onions,
 finely chopped

1 cup flour

½ pound (2 sticks) salted butter, melted

1 ½ cups whole milk, hot

 Pinch of nutmeg (optional)

1 teaspoon salt

1 egg, beaten

½ cup or more breadcrumbs

 Vegetable oil

 Four-Cheese Sauce (below)

 Toasted almonds, sliced, for garnish

Combine the ham and onion in a food processor and grind together. Stir in ½ cup of the flour and the butter and hot milk. Add the nutmeg and salt. Let the mixture cool and refrigerate for 3 hours or overnight, if desired.

Form the croquette dough into 2-inch-long log shapes. Place the remaining ½ cup flour in one bowl, the beaten egg in another bowl, and the breadcrumbs in a third bowl. Dip each log first into the flour to coat, then the beaten egg, then the breadcrumbs.

Meanwhile, heat 4 inches of vegetable oil in a saucepan until the temperature reaches 350°F. Add the croquettes in batches and deep-fry about 5 minutes until they're well-browned but not burnt. Do not overcrowd the saucepan. If they brown too quickly, reduce the heat and lower the temperature of the oil. Remove the croquettes from the oil and set on paper towels to drain.

Serve immediately, while still very warm. Garnish the four-cheese sauce with the toasted almonds and serve alongside the croquettes for dipping.

FOUR–CHEESE SAUCE

Salsa de Cuatro Quesos

¼ pound mozzarella cheese, grated

¼ pound blue cheese, grated

¼ pound Parmesan cheese, grated

¼ pound Gouda cheese, grated

1 teaspoon cornstarch

½ bottle, or 1 ½ cups inexpensive
 dry white wine

 Salt, to taste

Combine all the cheeses and the cornstarch in a large bowl. The cornstarch should keep the cheeses from clumping as they melt.

Heat the wine in a double boiler, or in a heatproof bowl set over a pot of simmering water (be sure the bottom of the bowl does not touch the water), and bring to a simmer. Add the cheeses slowly in batches, allowing each batch to melt before adding the next batch. It's important to keep the heat low when adding the cheeses so that they don't separate. Add salt, and then serve immediately.

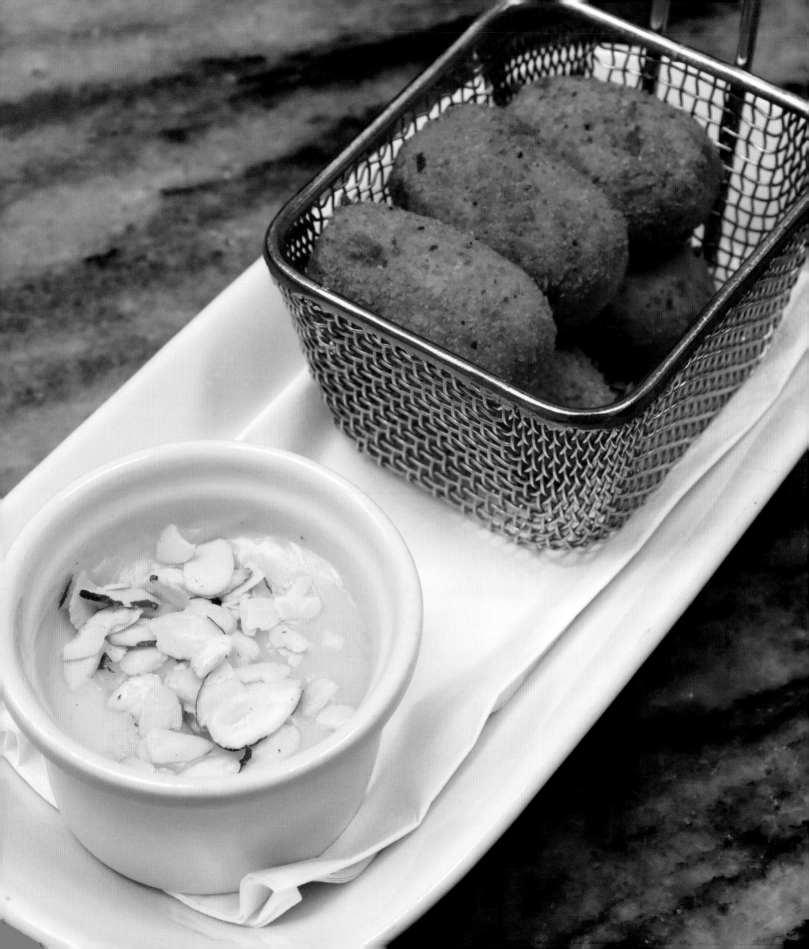

FRIED BEEF

Vaca Frita

Meat

5 pounds prime brisket beef

2 heads garlic, peeled and separated into cloves

2 onions, coarsely chopped

5 carrots, coarsely chopped

1 tablespoon ground cumin

1 tablespoon ground oregano

1 tablespoon salt

1 tablespoon freshly squeezed sour orange or lemon juice

2 bottles red wine (750 ml each)

Sauce

½ cup olive oil

1 cup finely chopped onion

1 tablespoon ground cumin

1 tablespoon ground oregano

2 tablespoons salt, or to taste

5 cups cooked black beans, pureed

To make the meat, combine the brisket, garlic, onions, carrots, cumin, oregano, salt, sour orange juice or lemon juice, and red wine in a pressure cooker or a Dutch oven. Make sure there is enough liquid to completely cover the meat; add water if necessary.

If using a pressure cooker, cook on high for 90 minutes. If using a Dutch oven, cook, covered, at a simmer for 4 to 5 hours, until the meat is very tender.

Remove from the heat and let the meat cool in the cooking liquid. When cool, remove the meat from the liquid, reserving 2 cups of the liquid. Shred the meat by hand into small pieces.

To make the sauce, heat the olive oil in a large frying pan over medium heat. Add the onion, cumin, oregano, and salt and cook, stirring, for about 5 minutes, until the onions are translucent. Add the shredded meat and 1 cup of the cooking liquid. Sauté for 5 to 10 minutes, until the meat has absorbed the onions. Add the remaining 1 cup cooking liquid as needed if the meat becomes too dry, or to deglaze the pan.

Serve hot over a molded bed of the black beans. The meat can also be refrigerated in a covered container for up to two days and can be served at room temperature, warm, or hot.

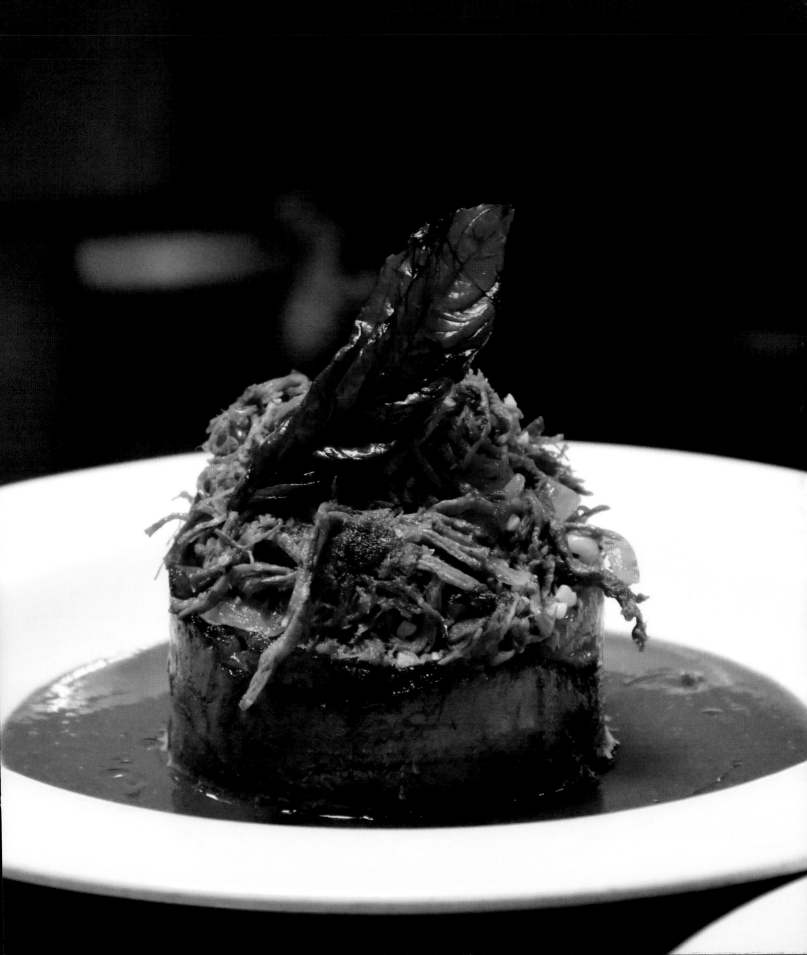

SWEET GUAVA SHELLS WITH CREAM CHEESE AND GUAVA SYRUP

SERVES 8

Cascos de Guava Dulce

Guava Shells Poached in Simple Syrup

12 mature and firm yellow guavas, peeled and halved

1 ½ cups sugar

3 cinnamon sticks

Pastry

1 ⅔ cups flour

1 cup sugar

1 teaspoon baking powder

½ teaspoon salt

14 tablespoons (1 ¾ sticks) cold salted butter

1 cup heavy cream

8 ounces cream cheese, softened to spreading consistency

8 decorative cookies (optional)

8 sprigs mint

To make the guava shells, remove all seeds from the guava pieces. Combine the sugar and cinnamon sticks with 2 cups water in a saucepan. Bring to a boil, then lower the heat to simmer and add the guava. Poach over low heat for 15 minutes or until the guava is soft but not disintegrating. Remove the fruit from the syrup and set aside to cool. Continue to cook the syrup at a simmer for about 20 minutes until it reduces and becomes very thick. Turn the heat off and let it cool. Once cool, transfer to a covered container. The syrup and the cooked guava shells should be in separate covered containers and can be kept at room temperature for up to 2 hours or refrigerated for up to 24 hours.

To make the pastry, combine the flour, sugar, baking powder, and salt in a food processor. Slowly add the butter to the food processor and mix until the dough holds together. If the dough is too crumbly, add 2 to 4 tablespoons ice water. Wrap the dough tightly in plastic wrap and refrigerate for 2 hours.

When ready to bake, preheat the oven to 350°F. Line two baking sheets with parchment paper. Roll the dough out to a ½-inch thickness and cut out eight 4-inch-wide rounds. Place the rounds on the prepared baking sheets and bake about 12 to 15 minutes, until golden brown. Watch closely and rotate the baking sheets from top to bottom and front to back halfway through the baking time. Remove from the oven and let rest for 2 minutes, then transfer to a wire rack and allow to completely cool. Once cool, these can be kept in a covered container at room temperature for up to two days.

When ready to serve, whip the heavy cream with an electric mixer on high speed until peaks form. Set aside.

Place one round of the pastry on each serving plate and top with a thin layer of softened room-temperature cream cheese and a layer of three guava shells. Fill the center of each shell with 1 teaspoon of the syrup, then drizzle more syrup over the plate and the pastry. Add a dollop of whipped cream, 1 decorative cookie, and a sprig of mint to each serving. Serve immediately.

LIME MERINGUE PIE
Tarta de Limón y Merengue

Crust

1 ⅔ cups flour

½ cup sugar

⅓ cup salted butter, softened

1 large egg

Filling

4 large egg yolks

1 can (400g) sweetened
 condensed milk

1 cup freshly squeezed lime juice

1 teaspoon gelatin dissolved in

1 tablespoon of hot water

Meringue

4 large egg whites

 Pinch of salt

¾ cup sugar

To make the crust, combine the flour, sugar, butter, and egg in a bowl and blend with an electric mixer on low speed until just combined. Alternatively, combine all ingredients in a food processor. Do not overmix.

Form the dough into a ball and roll out to a 10-inch circle. Place the dough in a 9-inch pie pan, covering its bottom and sides, and refrigerate it, covered tightly with plastic wrap, for at least 30 minutes, or up to three days.

When ready to bake, preheat the oven to 350°F.

Pierce the cold dough several times on its bottom and sides with a fork, then transfer to the oven and bake for 20 minutes until golden brown, but not darker.

While the dough is baking, prepare the filling: Whisk the egg yolks, then add the sweetened condensed milk, lime juice, and dissolved gelatin, and whisk by hand to blend well. Pour the mixture into the baked crust, return the pan to the oven, and bake for 20 to 40 minutes, until the filling is set.

While the pie is baking, make the meringue: Beat the egg whites and the salt together with an electric mixer on high speed until they are very stiff. Gradually add the sugar and beat on high speed until the sugar is completely dissolved and the meringue is creamy and shiny. Spread the meringue on top of the lime filling and bake for about 10 more minutes, or until just lightly browned.

Refrigerate the pie for up to 6 hours and serve cold.

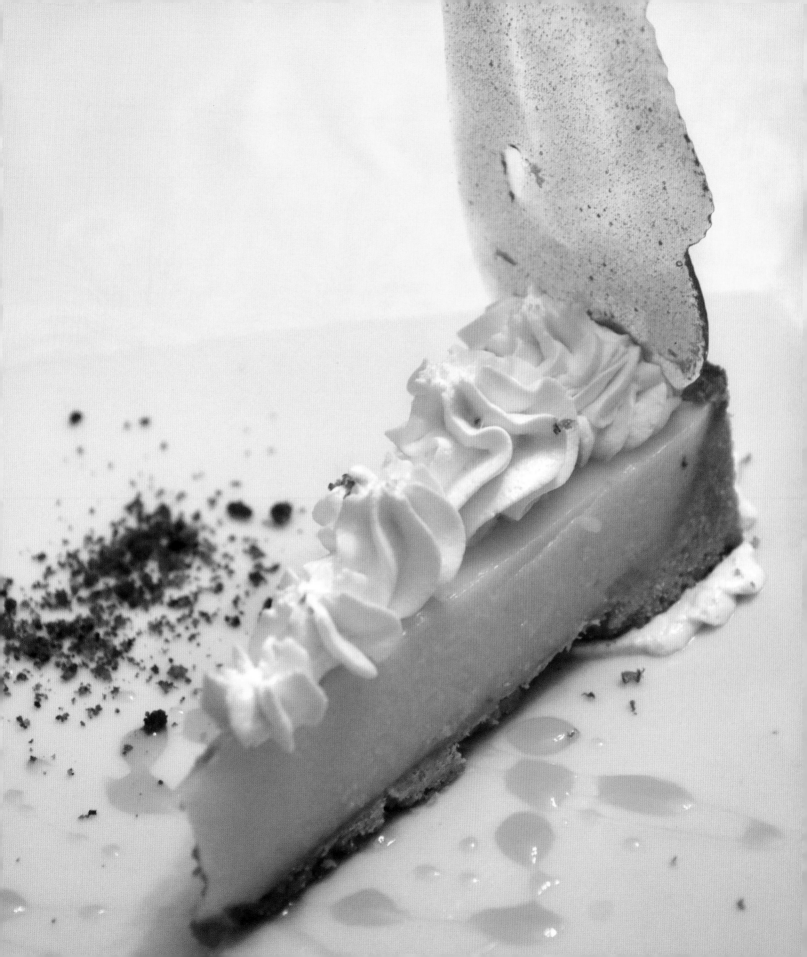

EL COCINERO

CALLE 26 NO. 57

To reach El Cocinero, one climbs three flights of spiral stairs located in an enormous brick building with an iconic smokestack that used to be a peanut oil factory. At the top is a renovated industrial space with an open outdoor area, featuring an oasis of modern furniture and decor coupled with groomed grass greenery and a view of the Vedado neighborhood buildings. There is also a lovely and more private outdoor garden terrace, as well as an indoor space for dining, located just before one even reaches the rooftop garden.

This paladar, with its contemporary design, has become a trendy spot for both Cubans and foreigners to enjoy dinner or drinks. The food is delicious, and though it may seem simple and reminiscent of "fast food," with menu items such as hamburgers and salads, it is actually much more complicated in its preparation and presentation. The menu at El Cocinero changes frequently, depending on the availability of materials and at the whims of its owners, who offer international dishes made with Cuban ingredients.

Next door, yet part of the same factory building, is the entrance to Havana's hottest club, La Fábrica del Arte Cubano. The venue has a vast and mesmerizing array of changing art displays made from a variety of media, including painting, photography, video projection, sculpture, film, music, clothing, jewelry, and even performance art, all in the sprawling former factory. Together El Cocinero and La Fábrica del Arte Cubano offer a harmony of art and food.

SERVES 8 JAPANESE SALAD

Ensalada Japonesa

1 ½ cups white sushi rice

2 tablespoons and 1 teaspoon coarse salt

1 pound (about 45) small or medium shrimp, peeled and deveined, with tails removed

1 teaspoon pepper

1 tablespoon freshly squeezed lemon juice

4 medium lobster tails, shelled

2 tablespoons brown sugar

1 teaspoon ground hot red pepper, or to taste

1 tablespoon anise liqueur

2 tablespoons red wine vinegar

1 teaspoon sugar

8 small radishes, half finely chopped and the other half sliced into small, match-sized pieces for garnish

¼ cup finely diced green papaya (fruta bomba)

¼ cup finely chopped chives

½ cup mayonnaise, or more if needed to keep ingredients moist

1 tablespoon wasabi

1 teaspoon lemon zest

1 teaspoon wakame, rehydrated and soaked in cold water

½ teaspoon fresh ginger

2 tablespoons nori, sliced into small, match-sized pieces for garnish

Combine the rice, 1 tablespoon of the salt, and 3 cups water in a saucepan over high heat. Bring to a boil, then immediately reduce the heat to low, cover, and simmer 20 minutes until the rice is soft and the water is absorbed. Set aside.

Bring another saucepan filled with water to a boil. Add the shrimp and boil until they start to turn pink, then immediately plunge them in ice water to stop the cooking. Cut shrimp lengthwise and season with 1 tablespoon of the salt, 1 teaspoon of pepper, and the lemon juice. Set aside.

Return the water to a boil, add the lobster, and boil for 10 minutes, then plunge the lobster in ice water to stop the cooking. Cut the lobster into slices. Heat a saucepan over medium heat and add the lobster slices, brown sugar, hot red pepper, the remaining 1 teaspoon salt, and more black pepper, to taste. Turn off the heat and add the anise liqueur. If desired, flambé by striking a match and carefully lighting the mixture on fire. Allow the flames to die off.

Cut the lobster and shrimp into same-size pieces. In a small bowl, mix the red wine vinegar with the sugar. Combine the chopped radishes, half of the papaya, and the chives, then mix in the red wine vinegar mixture and the mayonnaise, wasabi, lemon peel, wakame, and ginger to make a dressing. Mix the dressing with the cooked rice, and then stir in the lobster and shrimp slices.

Mold the rice and seafood mixture onto a plate and serve garnished with the remaining match-sized slices of radishes and the nori and papaya.

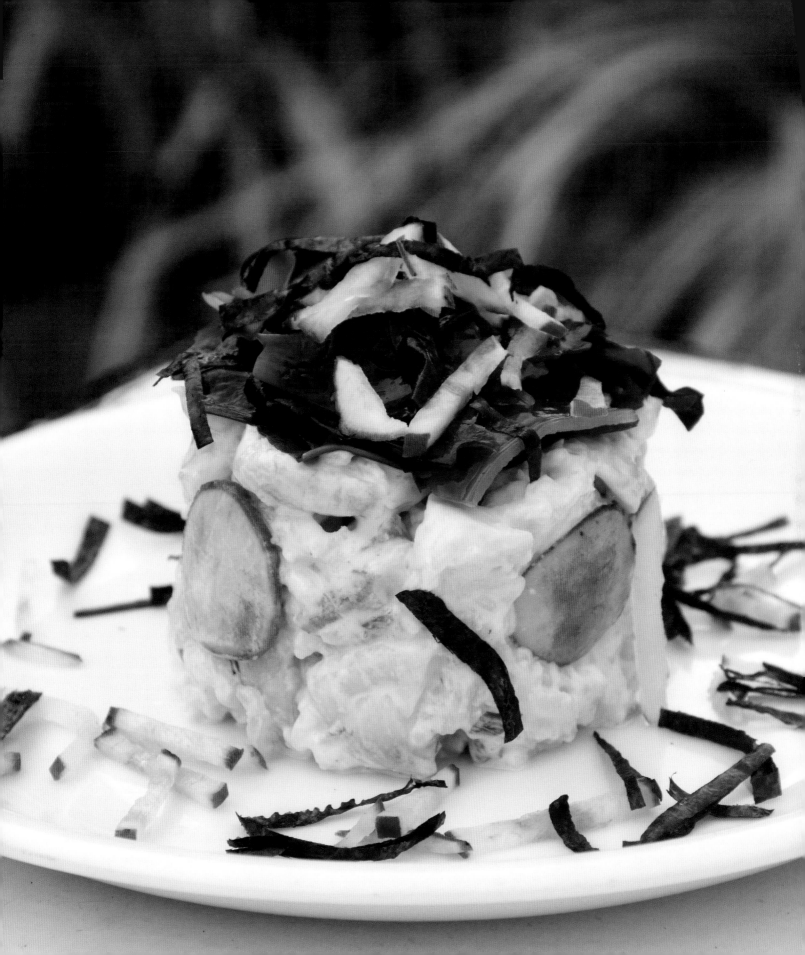

MINI CHEESEBURGERS

Mini-hamburguesas con Queso

Flat Bread

2	teaspoons dry yeast
1	teaspoon sugar
2 ½	cups flour
2	tablespoons rosemary
1	teaspoon salt
¼	teaspoon ground hot red pepper
½	teaspoon pepper

Caramelized Onions

2	teaspoons olive oil
3	cups peeled and thinly sliced onions
2	tablespoons salted butter
2	tablespoons aged Cuban rum

Cheese Topping

2	cups shredded manchego cheese
8	tablespoons (1 stick) salted butter, melted
1 ½	teaspoons salt
1	teaspoon pepper

To make the flat bread, heat ⅔ cup plus 2 tablespoons water until it is warm, 110° to 115°F. Mix the water with the yeast and sugar and let sit for 10 minutes, or until bubbly.

Add 2 cups of the flour and the rosemary, salt, hot red pepper, and black pepper. Beat for 2 minutes with an electric mixer fitted with the paddle attachment. Switch to a dough hook, or remove from the mixer, and knead for 8 to 10 minutes, adding the remaining flour as needed to keep the dough pliable, but not sticky.

Place the dough in a large bowl that has been lightly greased with vegetable oil. Allow the dough to rise in a warm place for about 1 ½ hours, or until doubled. Meanwhile, prepare the caramelized onions and the cheese topping.

To make the caramelized onions, heat the olive oil and onions in a large frying pan over high heat, stirring continuously so that the onions do not stick or burn. When the onions are a light caramel color, add the butter and rum. Continue to cook, stirring, over heat until the onions are well cooked and browned. Set aside at room temperature for up to 3 hours or refrigerate for up to 24 hours.

To make the cheese topping, mix the manchego, butter, pepper, and salt together in a bowl and set aside at room temperature for up to 2 hours, or refrigerate for up to 24 hours. Bring back to room temperature before serving.

Once the flat bread dough has risen, punch down the dough and divide it into 6 small balls. Set aside to rest for 15 minutes. Meanwhile, preheat the oven to 350°F. Line a baking pan with parchment paper.

Roll each ball of dough between your hands until smooth, then place in the prepared baking pan about 2 inches apart, leaving room to rise. Press down on the rounds slightly to create flat breads. Cover with a clean kitchen towel and allow to rise for an hour in a warm, draft-free location; an unused oven is ideal. Transfer to the oven and bake about 20 minutes, until lightly browned. Remove from the oven and let cool 5 minutes. Separate tops from bottoms to create 12 bottoms for open-face burgers.

Hamburgers

- **2** pounds chopped beef (preferably filet or sirloin)
- **2** cups finely minced onion
- **14** cloves garlic, minced or crushed
- **2** tablespoons coarse salt
- **2** small heads of lettuce (Bibb is preferable)
- **3** small round tomatoes, sliced

Serve the rolls with the burgers immediately, while they are still warm, or cover tightly with plastic wrap for a few hours, until all ingredients are prepared.

To make the hamburgers, combine the meat, onions, and garlic and shape the mixture into 12 small burgers that are the same size as the flat bread. Do not overwork the meat or it will toughen.

Preheat the grill to high. Coat a large cast-iron frying pan with the salt and heat over high heat. Make sure the kitchen is well vented, and sear the burgers in batches for 2 to 3 minutes in the hot frying pan, turning once, until they are browned on both sides. Do not overcrowd the burgers in the pan. Transfer the burgers to the grill and finish cooking to your desired doneness, about 2 to 3 minutes for medium rare and 5 to 6 minutes for medium.

Remove from the grill and place 1 tablespoon of the cheese mixture on top of each burger. Place under the broiler to melt the cheese. Watch closely so the burgers don't burn.

To serve, top each slice of flat bread with 3 small lettuce leaves, 1 small round of tomato, 1 cheeseburger, and 1 tablespoon of the onions. Immediately serve each guest 3 open-faced cheeseburger sliders.

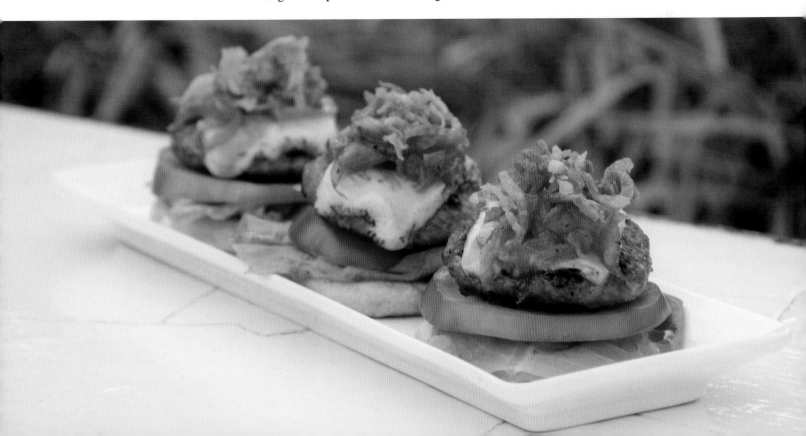

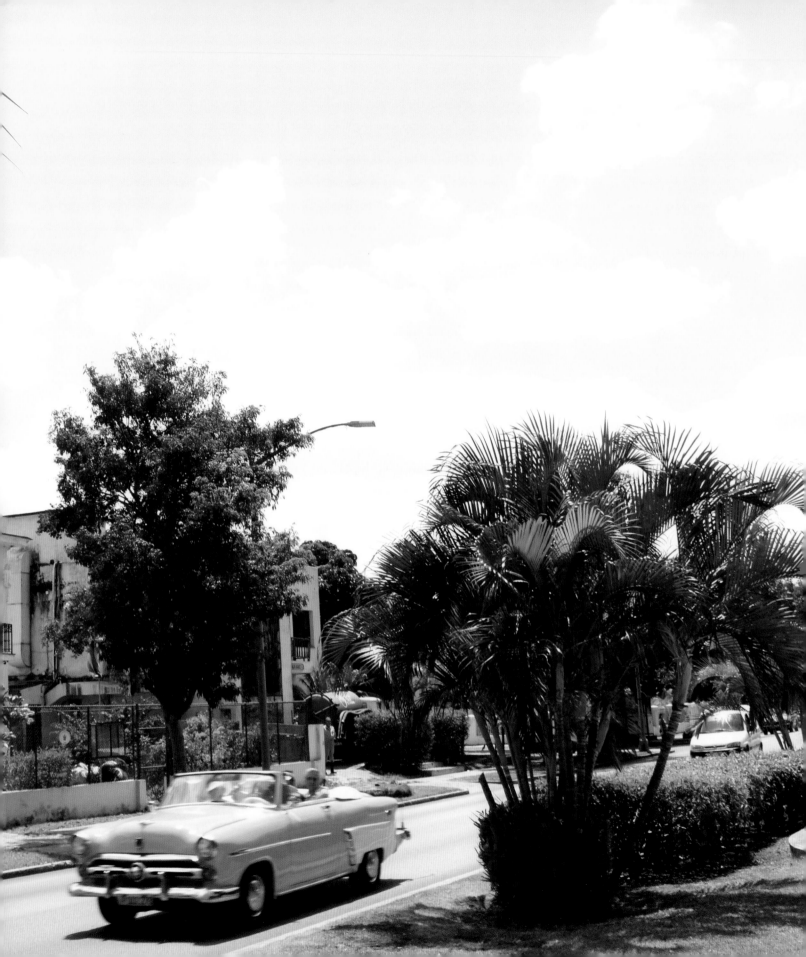

MIRAMAR

If you drive west from Vedado, through the tunnel going under the Almendares River, you exit onto the illustrious two-way boulevard of Quinta Avenida (5th Avenue), with a wide promenade dividing traffic, and well-groomed trees decorating the center. The avenue is in the prestigious, mostly residential Miramar neighborhood, one of the last areas of Havana to be developed. Grandiose mansions, which were owned by the wealthy prior to 1959, are now foreign embassies, diplomatic residences, local and foreign-owned business offices, banks, real estate offices, upscale hotels, and shopping centers, as well as homes for prominent Cuban leaders and wealthy foreigners. The neighborhood has a serene and exclusive atmosphere, with an ocean breeze coming from its northern side and tropical, tree-lined streets, parks, and plush gardens decorating the rest of the area.

Several popular nightclubs, including dance and music venues, are located in or near Miramar. The most internationally known club is nearby in the Marianao neighborhood: the Cabaret Tropicana Cuba, where you can dine and drink in a tropical setting while dancers perform under the stars. Cigar aficionados come from all over the world to experience the eminent tobacco store on 5th Avenue and 16th Street, La Casa del Habano, considered one of Cuba's premium cigar stores.

One of the first paladares in Miramar, and still one of the finest, is La Cocina de Lilliam. It serves a signature paella dish and several other house specialties.

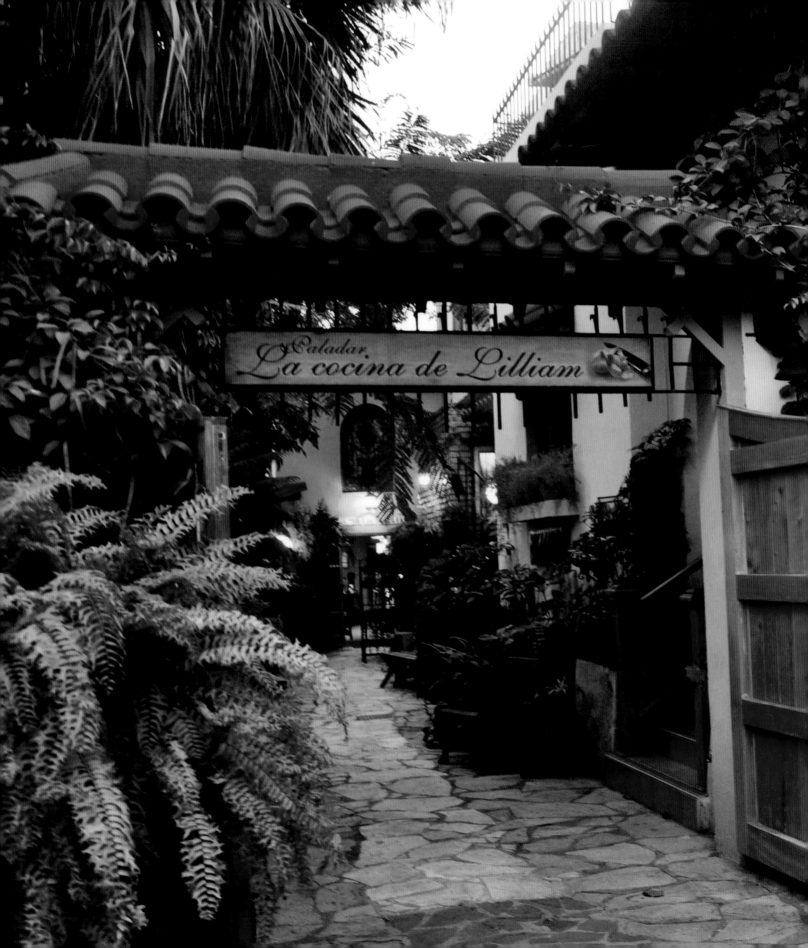

LA COCINA DE LILLIAM

CALLE 48 No. 1311

Lilliam Dominguez Palenzuela and her family were one of the first families to get state approval to run a paladar in their home in the 1990s. La Cocina de Lilliam has long held the reputation of being one of Cuba's best paladares for both food and atmosphere.

The outdoor stone entrance next to the family villa leads guests down a winding pathway through a tropical garden of luscious plants, flowers, and trees. The soothing, meditative sounds of water flowing from fountains are the background to the covered outdoor seating area, with its finely-polished wood furniture and elegant tiles on the walls and floors. In the kitchen, Lilliam and her staff are busy cooking delicious food and creating lovely plate presentations. One woman on staff quietly carves fruits and vegetables into flower shapes, using tips and tricks she learned from Lilliam, who loves to share her cooking style and expertise to ensure that her staff is well trained. Lilliam even has a television mounted on a kitchen wall that plays cooking shows, which teach and entertain the staff as they work.

Lilliam, once a fashion designer, brings her eye for detail, her work ethic, and her passion for cooking to her paladar. She learned how to cook when she was a teenager, with help from her mother and a neighbor who shared their techniques and European-influenced recipes. Today, Lilliam works with her husband and children as well as with several attentive and skilled helpers who each contribute to provide an exquisite dining experience. In 2002, President Jimmy Carter dined

Page 174: *5th Avenue's boulevard and sidewalk.*

Below: *Paladar owner and chef Lilliam Dominguez Palenzuela.*

at La Cocina de Lilliam during his visit to Cuba, and many other dignitaries have also been guests at the paladar. In describing the paladar, Lilliam said, "We rely on modern concepts of international and traditional Cuban cuisine, a beautiful patio, efficient service, and cuisine that matches the best." Homemade bread, baked daily without additives or preservatives, accompanies each meal at La Cocina de Lilliam. Other house specialties are bruschetta and seafood paella.

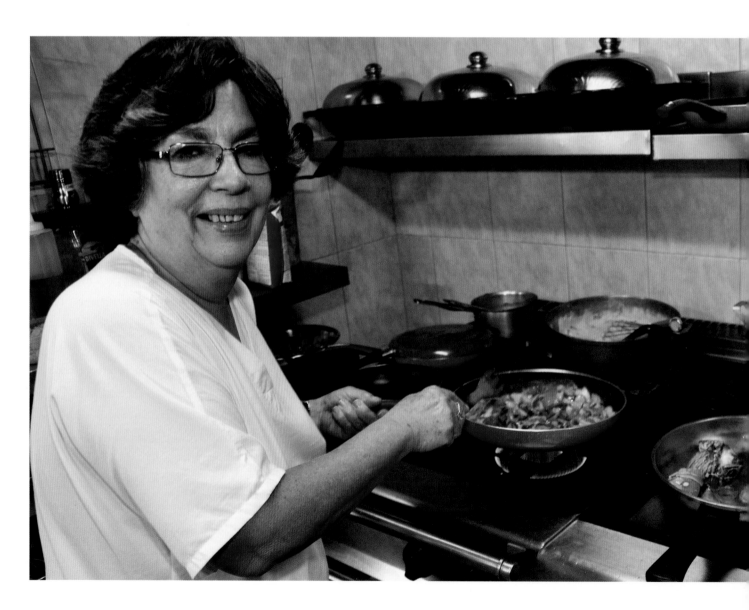

HOMEMADE BREAD

Pan

Two ¼-ounce packages dry yeast

⅓ cup sugar

2 teaspoons salt

3 tablespoons powdered
milk (optional)

8 tablespoons (1 stick) salted
butter, melted and cooled
to room temperature

2 large eggs

4 cups flour

Heat 1 cup of water to 110°F, then mix in the yeast and 1 teaspoon of the sugar. Wait about 10 minutes, or until the yeast bubbles, then add in the rest of the sugar and the salt, powdered milk, if using, butter, 1 egg, and enough of the flour to make a soft but not very sticky dough. (If the yeast fails to bubble, discard and start over.)

Knead the dough by hand for 8 minutes, or use an electric mixer with a dough hook, adding more flour as necessary to keep the dough from becoming too sticky. Allow the dough to rest for 15 minutes, then transfer to a clean, lightly greased bowl and place it in a warm, draft-free space. Cover the dough with a clean cloth and allow it to rise until it doubles, 1 ½ to 2 hours.

After the first rise, punch down the dough and shape it into two oval loaves. Cover a baking sheet with parchment paper or aluminum foil and place the loaves on the baking sheet. Allow to rise for 1 hour.

When ready to bake, preheat the oven to 350°F. Whisk the remaining egg into an egg wash and lightly brush each loaf with the wash. Transfer to the oven and bake the loaves until well browned, about 20 to 30 minutes. Let cool before slicing.

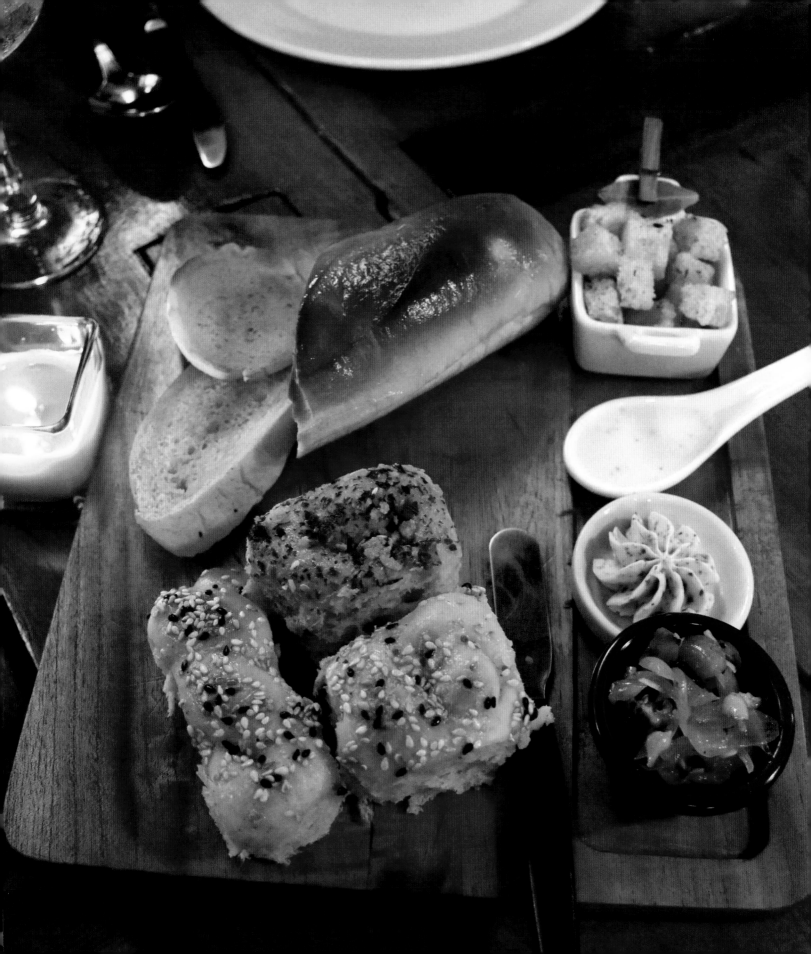

TUNA BRUSCHETTA

Bruschetta de Atún

2 tablespoons olive oil

1 tablespoon salted butter, melted

1 loaf French bread with soft crust
 (Homemade Bread, page 182, or
 store-bought), sliced ½ inch thick

1 tomato, finely chopped

2 cloves garlic, minced

2 tablespoons chopped onion

¼ cup chopped fresh basil

1 tablespoon chopped fresh oregano

4 ounces canned tuna,
 shredded (see Note)

 Salt and pepper, to taste

2 tablespoons grated Gouda cheese

1 tablespoon chopped fresh parsley

Preheat the broiler, or preheat the oven to 400°F. Mix 1 tablespoon of the olive oil with the butter. Spread the mixture on one side of each slice of the bread and broil on high heat for 2 minutes or bake 5 to 10 minutes until lightly browned. Set aside.

Combine the tomato, garlic, onion, basil, oregano, and the remaining tablespoon of olive oil, then add the tuna, salt, and pepper. Spread the tomato-tuna filling on the toasted side of each bread slice and sprinkle with the Gouda and parsley.

Broil on high heat for 2 minutes or bake 5 to 10 minutes until the cheese melts. Serve warm.

NOTE: The tuna can be replaced by diced ham or minced slices of anchovies.

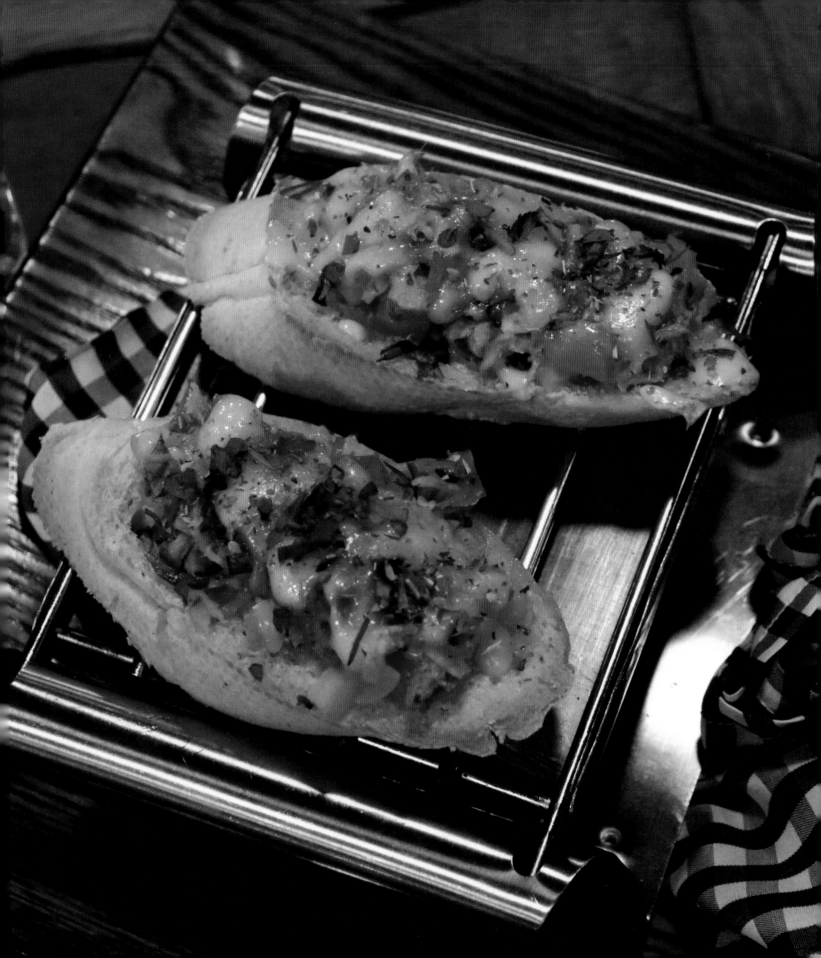

SEAFOOD PAELLA
Paella de Mariscos

1 tablespoon olive oil

1 large onion, finely chopped

1 head garlic, crushed and peeled

1 cup finely chopped tomato

1 green bell pepper, finely chopped

1 teaspoon minced cilantro,
 or more to taste

2 teaspoons salt

1 teaspoon pepper

2 cups white rice

4 cups Fish Stock (page 187), heated
 Pinch of saffron threads

1 tablespoon salted butter

¼ cup white wine

12 mussels and clams, well scrubbed

2 large raw lobster tails, shelled
 and cut into bite-size pieces

1 pound raw shrimp, deveined
 with tails intact

1 tablespoon heavy cream

1 tablespoon finely chopped
 fresh basil, for garnish

1 tablespoon finely chopped
 fresh parsley, for garnish

Heat the olive oil in a large frying pan over medium heat. Add the onion, garlic, tomato, green pepper, cilantro, salt, and pepper. Sauté for 5 minutes, or until the onions are translucent. Add the rice and stir for 30 seconds.

Add the heated Fish Stock and the saffron and bring to a boil, then decrease the heat to low. Cook, uncovered, over low heat until the broth is absorbed and the rice is cooked, about 30 minutes. If the rice is still crunchy after the broth is absorbed, add a small amount of water and bring to a boil, then return to a simmer and cook until the water is absorbed and the rice is cooked.

Combine the butter, white wine, and mussels in a separate saucepan over medium-high heat. Cover and cook until the mussels fully open, then quickly remove them from the pan and set aside. As the bivalves open, they will release their natural liquid into the pan. Leave the liquid in the pan as you remove the cooked mussels. Discard any mussels that do not open.

Lower the heat to medium, add the lobster to the pan with the mussel broth, and sauté for 5 to 10 minutes until it is almost cooked and almost fully opaque. Add the shrimp and continue to cook 5 more minutes, until all the seafood is opaque. Remove the seafood pieces from the pan as they cook so that they don't become rubbery. Reserve the broth in the pan.

Combine the mussels, lobster, shrimp, and the broth from the mussels with the heavy cream, then pour the seafood mixture over the rice. Garnish with the basil and parsley and serve immediately, while hot.

FISH STOCK
Paella de Mariscos

3 pounds fish bones and carcasses
(request from the fish market)

4 cups cold water

1 carrot

1 onion, quartered

1 stalk celery

1 tablespoon fresh parsley

1 tablespoon salt

Combine the fish bones, carrot, onion, celery, parsley, and salt in a large pot with a cover. Add enough water to submerge the ingredients and bring to a boil over high heat. Lower the heat to a simmer and cook, covered, for 30 minutes.

Strain the broth while hot and discard all the solids. Use the stock immediately, or transfer it to an airtight container and refrigerate it for up to one day or freeze it for up to 6 weeks.

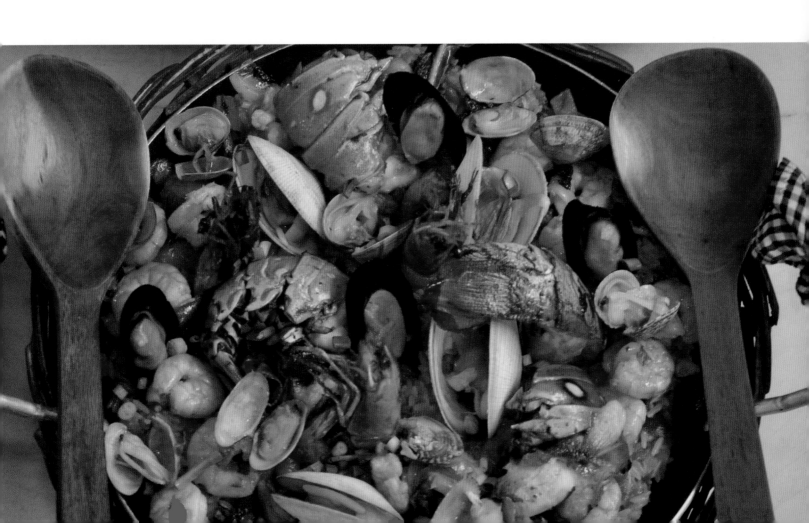

ÉLITE

Élite is a restaurant, not a paladar, owned by Antonio Rodriguez Calvo and Javier Gómez Martínez, who is also the restaurant's chef. It has a contemporary design, with all black-and-white furniture, walls, and place settings. However, Javier explained to us that the stylish and contemporary décor alone does not set his restaurant apart as unique and noteworthy. He is constantly considering how he can attract a clientele in an increasingly competitive market of dining choices. One way, he found out, is by using his personal connections to acquire hard-to-find ingredients. For example: A good friend of Javier's who lives in Granada, Spain, sends him the seeds for various types of leafy greens, which are then grown in Cuba on a friend's privately-owned farm and, when ready, are brought to the restaurant in another friend's truck. With these greens, the Élite chefs are able to make the tasty and unique mixed green salad on the Élite menu. In a country where for decades there was only one type of lettuce, and where today there is still no wholesale market for culinary entrepreneurs, having this salad on the menu gives the restaurant an edge.

Left: *A waiter outside the entrance of Élite.*

SERVES 4 — MIXED GREEN SALAD

Ensalada Verde Mixta

Salad

4 leaves green romaine lettuce

4 leaves purple romaine lettuce

4 leaves curly-leaf arugula

4 leaves flat-leaf arugula

8 small radishes, thinly sliced

4 carrots, sliced with a serrated decorative edge

½ cup cherry tomatoes, halved

½ cup thinly sliced cucumber

2 sprigs fresh dill, leaves only, finely minced

Dressing

6 tablespoons olive oil

2 tablespoons balsamic vinegar

1 tablespoon Dijon mustard

2 sprigs fresh thyme, finely minced and leaves only

2 sprigs fresh cilantro, finely minced and leaves only

2 sprigs fresh dill, finely minced and leaves only

Salt and pepper, to taste

To make the salad, tear the greens into bite-size pieces and combine with the radishes, carrots, tomatoes, cucumber, and dill in a large bowl.

To make the dressing, combine the olive oil, balsamic vinegar, mustard, thyme, cilantro, dill, salt, and pepper in a bowl and whisk well, or combine in a jar with a lid and shake to mix.

Pour the dressing over the salad and toss to coat each leaf evenly. Divide among four plates, place 3 slices of bruschetta on each plate, and serve immediately.

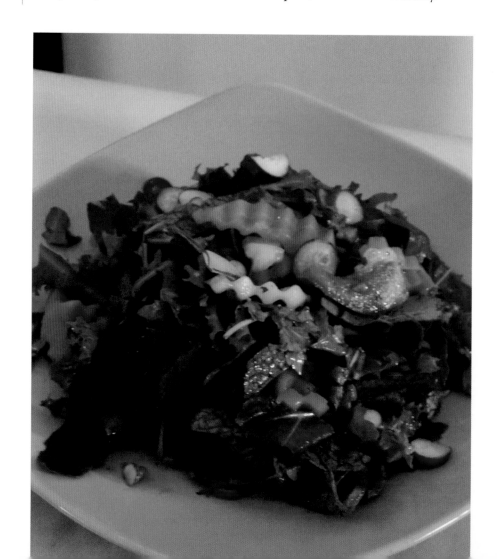

BRUSCHETTA

12 slices French bread

2 tablespoons olive oil

½ teaspoon salt

¼ teaspoon pepper

12 thin slices serrano ham

24 cherry tomatoes, sliced

½ cup grated Parmesan cheese

Preheat the broiler. Toast the bread slices under the broiler until lightly browned. Rub olive oil on one side of each slice of toasted bread and sprinkle with the salt and pepper. Layer one slice of ham on each piece of bread and top with a layer of cherry tomatoes and some of the Parmesan cheese. Return to the broiler for 3 to 5 minutes to melt the cheese, then serve immediately.

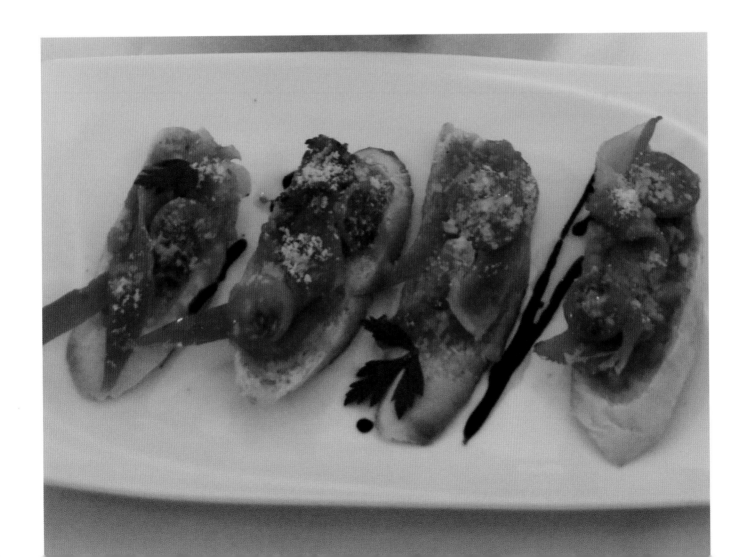

FISHERMAN'S PASTA

La Pasta al Pescador

8 ounces octopus legs

5 tablespoons olive oil

2 tablespoons sea salt

4 cloves garlic, crushed

8 tomatoes, chopped

1 teaspoon pepper

1 pound spaghetti

2 lobster tails, removed from shell and chopped into cubes

8 ounces medium shrimp, peeled and deveined

8 ounces thick-cut white fish (such as cod), cubed

2 tablespoons (¼ stick) salted butter

Fresh basil leaf slivers, for garnish

Heat a large pot of water to a boil and use tongs to lower the octopus into the boiling water 3 separate times for 5 seconds each to blanch and seal the octopus. Chop the octopus into cubes and set aside.

Bring another large pot of cold water to a boil and add 1 tablespoon of the olive oil and 1 tablespoon of the sea salt.

Heat the remaining 4 tablespoons of olive oil in a large sauté pan over medium heat, add the garlic, and cook for 3 to 5 minutes to soften the garlic. Add the tomatoes, the remaining 1 tablespoon sea salt, and the pepper, and cook, stirring occasionally, for 20 minutes.

While the tomato sauce cooks, add the spaghetti to the salted boiling water and cook, uncovered, on high heat until al dente, not too soft, then drain into a colander, reserving ½ cup of the boiling water.

While the pasta cooks, add the chopped octopus, lobster, shrimp, and fish to the tomato sauce and cook 15 to 20 minutes, just until the seafood is opaque. Pour the drained pasta into the sauce and continue to cook over medium heat for 2 to 3 minutes, stirring. This is an important step because it allows the pasta to absorb the briny tomato sauce flavor.

If the sauce is too thick, add the reserved pasta water a little at a time to loosen the sauce. Add the butter and more salt and pepper, then garnish with the basil. Serve immediately.

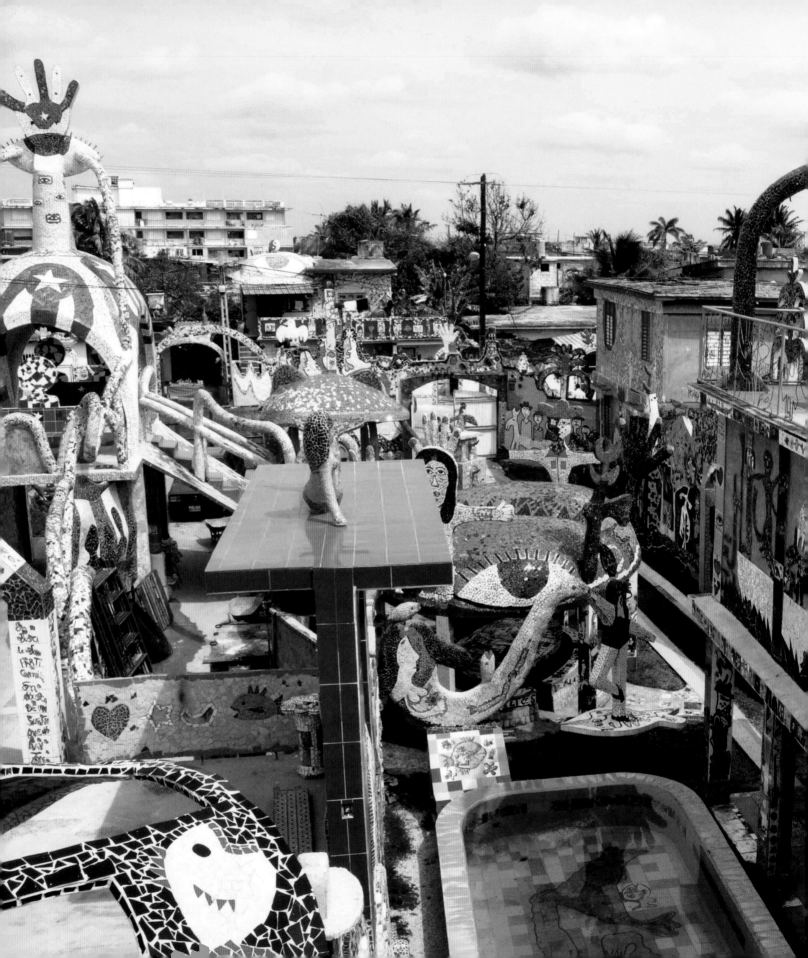

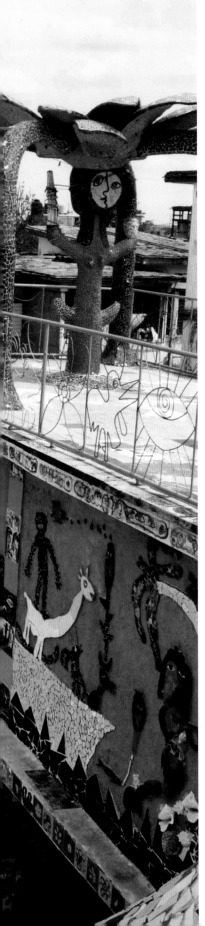

JAIMINITAS
("FUSTERLANDIA")

Just twelve miles west of Havana City is a small town on the northern coast of Cuba named Jaimanitas—or, as it is more commonly known, "Fusterlandia," after the renowned Cuban artist José Antonio Rodriguez Fuster, who has transformed not only his own home, but also the entire town, with his creativity. Fuster, as his friends and family call him, has often been referred to as the "Gaudí of Cuba," a reference Fuster is proud to acknowledge. As travelers turn off the highway into Jaimanitas, Fuster's artwork titled *Homage to Gaudi* seems to greet visitors with open arms.

Wandering along the roads and around the town, visitors feel as if they've entered a magical land with visual eye candy everywhere. Fuster has transformed this small fishing village on the coast into a fantastical, colorful experience, with mosaic tiles representing Cuba's culture, colors, history, values, and heroes, all of which are Fuster's celebration of love, life, and his country. The entire town has become Fuster's canvas, an ongoing and ever-changing artistic expression, which began with the front gate of Fuster's home.

After more than forty years of international fame as a Cuban painter, Fuster was driven to experiment with mosaic tiling around his home, a continuous expression of his creativity. His son, Alex, explained to us: "Fuster couldn't sleep . . . after just four hours of sleep, he would get up and continue tiling our house." As Fuster's mosaic-tiled home grew in size and artistic complexity, neighbors repeatedly asked when he would tile their homes. The result is a unique panorama of tiled extravaganza, with more than fifty homes in the town tiled by Fuster and his team, a wonderland now visited daily by travelers from around the world.

Strategically placed mosaic tiles transform the common and basic elements of the town's homes into enchanting shapes and forms.

Fuster's pride and passion for Cuba, combined with his love of art, music, dance, and color, are effervescently reflected in every part of his creations. In Fuster's world, nothing stays flat; one's mind is tempted and encouraged to dream. His shapes and forms morph and undulate throughout the town. The vibrant Caribbean colors, the cubist faces, and the emerging anthropomorphic shapes throughout his magical land make it impossible to focus for very long on any one area; the eye is constantly drawn away and back again. Fuster explained about his identity, "I am timeless. I welcome and represent the present, the past, and the future. I create with the hope that my art will improve the lives and imagination of people going forward."

Fuster's family is often at Fusterlandia, assisting with Fuster's art gallery and the seemingly endless stream of visitors. Just inside the grand entrance gate to Fuster's home is a shaded, tiled, round dining table where special guests can enjoy a private meal. Alex shared the delicious recipe for one of the cakes they serve to guests. It's made by one of Fuster's favorite nearby bakeries.

Page 194: *A view from José Fuster's house.*

Below: *Fuster in his home.*

Opposite: *The cake served at Fusterlandia.*

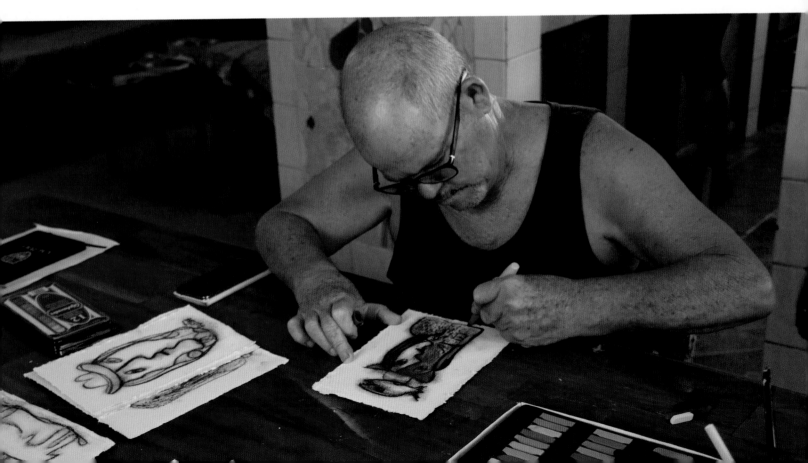

FUSTERLANDIA CAKE

Cake Batter

4 large eggs

8 large egg yolks (set 5 whites aside for the buttercream icing)

½ cup sugar, plus additional for sprinkling the pans

1 tablespoon vanilla extract

1 cup flour (see Note)

Simple Syrup

½ cup sugar

Buttercream Icing

2 ½ cups sugar

5 egg whites

⅝ pound (2 ½ sticks) salted butter, at room temperature

Food coloring, as desired (optional)

Preheat the oven to 300°F. Spray three 8-inch round cake pans with nonstick spray and sprinkle the insides with granulated sugar. Set aside.

Beat the eggs and egg yolks together with an electric mixer on high speed for 10 minutes. Add the sugar and beat for 5 more minutes.

Mix the vanilla extract with 1 cup of room-temperature water, add to the eggs and sugar, and beat for 5 more minutes. Add the flour and continue to beat for 5 more minutes.

Divide the batter evenly among the 3 prepared pans and bake until cooked through, and a knife comes out clean when the cake is pierced through the middle, about 20 minutes, rotating the pans from top to bottom and front to back halfway through the baking time.

Remove from the oven and immediately run a knife around the edges of each pan to loosen the cakes from the pans. Set the cake layers aside to cool for 5 minutes in the pans.

Unmold the cakes onto a serving pan, not a wire rack, and cool completely at room temperature.

To make the simple syrup, bring ½ cup water to a boil, add the sugar, and cook for 5 minutes on medium heat. Set aside to cool.

To make the buttercream, combine ½ cup water and 1 ½ cups of the sugar in a saucepan and cook over high heat until a candy thermometer reads 240°F.

While the mixture is heating, beat the egg whites with an electric mixer on high speed for 3 to 5 minutes, just until the whites are stiff and the peaks hold their shape, then gradually add the remaining 1 cup sugar over the course of another minute.

Add the sugar syrup to the egg white mixture in a thin and steady stream and beat for 10 more minutes, or until the outside of the bowl is cool to the touch.

Beat in ⅝ pound (2 ½ sticks) of the butter, spooning in 1 tablespoon at a time. The mixture may look curdled—continue beating until the butter becomes fully incorporated. When fully incorporated and thick, add food coloring, if desired.

Once cooled, frost cooled layers, tops and sides, with buttercream.

Refrigerate the cake until ready to serve. Let sit at room temperature for 30 minutes before serving to soften the buttercream.

Below: *The dining table for private parties at Fuster's home.*

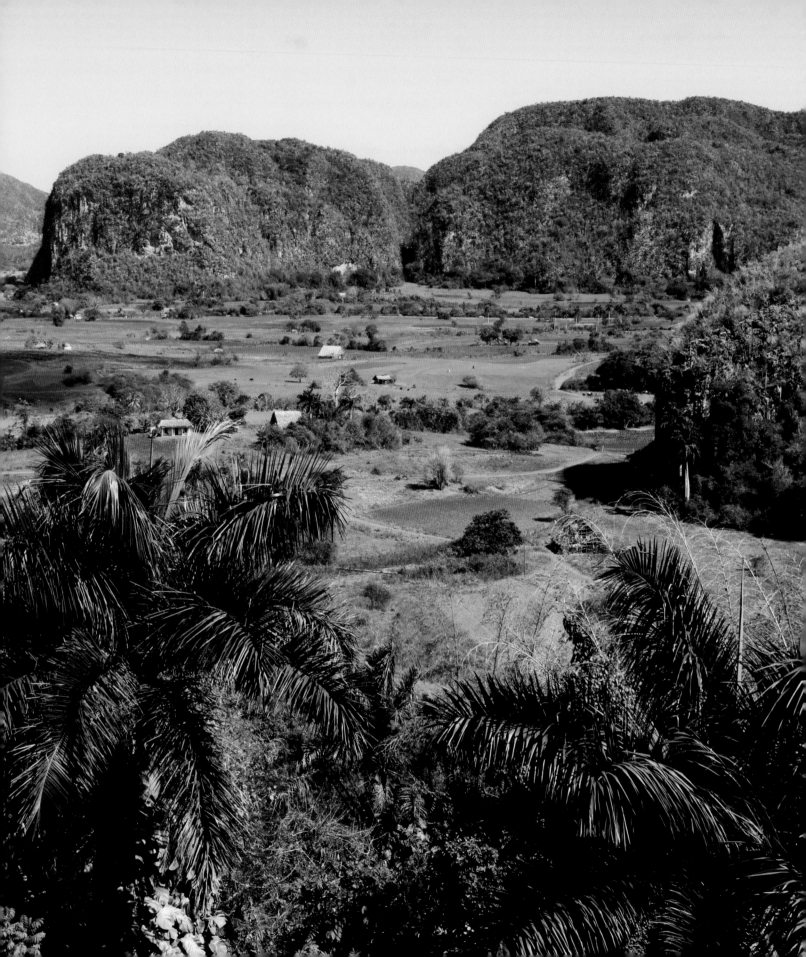

CHAPTER SIX

VIÑALES, PINAR DEL RÍO

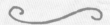

Pinar del Río, Cuba's farthest-west region, has land that is naturally rich in nutrients and a climate that is ideal for growing vegetation and the world's finest tobacco. It was originally inhabited by a group of nomadic people known as the Guanahatabeys, who lived in the area's caves, which are now popular destinations to tour. The central city, also called Pinar del Río, was founded and developed by people from the Canary Islands of Spain in the late 1500s. They began tobacco farming in the region, and this practice continues today, with the region providing most of the tobacco for Cuba's famous cigar industry. Sprinkled throughout the open tobacco fields are small triangular shaped huts, known as *bohíos*, which are where the tobacco leaves are hung to dry.

In 1999, UNESCO declared the fertile Viñales Valley, in Pinar del Río, a World Cultural Heritage site because of its diverse flora and fauna. The lush valley is characterized by striking natural landscapes of flat plains bordered with limestone hills called mogotes. They are remnants of a huge plateau that rose from the sea during the Jurassic period.

The city of Viñales is now home to brightly colored, freshly painted houses with crafted wooden doors and windows, and rocking chairs swaying on the quiet, breezy porches. Many of the homes have become bed-and-breakfasts for the growing number of visitors to the area. A general respect for nature and for the region's undeveloped surroundings and visually astounding landscape abounds among the residents. Men on horseback work the fields, and some offer rides to foreigners who come to experience the area's natural beauty and alluring tropical gardens.

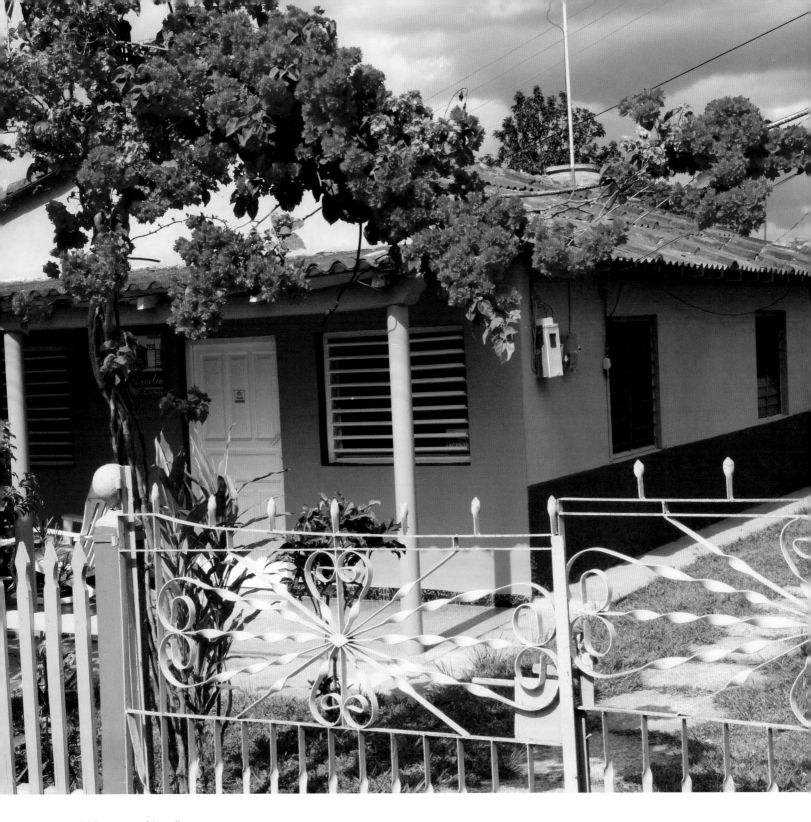

Page 200: *A view of the valley.*

Opposite: *A horseman rides through town.*

Above: *Flowers adorn a house*

where the owners rent rooms.

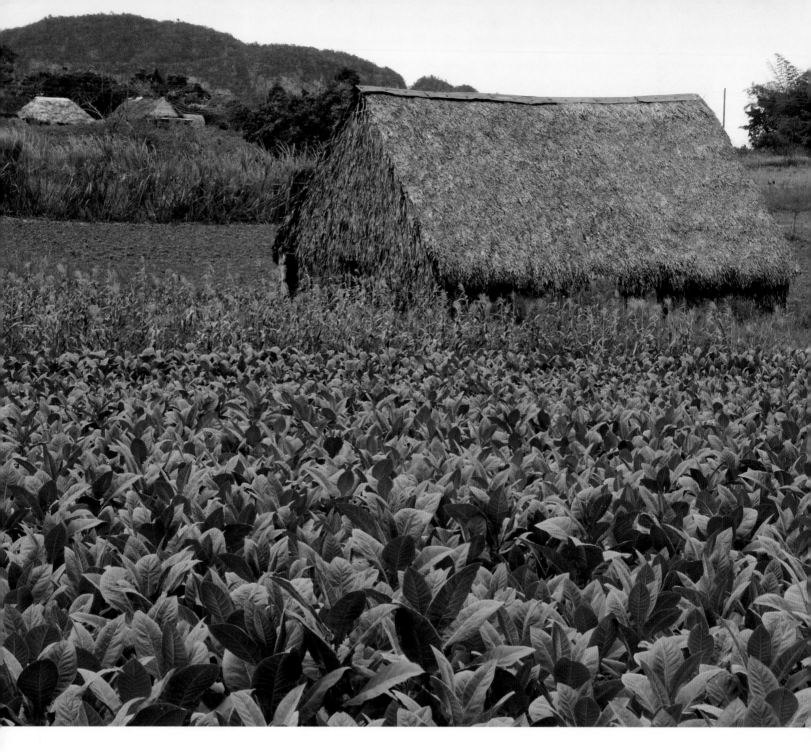

Above: *Tobacco grows by a thatched roof hut (a bohío), where the tobacco is taken to hang and dry.*

Opposite: *An actor portrays an indigenous Indian outside one of the thousands of caves in the region.*

FINCA AGROECOLOGICA EL PARAISO

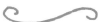

Sustainable organic farms, such as Finca Agroecologica el Paraiso, have been sprouting up in Cuba since the fall of the Soviet Union in 1991, when, after decades of support, Russia stopped subsidizing Cuba by sending fossil fuels, petroleum-based fertilizers, pesticides, and food. To handle the transition, Cuba embarked on a massive and rapid conversion to agroecological agriculture, which continues today.

Finca Agroecologica el Paraiso, an organic farm and paladar located in the east side of the Viñales Valley, is run by Wilfredo García Correa and his daughters, Rachel and Rosalba. As its name suggests, it is a little piece of paradise, with breathtaking landscape views of the mogotes of Viñales Valley. Its rows of vegetables, herbs, and flowers were meticulously planted according to Wilfredo and his team's extensive knowledge of which plants should grow side-by-side for a successful harvest and which plants need more space to keep invasive sprawl to a minimum. According to Wilfredo's arrangement with the government, in exchange for permission to work this land, 10 percent of his crops are donated to public beneficiaries such as maternity homes, hospitals, schools, and senior centers. The other 90 percent of the vegetables and herbs reaped by the hard work of local workers from Viñales are used by the restaurant business on the farm.

Knowledgeable guides give tours of the grounds and teach visitors about the farm animals and bird species, while also sharing their wealth of horticultural wisdom. Guide Martín Luis got his PhD in Geographical Sciences and grew up

Page 206: *An employee walks down to the garden from the paladar at Finca Agroecológica el Paraiso.*

Below: *A variety of organic herbs and other crops are sustainably grown.*

in Cuba studying maps of the world. He entertains guests with his cartography skills: he is able to draw a map of the world to include whatever city or country the visitor lives in. Martin also says he is like a guinea pig for the Cuban government to test the medicinal healing power of various natural and organically grown substances from the farm. He likes to boast that this is one of the reasons he has stayed very healthy.

At Finca Agroecologica el Paraiso, diners sit outdoors on the farmhouse porch and meals are served family-style. They begin with the restaurant's famous anti-stress drink (see page 210), and they end with a traditional sweet and creamy caramel custard flan.

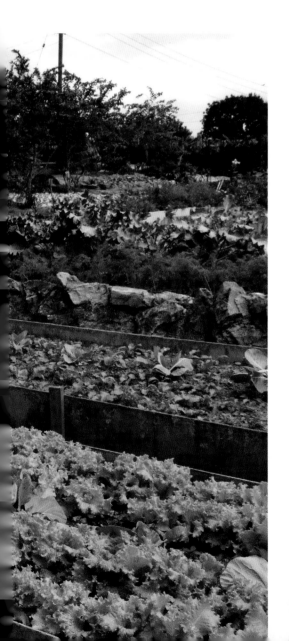

Right: *Martin Luis, one of the farm's guides who also advises on how to avoid erosion and keep the farm organic and fertile.*

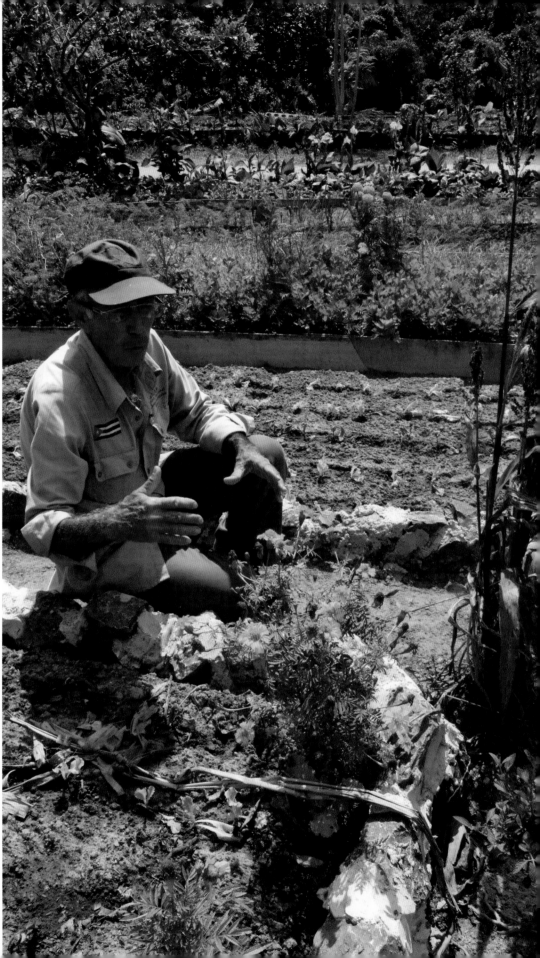

ANTI−STRESS DRINK

Bebida Anti-Estrés

2 cups pineapple juice

1 teaspoon minced fresh basil leaves

1 teaspoon minced fresh peppermint leaves

1 teaspoon minced anise leaves

1 teaspoon minced fresh spearmint leaves

¼ teaspoon minced fresh lemongrass (see Note)

1 cup coconut milk

1 teaspoon cinnamon

1 tablespoon honey, or more to taste

Combine the pineapple juice, basil, peppermint, anise, spearmint, lemongrass, and coconut milk, in that order, in a blender, and blend vigorously to puree. Pour over ice and then into 4 glasses. Decorate each with the cinnamon and honey.

NOTE: Because lemongrass is strong, much less of it is used than of the other herbs. Lemongrass is available online or in specialty food markets in the United States.

FLAN

2 cups sugar

1 cup powdered milk (see Note)

1 large egg

Preheat the oven to 325°F. Have ready a 9-inch loaf pan or 8-inch pie pan and a 10-inch or larger casserole dish that the loaf or pie pan will fit inside, to bake the flan in a water bath (also called a bain-marie).

Heat 1 cup of the sugar and ¼ cup of water in a frying pan over medium heat. This will become the caramel. Do not stir this at any point; stirring will ruin the recipe. As the sugar heats, tilt the pan, sometimes aggressively, to keep the sugar melting. The caramel will become tan colored, then light amber, then dark amber. The heat can be turned to medium-high to cause the caramel to more quickly become dark amber. When the temperature reaches 350°F, remove the pan from the heat and pour the caramel into the prepared loaf or pie pan, coating the bottom completely. Set aside.

Mix the powdered milk with 1 cup of water in a saucepan over medium heat, and add the remaining 1 cup sugar. Heat until warm. Beat the egg in a separate bowl and then gradually add the milk mixture to it. The milk mixture should be warm, but not hot. Stir to combine well, then pour the egg-milk mixture into the loaf or pie pan, covering the caramel syrup, which should now be hardened.

Place the pan in the middle of the larger casserole dish and place the dish on a rack in the bottom third of the oven. Slowly pour boiling hot water into the casserole dish to reach halfway up the sides of the loaf or pie pan so that the pan is sitting in the middle of a bath, not touching the sides of the larger pan. Bake up to 1 hour for the loaf pan or for 45 minutes for the pie pan, until the middle is no longer jiggly and the internal temperature is 175°F.

Remove the smaller pan from the water bath and let cool at room temperature on a wire rack for 2 hours. After 2 hours, invert the pan onto a serving platter. The caramel will run, so use a serving plate with a rim. Refrigerate for up to two days until ready to serve.

NOTE: This recipe requires the powdered milk to offset the use of only one egg. We remain loyal to the chef's vision and style and have faithfully reproduced the original recipe. If you wish to use liquid milk instead of powdered milk, this is not the recipe for you. However, the restaurant has since changed their recipe and they now make a more Americanized version, using 1 can (400 g) each of sweetened condensed milk and evaporated milk, and 2 eggs. They cook the custard on the stove and then bake it in a pressure cooker.

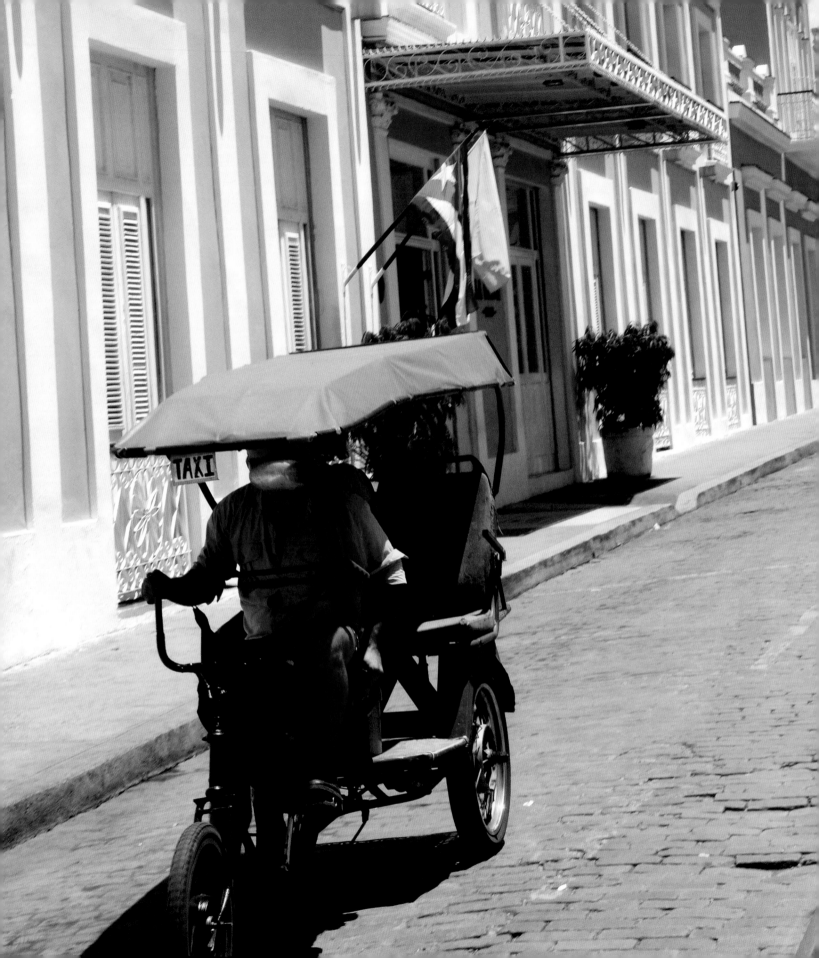

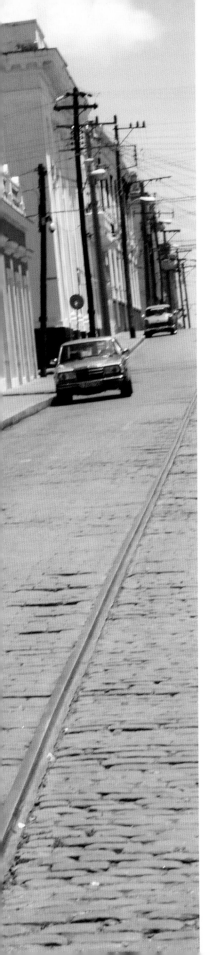

CHAPTER SEVEN

CIENFUEGOS

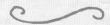

About 140 miles southeast of Havana is the city of Cienfuegos. Taino Indians were the original settlers of the city, and their name for it was Cacicazgo de Jagua, which translates to "the Chiefdom of Chief Jagua." Later, the Spanish colonized the region, and in the late 1700s and early 1800s, an influx of French émigrés came. The French émigrés renamed the city Fernandina de Jagua, honoring both the king of Spain at the time, Ferdinand VII, and Chief Jagua. Many of the street names and much of the elegant architecture still echo the influence of the early French settlers. The area was renamed again in 1829, this time as Cienfuegos, in honor of a Cuban general, José Cienfuegos, who in 1825 helped rebuild the area after its destruction from a severe storm.

The commercial port of Cienfuegos Bay has always been an important place for trade of the region's tobacco, sugar, mango, and coffee. Christopher Columbus called Cienfuegos the "Pearl of the South" for the beauty of its bay, and the city became a World Heritage Site in 2005. It is known for its urban planning, grid geometry of streets, public spaces, and eclectic architecture, including neoclassical, art nouveau, and art deco styles. Many historically important buildings and monuments surround the central plaza, named José Martí Square, where large trees gracefully sway in the breeze over park benches and passersby. As in Havana, a sea wall, also named the Malecón, links the Old Center of the city with the more residential area of Punta Gorda. The colorful facades of Cienfuego's buildings, its wide streets, and its well-preserved, mixed styles of architecture give it both a calming and whimsical character. This combination is also present in the city's Villa Lagarto paladar.

Page 214: *People ride a bicitaxi down a renovated cobblestone street.*

Below: *The main square of Cienfuegos, Plaza de Armas, with the Parque Marti in the middle. The red domed gray building is the Palacio de Gobierno, where the provincial government assembly meets.*

Right: *Facing Plaza de Armas is Catedral de la Purisima Concepcion (Cathedral of the Most Pure Conception). The Medici lion statue is in front.*

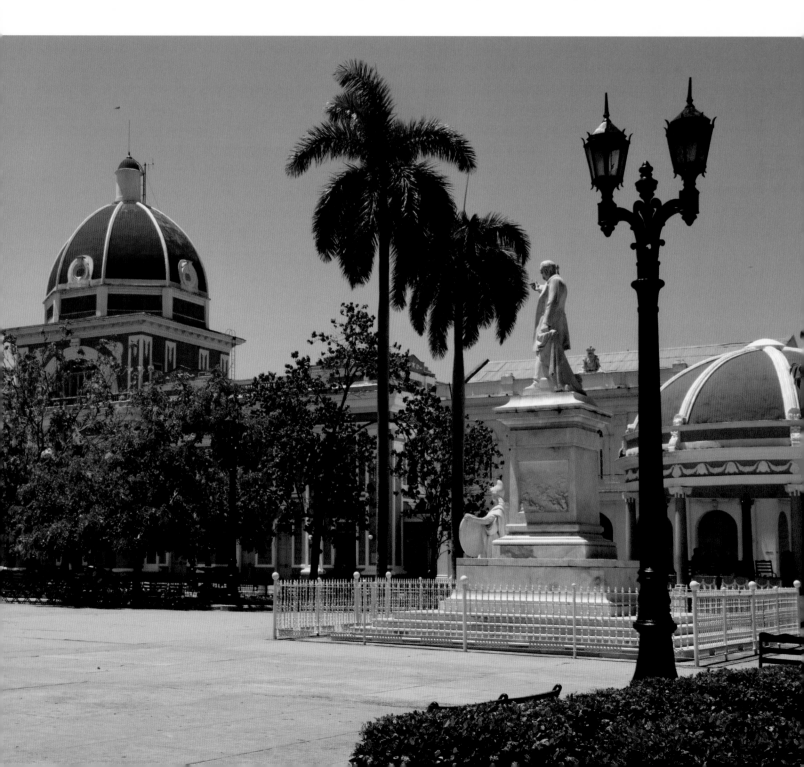

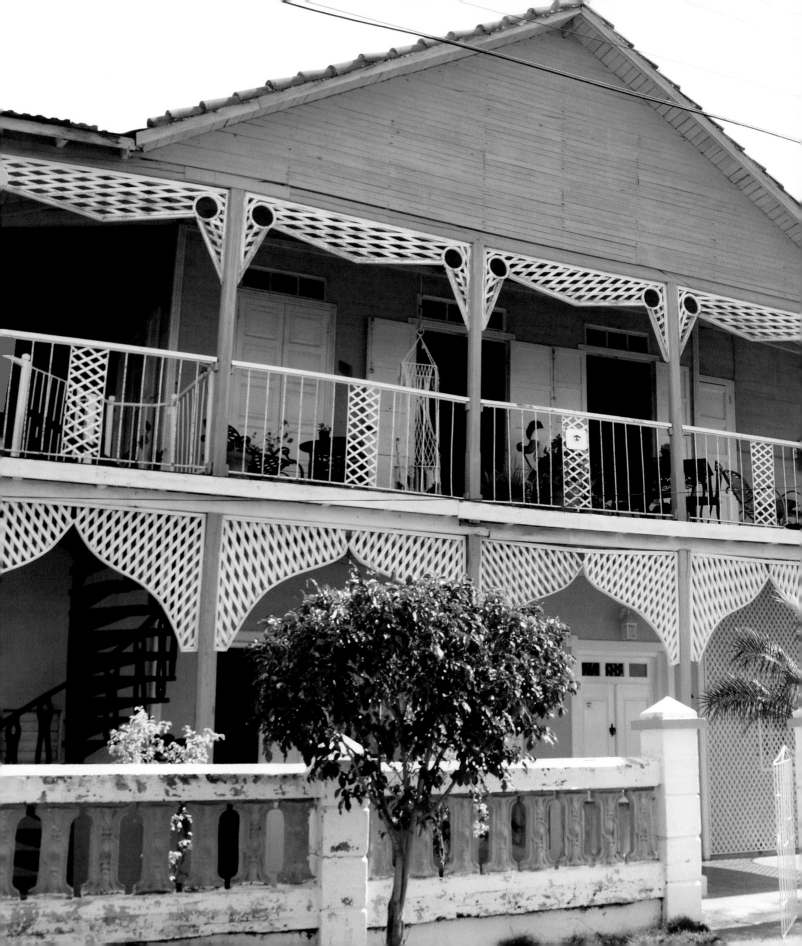

VILLA LAGARTO

Calle 35 No. 4B, La Punta, Punta Gorda

Located by the bay, with a tranquil view of the water and a refreshing breeze, the paladar Villa Lagarto (the Lizard) is an oasis for dining in the city of Cienfuegos. A large, striking, bright yellow Victorian-style is next to it, and as guests approach, colorful life-size ceramic animals welcome them down a path and into the dining portion of Villa Lagarto. Its long, lush entryway is decorated with typical Cuban wooden rocking chairs, a pretty pool, a polished wooden bridge, and a large ceramic alligator with water streaming from its mouth into the pool, as well as smaller, colorful ceramic statues of creole Cuban women, and a tree of tropical fruits available for the taking. The atmosphere is serene, with views of the bay. The food is traditional Cuban fare with both a Southern and French twist, typical of this part of the island.

Left: *The Lleonart family's house adjacent to Villa Lagarto.*

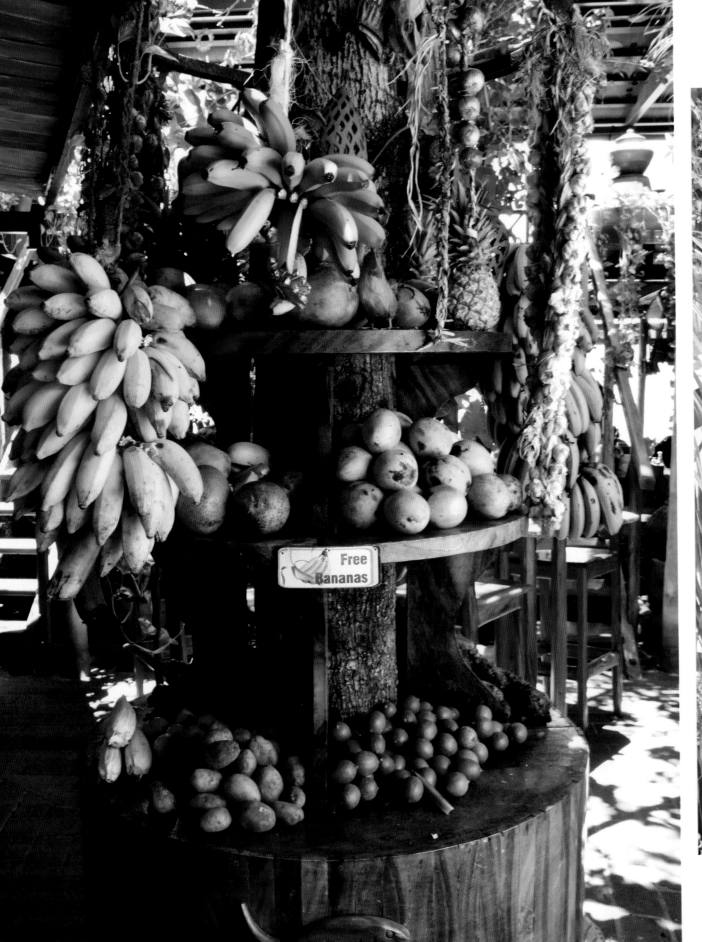

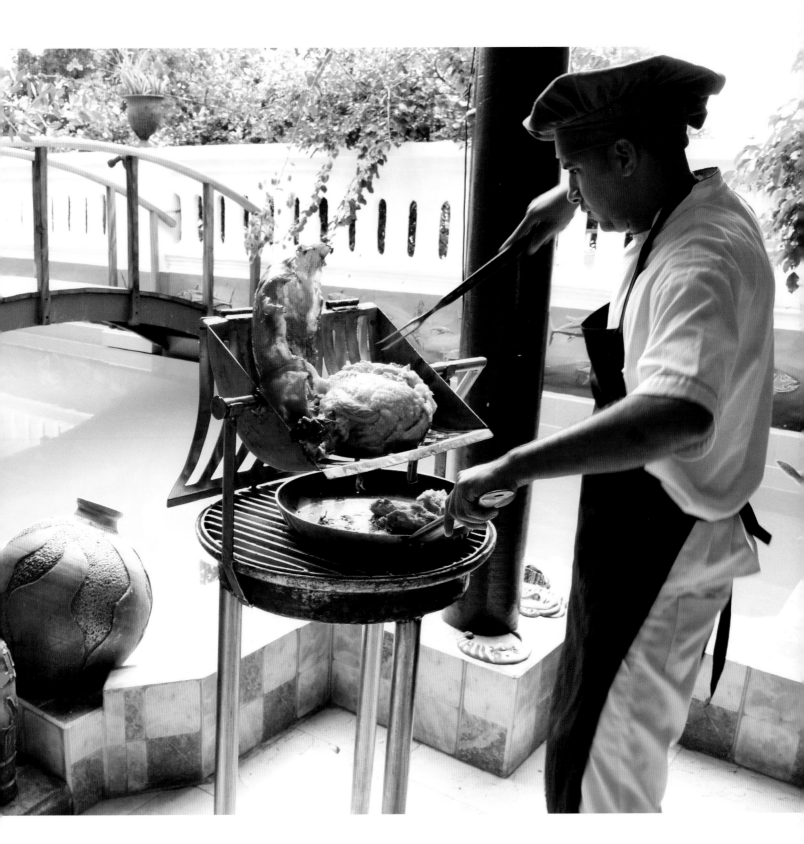

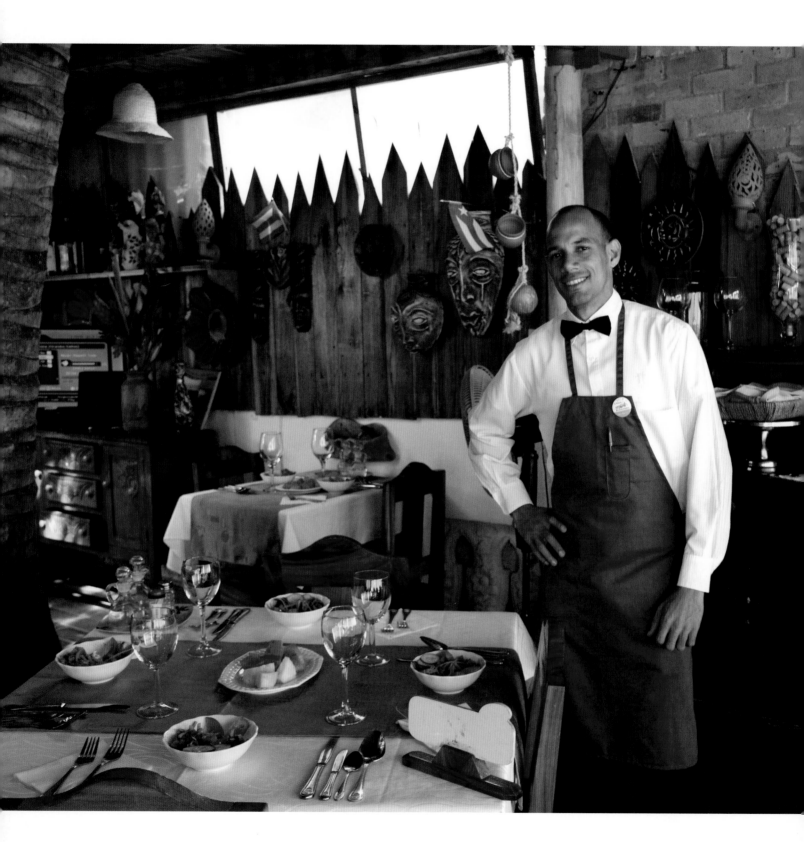

GREEN PLANTAIN CHIPS

Mariquitas de Plátanos Verdes

1 green plantain, peeled

Vegetable oil

Salt, to taste

With a mandoline or a very sharp knife, slice the plantains thinly on the diagonal to no more than 1/16 inch thick and 2 inches long.

Heat 4 inches of vegetable oil in a deep large saucepan to 350°F. Add the plantain slices and deep-fry until crispy, about 3 minutes. Remove the plantains from the oil with a slotted spoon and set on a paper towel to dry. Season with salt.

SERVES 8 VEGETABLE SOUP

Sopa de Verduras

2 tablespoons olive oil

1 cup chopped onion

3 cloves garlic, minced

1 cup diced pumpkin or other hard squash (½-inch cubes)

1 cup diced taro root or Idaho potatoes (½-inch cubes)

1 cup shredded white cabbage

1 cup chopped plum tomatoes

2 tablespoons salt, or more to taste

½ teaspoon pepper, or more to taste

1 tablespoon shredded fresh parsley, for garnish

Heat the olive oil in a Dutch oven over medium heat or in a pressure cooker, then add the onion and garlic. Sauté until the onion softens, about 5 minutes. Add the pumpkin, taro root, cabbage, tomatoes, salt, pepper, and 4 cups of water.

If using a Dutch oven, bring to a boil, then lower the heat to a simmer and cook, covered until the vegetables are soft, about 20 minutes. If using a pressure cooker, set the machine to the soup setting or cook for 12 minutes on high.

Taste and add additional salt and pepper as needed, and serve warm, garnished with a sprinkle of the parsley. The chefs at Villa Lagarto serve this soup chunky, but it could also be pureed in a blender in batches or using an immersion blender. This can be kept refrigerated in an airtight container for up to two days or frozen in an airtight container for up to three months.

SERVES 12 # SHREDDED BEEF

Ropa Vieja

4 pounds brisket or boneless short ribs

½ tablespoon ground red pepper or
 2 chili peppers, finely chopped

½ tablespoon sazon (see Note)

½ tablespoon ground cumin

1 teaspoon curry powder

2 onions, finely chopped

1 cup red wine

1 head of garlic
 (about 10 cloves), peeled

1 tablespoon course salt

Tomato Sauce

8 tomatoes, peeled, skinned, and diced

½ white onion, finely chopped

4 cloves garlic, minced

1 tablespoon coarse salt

1 tablespoon sugar

Heat a large Dutch oven over high heat, add the beef, and sear on all sides. Or, sear the beef in a pressure cooker.

Combine the dried red pepper, sazon, cumin, and curry powder, add to the beef, and stir to coat all sides of the meat with the mixture. Add the onions, red wine, garlic, and salt. If using a Dutch oven, reduce the heat and simmer, covered, for 3 to 4 hours, until the beef is very tender. If using a pressure cooker, cook on stew setting for 75 minutes. Let cool in the liquid.

Make the tomato sauce while the meat is cooking: combine the tomatoes, onion, garlic, salt, and sugar in a saucepan and bring to a boil. Lower the heat, cover, and simmer for 30 minutes, or until well cooked, then remove from the heat and let cool.

Transfer the cooled sauce to a blender and puree, or use an immersion blender. The tomato sauce can be made in advance and refrigerated in an airtight container for several days or frozen for up to three months.

When the meat is cool, tear it by hand into tiny shreds of beef ropes.

Heat the tomato sauce and 1 cup of the cooking liquid together in a large frying pan. Add the shredded meat and mix. Serve hot or at room temperature.

NOTE: Sazon is a combination of 5 dried herbs, plus salt and pepper. To make it, combine 1 tablespoon each of achiote (turmeric can be substituted), coriander, kosher salt, cumin, and garlic powder. Add 2 teaspoons oregano and 1 teaspoon black pepper. Sazon can also be purchased already combined.

ROASTED PORK WITH RICE MIXED WITH BEANS

SERVES 4

Cerdo Asado con Arroz Moro

4 pounds pork shoulder (see Note)

1 tablespoon coarse salt

1 teaspoon pepper

4 cloves garlic, crushed

2 tablespoons freshly squeezed lemon juice

4 tablespoons olive oil

1 small onion, finely chopped

½ green bell pepper, diced

½ red pepper, diced

1 cup white rice

1½ cups canned black beans, drained

½ teaspoon ground cumin

1 teaspoon finely chopped fresh oregano

1 bay leaf

1 teaspoon salt

¼ teaspoon pepper

Preheat the oven to 300°F. Place the pork in a baking dish or casserole dish and season with the salt and pepper, 2 cloves of the crushed garlic, the lemon juice, and 2 tablespoons of the olive oil. Transfer to the oven and cook for 3 hours or more, until the meat easily shreds, basting occasionally with the mixture. Remove from the oven and let cool.

Combine the remaining 2 tablespoons olive oil and 2 cloves garlic, the onion, and the peppers in a large frying pan and sauté over medium heat for 5 minutes to make the sofrito. Add the rice, beans, cumin, oregano, bay leaf, salt, pepper, and 1½ cups cold water. Bring to a boil, then lower the heat and cook, covered, at a simmer, until the water is fully absorbed and the rice is tender.

Once the meat is cool enough to handle, shred it and serve alongside the hot rice.

NOTE: The paladar serves this dish with pork legs, but they are hard to find in US markets, so pork shoulder is a good substitute.

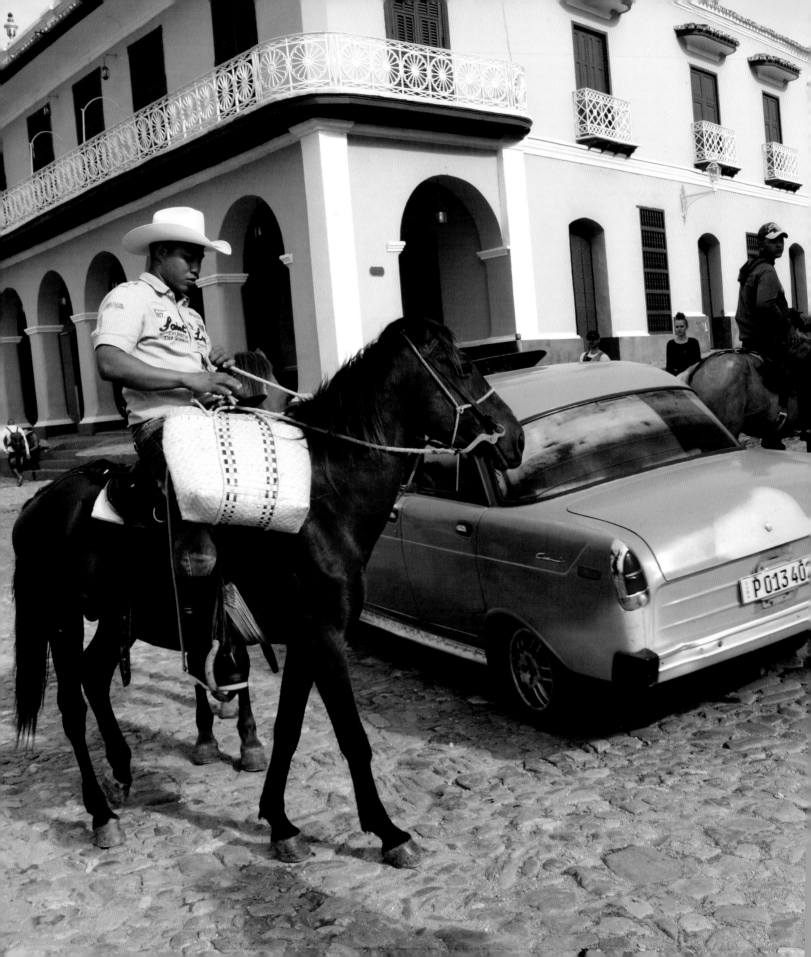

TRINIDAD

D riving south from Cienfuegos to the town of Trinidad, on Cuba's southern coast, travelers can go miles with only views of sprawling land; landscapes that look as if they came out of an impressionist painting. The land once served a wealthy sugar industry, but economic reforms have closed most of the factories and mills of the region, leaving just a sprinkling of farmers and their farmhouses.

Trinidad's famous bell tower decorates the entrance to the restored colonial town, which features terracotta-tiled roofs and Moorish-style courtyards. Located in the central Cuban province of Sancti Spíritus, Trinidad was colonized by the Spanish in 1514, as the island's third settlement. In 1518 the town was depleted of most of its original inhabitants when the Spaniard Hernán Cortés passed through, recruiting mercenaries for an expedition to Mexico. The remaining local Taíno people maintained an economy of farming and cattle rearing, but due to poor communications, they were cut off from colonial authorities in Havana. Soon after, Trinidad became a haven for pirates and smugglers running an illegal slave trade with the nearby British-controlled island of Jamaica.

Sweeping changes came to Trinidad in the nineteenth century when French refugees fled to the area after violent slave rebellions in Haiti. The French set up sugar mills and sales of sugar surpassed those of leather and salted beef, making it the region's most important industry. Trinidad became an important trading center, where wealthy merchants lived in opulent mansions decorated with French and Italian furniture. The sugar market flourished in town and also in the nearby

Valle de los Ingenios (Valley of the Sugar Mills) from the late eighteenth century to the late nineteenth century, as thousands of African slaves were brought over to work. However, competition from other sugar-producing countries, slave uprisings on Cuban plantations, and a wave of independence struggles throughout the Caribbean led to the downfall of the area's sugar industry by the end of the 1860s, causing the magnificent town of Trinidad to be frozen in time for decades, without any maintenance or development.

In the 1950s, Cuban President Fulgencio Batista passed a preservation law recognizing Trinidad's historic value, which led to a surge of tourism and a regeneration of the once-beautiful town. In 1965 the Cuban government declared Trinidad a national monument. In 1988 Trinidad became a UNESCO World Heritage Site. Today the charming city is known as Cuba's museum town, and is one of the country's historic treasures, with a soaring tourism industry and a reputation heralded throughout the world.

The great wealth from the sugar industry's boom period is still present in the ornate neoclassical architecture of many of Trinidad's buildings, including its palaces and luxurious mansions, which escaped the early-twentieth-century wave of modernization in Cuba. Trinidad is also spotted with government-maintained, pastel-colored homes full of antiques, and building exteriors with wrought-iron grilles. Charming winding cobblestone streets are speckled with classic old American cars, horse-drawn carts, motorcycles, and bicycles.

The Plaza Mayor, the town's main square, is lush with a central park surrounded by palm trees, museums, churches, homes, and paladares. Some of its vendors sell handmade clothing, precious baby shoes, pottery, jewelry, arts, and crafts; others sell fast food from carts, or even special herbs, like chamomile, out in the streets. In Trinidad's well-preserved squares and plazas, actors dress as pirates or old peanut sellers (*maniceros*) to make wanderers feel that they're journeying back in time.

The town of Trinidad is always abuzz with awe, energy, and intrigue. Local musicians play traditional Cuban music in its streets and in the Palacio de la Musica. Folkloric dance is performed nightly at the Palenque. Residents who provide basic services, such as shoe repairs, work alongside iconic Cuban imagery that covers the peeling paint on the walls of their shops. (Resources like paint are reserved and allocated to restoring and repairing the infrastructure of the streets that bustle with tourism.)

As is true for much of Cuba, the primary culinary influences in Trinidad came from its Spanish and French colonizers, as well as from the African slave trade. Today fresh fruit, and food and vegetable carts are more abundant than ever, as the government has moved toward

Page 232: *Men on horseback ride through Plaza Mayor.*

Below: *Plaza Mayor.*

encouraging private enterprise. In 2011 there were only three private restaurants; today there are more than one hundred. Most of Trinidad's restaurants and paladares serve traditional Cuban food and drinks. Two paladares, Sol Ananda and Davimart, are particularly notable for their cuisine and ambiance.

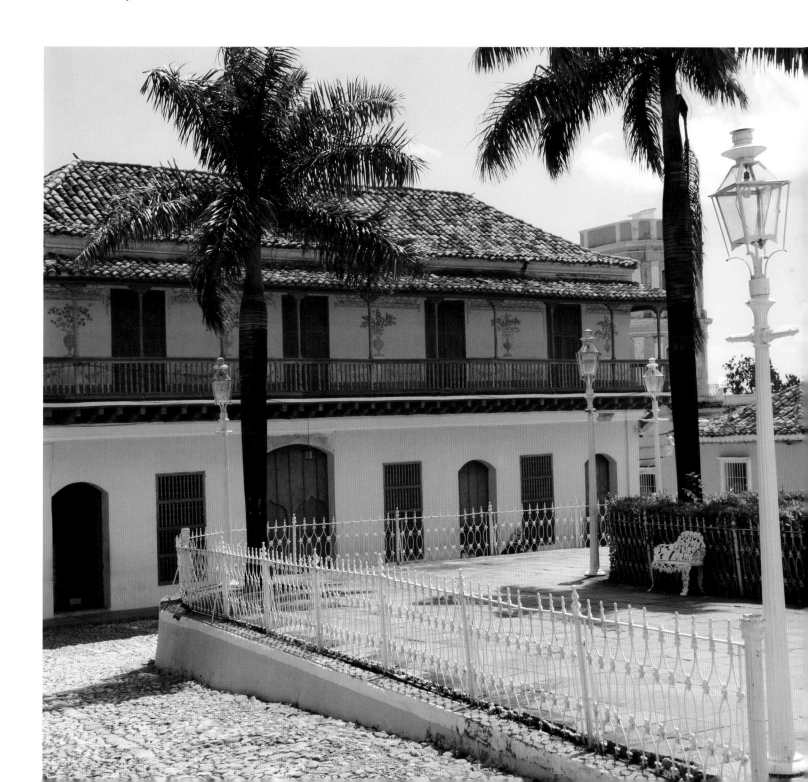

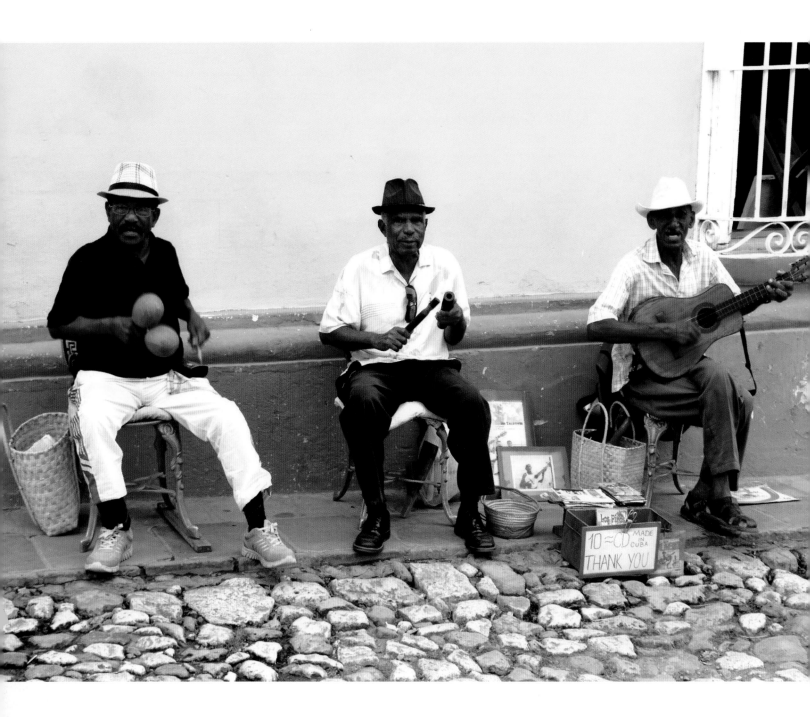

Above: *Musicians from the traditional music group Los Pinos.*

Opposite: *Horse-drawn buggies are still used for transportation in Cuba.*

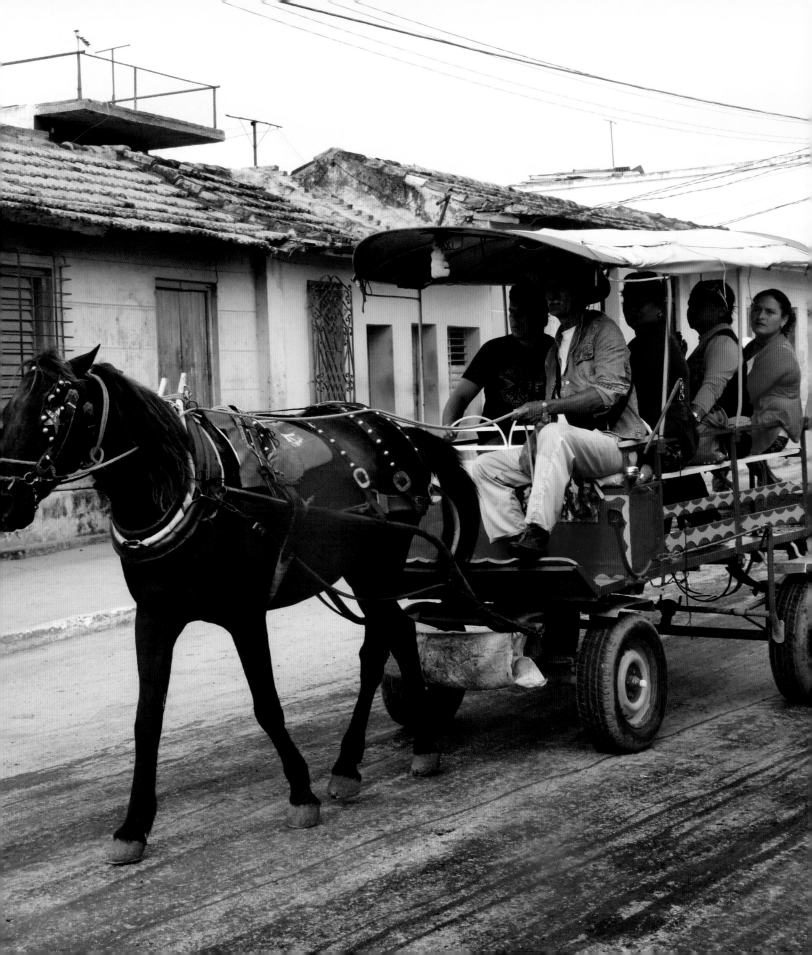

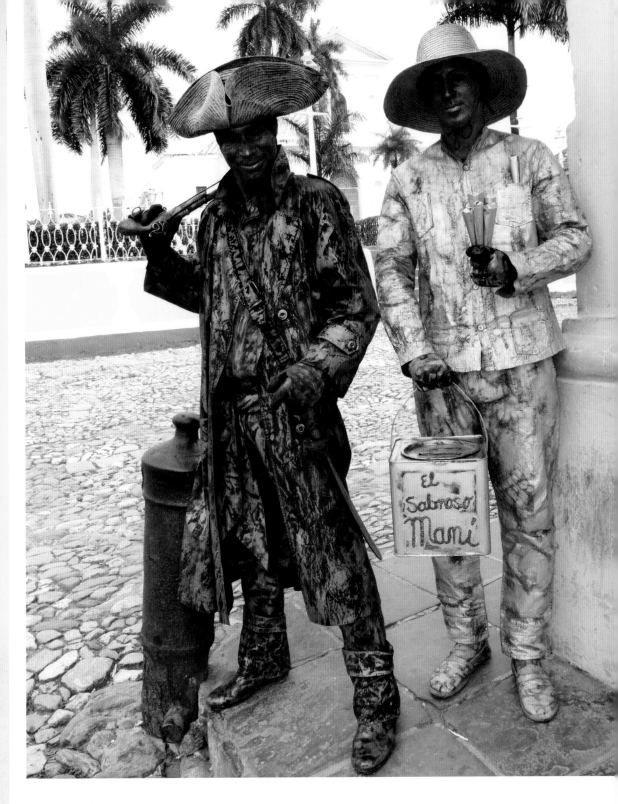

Left: *Men sit on a stoop in the Plaza Mayor.*

Above: *Actors portray a pirate and a peanut (mani) vendor.*

SOL ANANDA

CALLE REAL DEL JIGÜE NO. 45, PLAZA MAYOR

Sol Ananda is situated in the heart of Trinidad, on a prominent corner of Plaza Mayor and in one of the town's oldest houses. Its building dates back to 1750 and was home to Don Martín de Oliveras, the owner of one of the town's first sugar mills and later its mayor.

The mansion was fully renovated into its museum-like state in the early 2000s by its owner, architect Lázaro Morgado Orellana, and opened as a restaurant in January 2011. Fine eighteenth-century china, chandeliers, depression-era glassware, lace tablecloths, and antique European furniture, such as a bed, night tables, and armoires, adorn the restaurant rooms, giving guests a flashback to the town's glorious and prosperous past. Each menu is printed with historic black-and-white photos of Cuban gentry and welcoming text:

> Here we offer you an idyllic opportunity to taste good food while making an imaginary journey in time and space to the historical period in Trinidad, just as if you were one of the main landowners or officials, such as Don Mariano Borrell, Major Sergeant Don Martin de Oliveras or his daughter, Maria Oliveras, Count Brunet, Don Justo Cantero Germain, or any other of the celebrities or dignitaries of the colonial period in this part of the island.

Left: *One of the dining rooms at Sol Ananda.*

The quality and variety of the paladar's eclectic cuisine reflects the elegance of the surroundings. Chef Jorge Alejandro Rondón Muñoz's recipe for Cuba's classic dish, ropa vieja, is made with pork, not beef, because as Chef Jorge explains, "pork is easier and cheaper to buy these days in Cuba."

Below: *The chefs and bakers at Sol Ananda.*

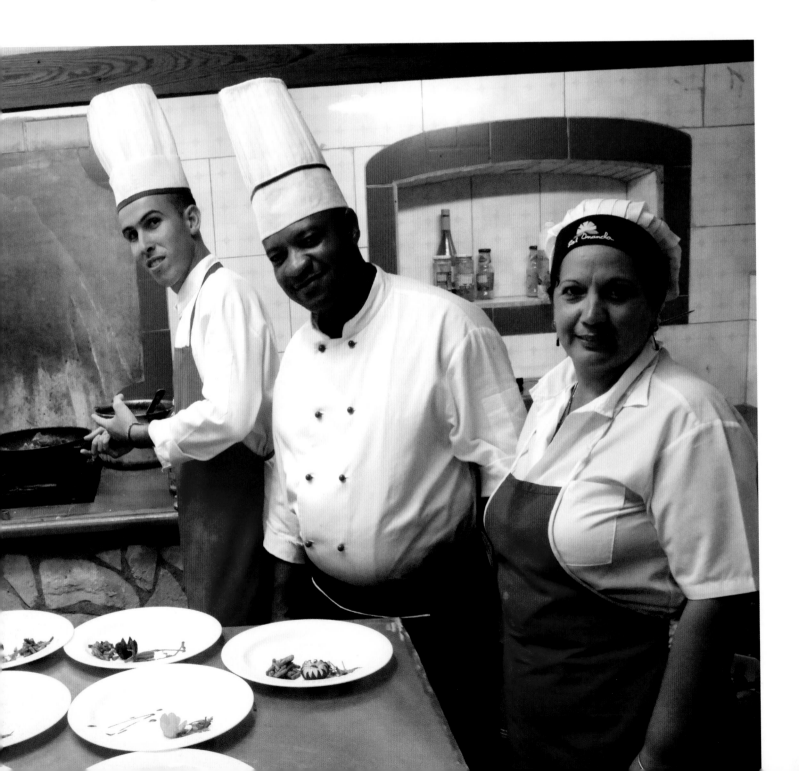

SHREDDED OR PULLED PORK

Ropa Vieja de Cerdo

1 tablespoon olive oil

10 cloves garlic, peeled

6 tomatoes, skin removed, chopped
 and drained, align with others

4 fresh basil leaves, chopped

3 pounds pork shoulder, also known
 as Boston butt (request a tough
 cut of meat from the butcher)

1 tablespoon ground cumin

1 tablespoon ground oregano

1 tablespoon salt, or more to taste

1 teaspoon black pepper,
 or more to taste

3 carrots, chopped into ½-inch pieces

2 onions, chopped

1 red bell pepper, chopped

1 bay leaf

1 750 ml bottle red wine

Heat a large frying pan over high heat and add the olive oil. Mince or press 4 of the garlic cloves and add to the hot oil. Lower the heat to medium and sauté the garlic for 3 minutes. Add the drained tomato pulp and basil leaves and cook, stirring occasionally, for 15 minutes over medium heat.

Rub the outside of the pork all over with the cumin, oregano, salt, and pepper. (Do not trim the fat and skin from the pork.) Place the pork in a large Dutch oven, pressure cooker, or crockpot, and add the tomato and basil sauce, the remaining 4 cloves garlic, and the carrots, onions, red pepper, bay leaf, and red wine. If using a Dutch oven, cover and cook for 3 to 4 hours at a simmer, until the meat is very tender. If using a pressure cooker, cook for 90 minutes on medium or the stew setting.

Remove the meat and set it aside to cool, reserving the cooking liquid. While the meat cools, transfer the cooking liquid from the crockpot or pressure cooker to a frying pan, or leave it in the Dutch oven, and bring to a boil. Lower the heat to medium and cook until the liquid is reduced by, or has been reduced by three quarters and has the consistency of a sauce.

When the meat is cool enough to handle, separate it into tiny shreds, pulling each strand along the grain. Serve the shredded pork mixed with the reduced cooking liquid. The meat and sauce can be kept refrigerated in an airtight container for up to three days.

GLAZED FRUITS
Frutas Glaceadas

4 tablespoons (½ stick) salted butter

¼ cup honey

1 cinnamon stick

¼ large papaya, unripe and green
 to yellow in color (see Note)

1 mango (see Note)

1 guava (see Note)

¼ pineapple (see Note)

1 cup vanilla ice cream

¼ cup Dulce de Leche (page 58)

Combine the butter, honey, and cinnamon stick in a large saucepan over medium heat to melt. While the syrup is melting, peel the fruits and cut into ½-inch cubes. Add the fruit to the syrup and lower to a simmer. Cook, uncovered, for 40 minutes. Discard the cinnamon stick.

The fruit can be plated immediately or allowed to cool in the syrup and refrigerated for several hours. Serve warm with vanilla ice cream and a drizzle of warm dulce de leche.

NOTE: Tropical fruits are preferred, but this recipe can also be made with stone fruits such as peaches or nectarines.

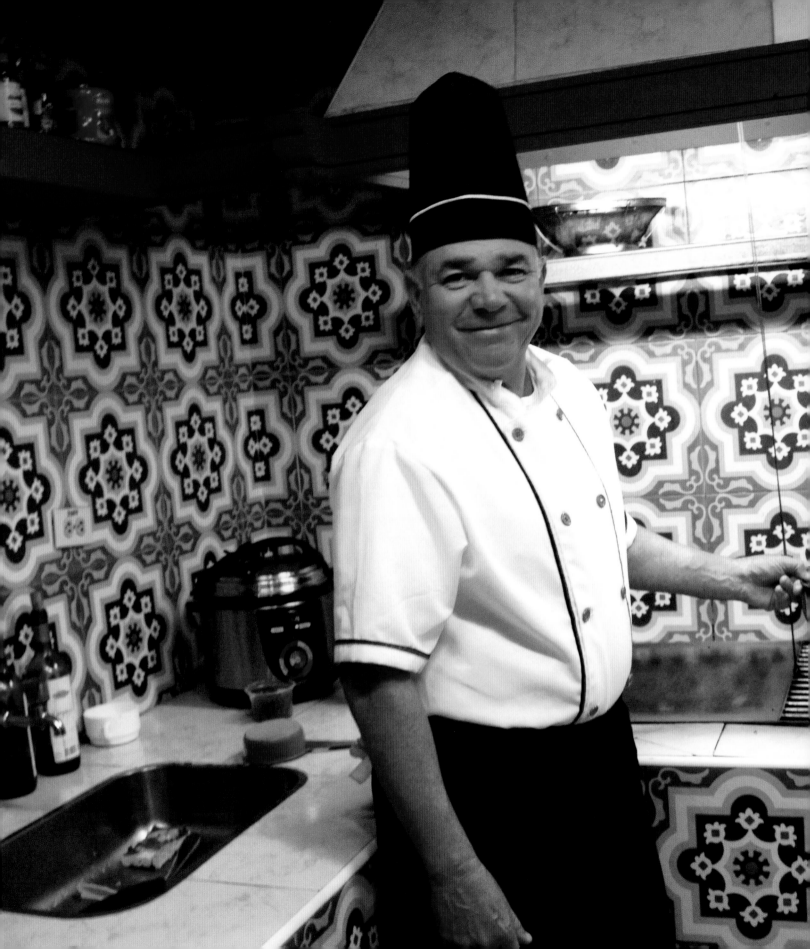

DAVIMART

ANASTASIO CÁRDENAS No. 518

David Aloma Aguíla, the owner and chef of Davimart, says the secret to the success of his paladar relates to its open kitchen, which he designed and built himself with Spanish tiles. David explained, "In my paladar, first one sees the fresh food being prepared, then one smells the fragrant aromas of the food cooking, and after that experience of the senses, are the delicious tastes of the food I've prepared for my guests."

David first trained as a mechanical engineer, but he says, "I always wanted to be a chef." His father died when he was nine years old and his mother died when he was nineteen, so he had to cook and survive on his own from an early age. In the early 1990s, during the "special period" in Cuba, when running a paladar was not allowed, David opened a restaurant "under cover," and bought his ingredients on the black market. At that time, there were no farmers' markets allowed in Cuba, only government-run stores with rationed and limited amounts of food available per person, which had to be obtained with a *Libreta de Abastecimiento* (Supplies Booklet).

In 1998, David and his family were one of the first families in Cuba to request legal permission from the government to open a paladar. The request was approved, but with strict regulations and restrictions to prevent the paladar from competing with and taking away business from the state-run restaurants. For example, at this time it prohibited for paladares to offer lobster, fish, shrimp, or beef on the menu. However, many Cuban paladar owners, such as David, risked the fines of being caught and served these foods anyway. In 2002, during an unannounced joint inspection by the Ministries of Labor and the Interior (the

national police), an inspector discovered that Davimart was offering some of the forbidden foods. As a result, authorities closed down the paladar for what David says were "nine long years of waiting, until 2011 when Raul Castro's government began encouraging private business." David was then once again allowed to open Davimart.

During the years when Davimart was closed, David received a license to rent out two rooms and was allowed to serve meals to his guests only. It was also during this time that David was invited to work in a restaurant in Brittany, France, where he says he "really learned how to cook." David explains, "Everything I know about cooking now, I learned in France."

David built himself his dream kitchen. It is an open kitchen, where he can show off his culinary skills—something he always wished he could do by having his own cooking show on television. He says his open kitchen provides the next best thing: a stage on which to perform a live cooking show for his guests during every meal. The open kitchen features a charcoal grill created so that David can mechanically lower and raise the coal to regulate the heat. It has both a flat top and a side with an open grill.

The tropical, fresh seaside air of Trinidad flows freely in the courtyard while guests watch David at work cooking skillfully and passionately—traits that have brought him well-deserved recognition. Davimart was given an Award of Excellence by TripAdvisor in 2013, 2014, 2015, and 2016, and after President Barack Obama visited Cuba, in 2016, David received a letter of recognition from the Office of the US President for his contribution to the development of "People to People" exchange between Cuba and the United States.

In 2001, an Irish chef from Boston went to cook with David as part of a food and cultural exchange. A Boston television station did a feature story on the cooking encounter, making a segment out of the chefs' collaborative experience. This American television footage is displayed on three large monitors in Davimart's outdoor courtyard dining room, where guests dine at wood tables under partial covering.

Today, David deftly runs Davimart and always greets guests with a beaming, welcoming, and proud smile. He lives in the house with his wife, Sarah, and their young daughter. His son, who is in his twenties, helps with the paladar's marketing and business side, leaving the creativity to his father.

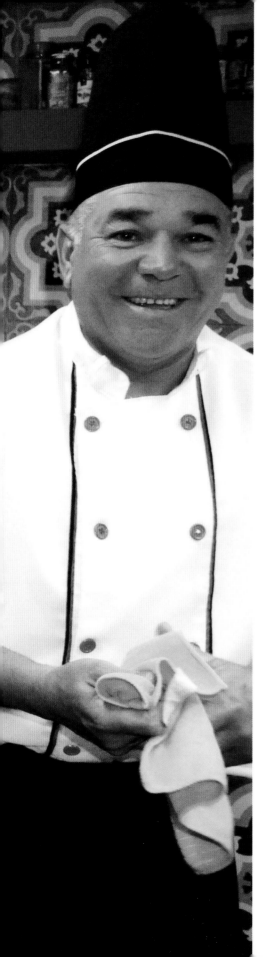

248, left, and above: *Davimart*
owner and chef David Aloma Aguíla.

Pages 258 and 259: *La Playa de L'Este.*

SERVES 4 # MIXED SEAFOOD GRILL
Parilla de Mariscos Mixtos

3 tablespoons vegetable oil

8 tablespoons (1 stick)
 salted butter, melted

4 extra-large shrimp, shells
 removed, deveined, tails intact

2 spiny lobster tails

 Salt and pepper, to taste

Preheat the grill to high. Brush 1 tablespoon of the vegetable oil on the grill so the seafood does not stick.

While the grill is heating, combine the butter and the remaining 2 tablespoons vegetable oil. Brush the mixture on both sides of the shrimp, then set the shrimp and the remaining butter-and-oil sauce aside.

With their shells on, grill the lobster tails cut-side down for 5 minutes. Remove from the grill and pull the lobster meat partially out of the shells. Return the lobster to the grill and lower the temperature. Baste the lobster with the butter-and-oil sauce and cook for 10 minutes, or until the meat is thoroughly cooked and no longer translucent.

Place the shrimp in a basket and place on the grill (or cook the shrimp directly on the grill). Cook, basting with the butter-and-oil sauce and moving the shrimp around, over high heat for 3 to 5 minutes, just until the flesh turns pink and is no longer translucent.

Remove from the heat, combine the shrimp and lobster, and add salt and pepper. Serve immediately.

GRILLED FISH
Pescado Asado

2 tablespoons vegetable oil

4 tablespoons (½ stick) salted butter, melted

4 fish fillets (such as dorado, sea bass, flounder, or sole)

1 teaspoon salt

Preheat the grill to high. Brush 1 tablespoon of the vegetable oil on the grill so the fish does not stick.

While the grill is heating, mix the butter with the remaining 1 tablespoon of vegetable oil and brush the mixture on both sides of the fillets. Sprinkle with salt. Grill over high heat, turning once, until the fish is cooked through, about 3 minutes per side. Remove from the heat and serve immediately.

CHOCOLATE–COVERED BANANAS

Plátanos Cubiertos de Chocolate

4 ounces semisweet or
 bittersweet chocolate, chopped
 if in bar form, or chips

¼ cup heavy cream

2 ripe bananas, peeled and halved
 (can be frozen if desired)

Place the chocolate in the top of a double boiler, or in a heatproof bowl set over a pot of simmering water (be sure the bottom of the bowl does not touch the water), and heat until half the chocolate is melted. Remove from the heat and stir until the chocolate is completely melted.

Whip the heavy cream with an electric mixer on high speed until soft peaks are formed.

Dip the banana pieces in the melted chocolate, decorate with the whipped cream, and serve immediately.

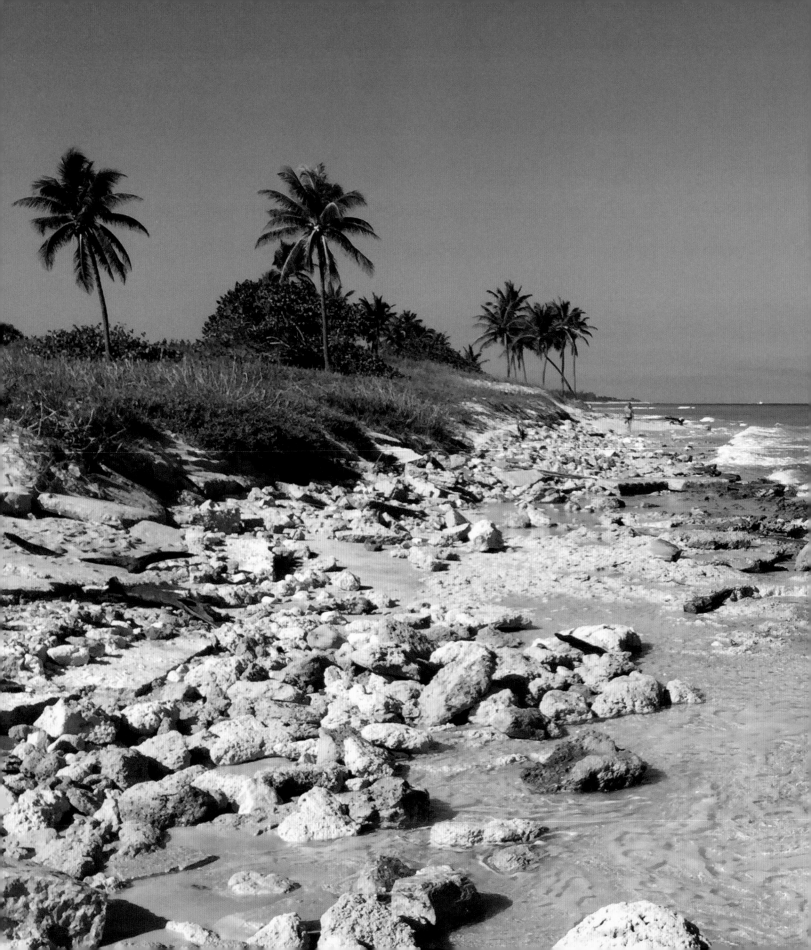

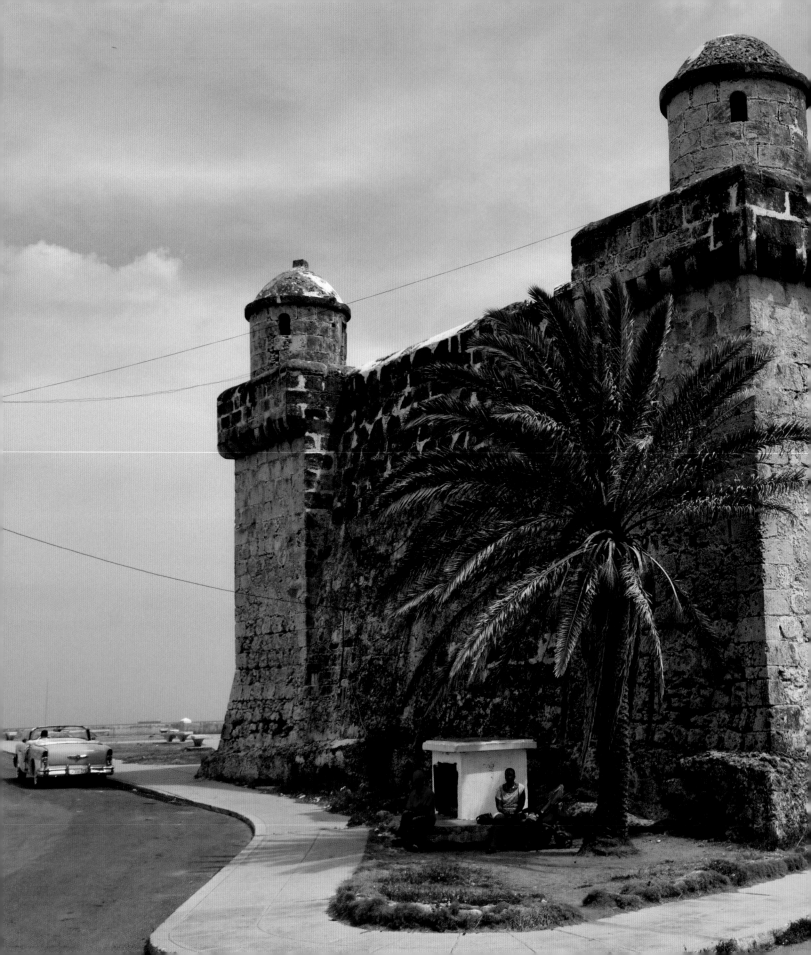

COJIMAR

⁓

East of Havana and by the ocean is the small fishing village of Cojimar. This seaside area was where Ernest Hemingway kept his boat, the Pilar, and was the setting for his novel *The Old Man and the Sea*. Gregorio Fuentes, who lived in Cojimar, was Hemingway's trusted guide at sea and is often thought to have been the inspiration for the character of the Old Man in the novel. Today, there are several elderly men who claim to be descendants of other fisherman who joined Hemingway on his boating adventures. These men love to talk with visitors, tell stories, and share photos of themselves as young boys with their fisherman fathers alongside the celebrated author, "Papa Hemingway." Local fisherman built a memorial with a prominent bust of the writer displayed on a pedestal, surrounded by a circle of white columns and placed next to a small bayside fort built by the Spaniards to keep pirates away. Nearby are several stands selling a variety of souvenirs, such as historic books and posters, in front of private homes, as well as many restaurants and paladares. Ajiaco Café is one of the best.

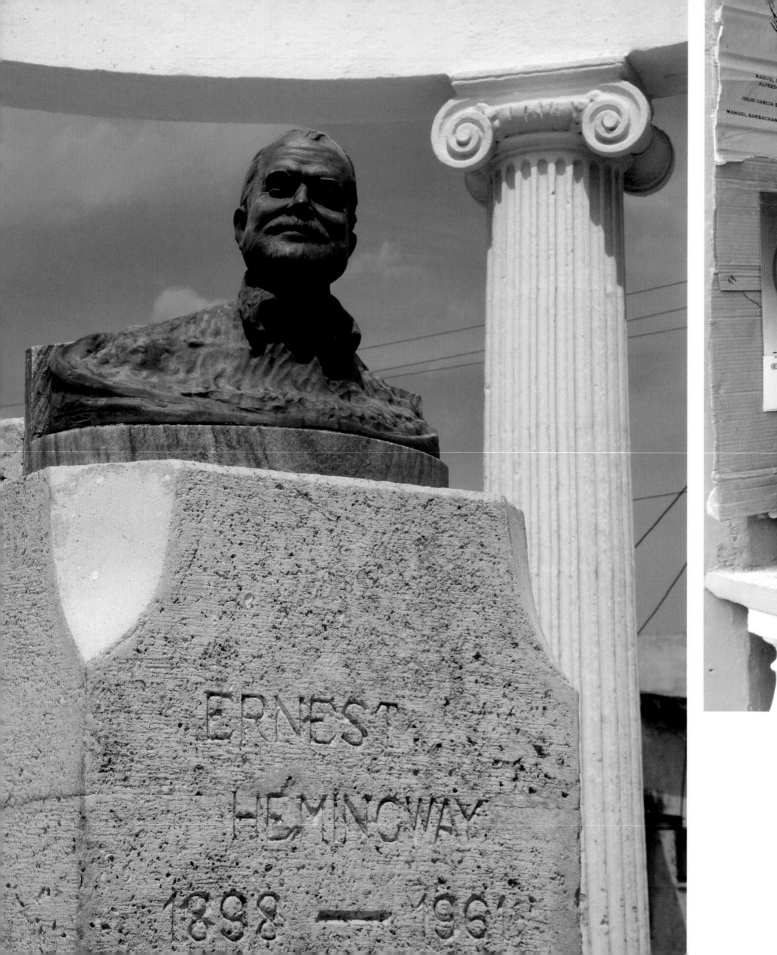

Page 260: *A fortress.*

Opposite: *A memorial to Ernest Hemingway. After Hemingway's death, his fisherman friends collected bronze from abandoned ships to build the bust.*

Above: *A private vendor sells Cuban memorabilia on the porch of her home.*

Page 264: *The living room at Finca Vigía (Lookout Farm), where Ernest Hemingway lived from 1939–1960 and where he wrote* The Old Man and the Sea.

Page 265: *The dining room at Finca Vigía.*

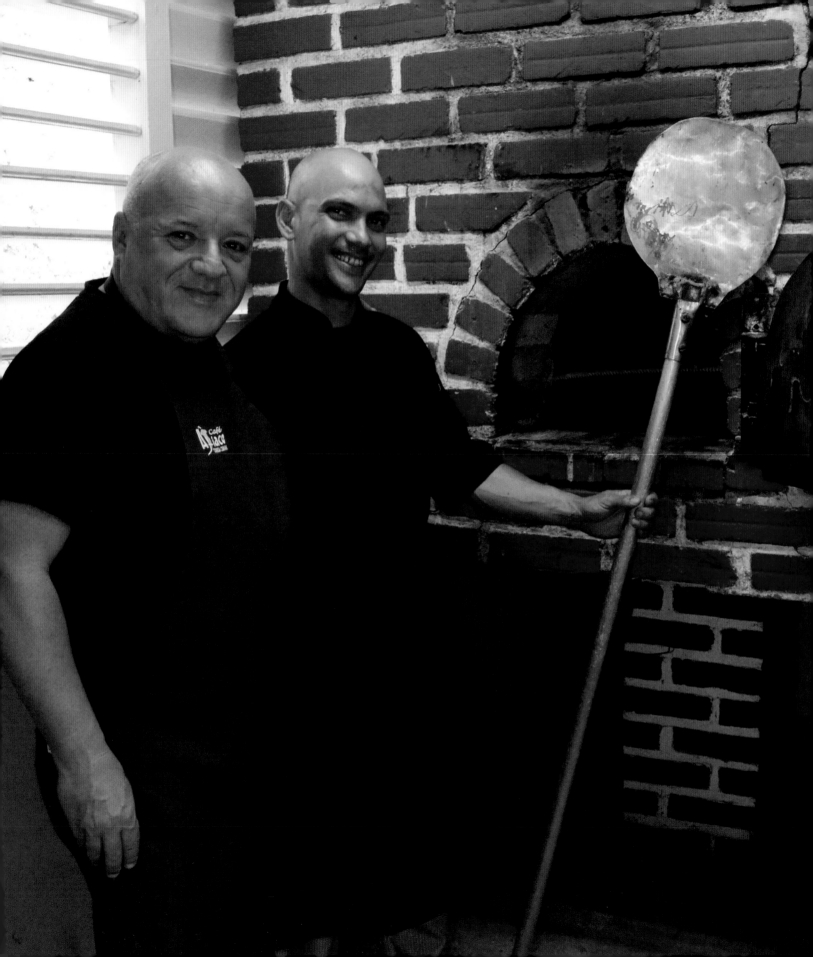

AJIACO CAFÉ

Ajiaco Café, a restaurant owned by award-winning sommeliers Pedro Eugenio Tejeda Torres, his wife, Zudlay Napoles Patterson, and Alexis Garcia Bou, was one of the earliest private dining establishments in Cuba to be a stand-alone business and not part of a home. The name comes from two traditional Cuban symbols: ajiaco stew and coffee. Ajiaco Café treats diners to a complimentary platter of appetizers that include vegetable empanadas, fish croquettes, yuca, and ham fritters. Cuban families dine among foreign travelers visiting the nearby Finca Vigía, Hemingway's former home, which is now a national shrine to the author who spent much of his life in Cuba.

The restaurant is known to mix textures and flavors for a more modern Cuban taste, while using raw materials such as honey instead of sugar. Most of the authentic Cuban and organic herbs used in the restaurant's dishes, such as cilantro, coriander, basil, parsley, and thyme, come from the local organic garden just a few blocks away. In addition to running Ajiaco Café, Pedro and Zudlay offer classes with information about Cuban cuisine, which include a tour of the nearby herb garden, followed by a cooking class in the outdoor patio area of the café. After learning how to cook a few traditional Cuban dishes as well as make Ajiaco-style mojitos with dark rum and honey, participants then get to meet the staff in the kitchen and enjoy the dishes and drinks made during their class.

Left: *Pedro Eugenio Tejeda Torres, left, with Chef Antonio Gonzales Gomez.*

VEGETABLE EMPANADAS

Empanadas Vegetales

Dough

2 cups flour, or more as needed

1 teaspoon baking powder

½ teaspoon salt

1 tablespoon olive oil

1 tablespoon salted butter,
 melted and cooled

1 egg, beaten

1 tablespoon dry white wine

½ cup Simple Syrup (page 287), cooled

Filling

4 tablespoons (½ stick) salted butter

1 cup chopped tomato

1 cup chopped cabbage

1 cup chopped onion

1 cup chopped carrots

 Salt, to taste

To make the dough, combine the flour, baking powder, and salt in a large bowl. Add the olive oil, butter, egg, wine, and simple syrup and mix to make a dough. Add flour if the dough is too sticky; the dough should be elastic. Do not overmix. Cover tightly and refrigerate the dough for 30 minutes.

In the meantime, make the filling. Heat the butter in a cast-iron frying pan, add the tomato, cabbage, onion, and carrots, and sauté until just tender, about 5 minutes. Add the salt and stir to combine. Let cool.

Preheat the oven to 350°F. Roll the dough on a floured surface until very thin, ¹⁄₁₆ to ⅛ inch thick, and cut into 2-inch circles. Place 1 to 2 tablespoons of the filling in the center of each dough circle, then fold the dough in half to make half-moon shapes and crimp the edges with a fork to seal. Transfer the empanadas to a baking sheet and bake 15 to 20 minutes until brown. Serve warm.

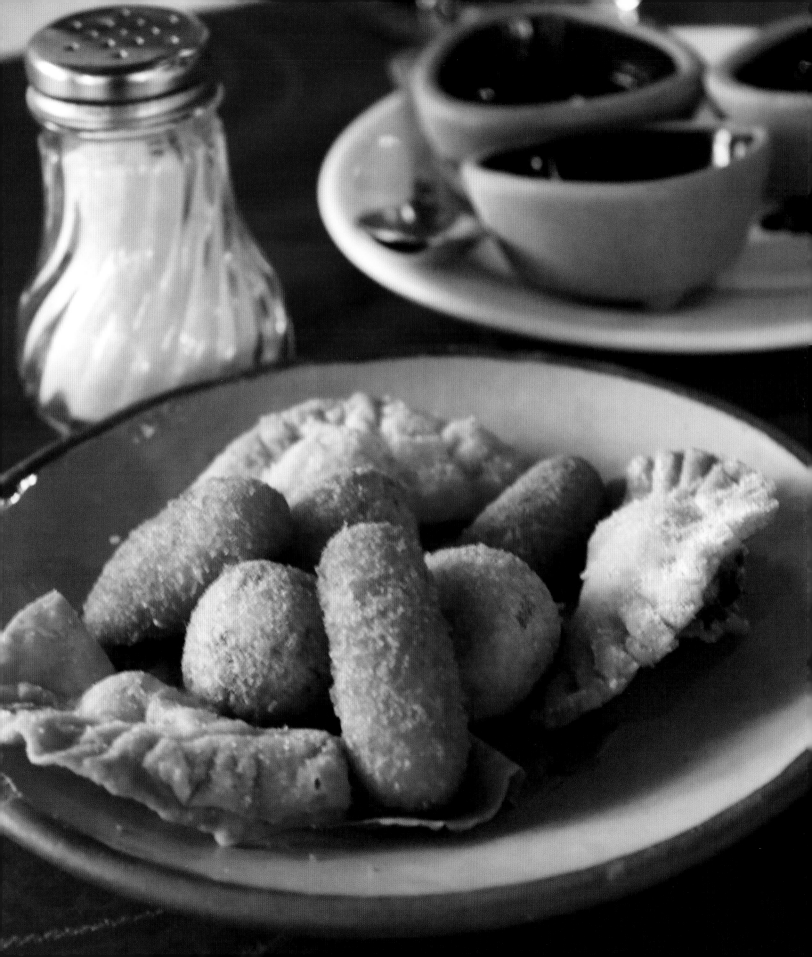

AJIACO STEW

Guiso de Ajiaco

Pork Steak

2 tablespoons olive oil

1 tablespoon coarse salt

1 teaspoon black pepper

2 pounds boneless pork shoulder

2 cups white wine

Jerked Beef

½ pound brisket or boneless short ribs

1 teaspoon spicy or mild jerk rub

1 cup red wine

1 cup water

Ropa Vieja

1 pound brisket or boneless short ribs

1 teaspoon ground cumin

1 teaspoon garlic powder

1 teaspoon salt

1 white onion, finely chopped

1 red bell pepper, finely chopped

2 cups red wine

To make the pork steak, combine the olive oil, salt, and pepper to make a seasoning. Rub the seasoning all over the pork shoulder and let it sit overnight in the refrigerator. Place the pork in a Dutch oven or pressure cooker, and add the white wine and 1 cup water. Cook in the Dutch oven for 3 hours, or in the pressure cooker for 60 minutes. Let cool, then shred and set aside.

To make the jerked beef, rub the beef with the jerk rub and place in a Dutch oven or pressure cooker. Add the red wine and water. If using a Dutch oven, cook for 3 hours. If using a pressure cooker, cook for 60 minutes. Let cool, then shred and set aside.

To make the ropa vieja, rub the beef with the cumin, garlic powder, and salt. Place in a Dutch oven or pressure cooker and add the onion, red pepper, and red wine. If using the Dutch oven, cook for 3 hours at a simmer. If using the pressure cooker, cook for 60 minutes. Let cool, then shred and set aside.

To make the tomato sauce, combine the olive oil, tomatoes, garlic, onion, salt, and sugar in a saucepan and bring to a boil, then lower the heat and simmer, covered, for 30 minutes. Let cool, then puree in a blender or with an immersion blender and set aside.

To make the stew, combine the pork steak, jerked beef, tomato sauce, chicken, yuca, yam, taro, pumpkin, corn, plantains, onion, tomatoes, pepper, garlic, cumin, oregano, and salt in a Dutch oven or pressure cooker. Add enough water to cover all the ingredients. Cook, covered, for 1 ½ hours at a simmer in the Dutch oven, or for 25 to 30 minutes in the pressure cooker.

Remove the lid and continue to simmer, uncovered, until the sauce thickens. Garnish with the ropa vieja and lime slices, then serve. Leftovers can be refrigerated in an airtight container for up to three days or frozen for up to three months.

Tomato Sauce

1 tablespoon olive oil

1 cup chopped tomatoes

2 cloves garlic, minced

¼ cup finely chopped onion

1 teaspoon coarse salt

1 teaspoon sugar

Stew

1 chicken breast, cut into cubes

2 cups cubed yuca

2 cups cubed starchy, white-fleshed yam, or white-fleshed sweet potato (see Note)

1 cup cubed taro root

1 cup cubed Caribbean pumpkin (see Note)

2 small corn cobs, cut into 1-inch-wide pieces

2 mid-ripe plantains, peeled and sliced ½ inch thick

1 large white onion, chopped

16 small, ripe tomatoes, chopped

1 large green bell pepper, chopped

6 cloves garlic, peeled

1 teaspoon ground cumin

1 teaspoon ground oregano

2 ½ teaspoons salt, or more to taste

 Lime slices, for garnish

NOTE: Butternut squash can be used in place of the Caribbean pumpkin, and sweet potato in place of the starchy, white-fleshed yams. White-fleshed sweet potato is, however, far preferable.

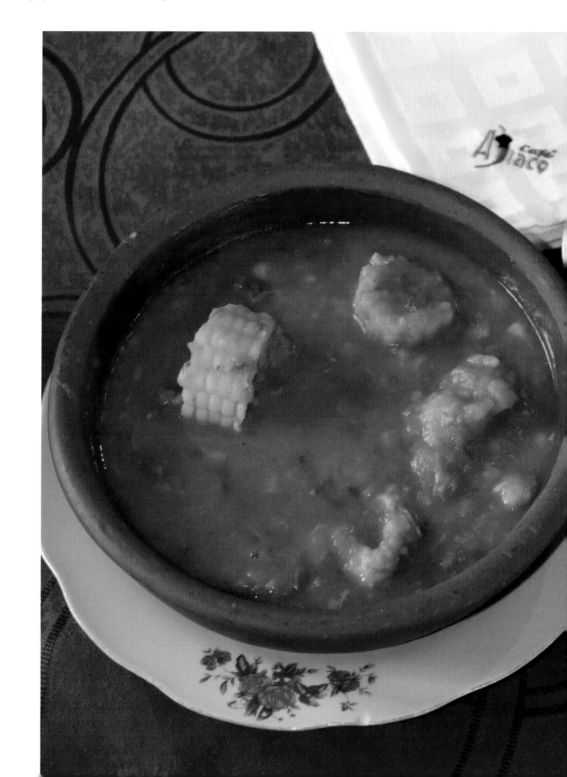

SERVES 4 FRESH FRUIT COCKTAIL

Cóctel de Frutas Frescas

Lime juice (optional)

Granulated sugar

¼ papaya, ripe and yellow
(not green), peeled (see Note)

1 mango, peeled (see Note)

¼ pineapple, peeled (see Note)

2 small guavas, peeled (see Note)

Prepare serving glasses by dipping them in water or lime juice and then in granulated sugar for decoration.

Remove the seeds from the papaya, the pit from the mango, and the stringy center from the pineapple. Finely dice all the fruits, then combine and divide among the serving glasses.

NOTE: The chef uses whatever fruits are available in the market.

RICE PUDDING

Arroz con Leche

1 cup white rice

1 cinnamon stick

1 piece lemon peel

1 cup whole milk

1 cup sugar

1 cup heavy cream

Combine 4 cups of water and the rice, cinnamon stick, and lemon peel in a saucepan and bring to a boil, then decrease the heat and simmer, covered, until the rice is softened, at least 20 to 30 minutes.

Drain off any excess water from the rice, add the milk and sugar, and return to a boil, then lower to a simmer and cook until the mixture is well combined and the sugar is absorbed and no longer granular. When finished, the rice should be soft and have a creamy texture. Remove from the heat and let cool.

Whip the heavy cream in a cold bowl with an electric mixer on high speed until peaks form. Do not overbeat. Fold the whipped cream into the rice pudding until you reach the desired consistency. Some people prefer soft pudding and others prefer a firmer consistency.

RICE PUDDING WITH MOJITO GRANITA

Arroz con Leche con Mojito Granita

1 sprig spearmint or peppermint leaves

1 teaspoon honey

Juice of ½ lemon

1 shot (3 tablespoons) dark rum

Seltzer, to taste

Rice Pudding (above)

Muddle the mint leaves and combine with the honey and lemon juice in a freezer-safe container. Add the rum and stir, then add the seltzer.

Freeze the mixture until solid, then use a spoon to scrape off shavings. Serve with the rice pudding.

NOTE: This can also be served as a cocktail before freezing.

CHAPTER TEN

CUBAN BEVERAGES

In a country where temperatures can soar, drinking cool and refreshing beverages is essential and the options are plenty. The abundance of fresh tropical fruits available at affordable prices provides a delicious base for many fresh juices and batidos (milkshakes). A shot of the island's world-renowned rum is often offered in paladares as an optional addition to a glass of fruit juice to spice up one's meal.

After losing Russian support in the early 1990s, and as a result of the decades-long long US economic embargo restricting trade, including imports of medicines, Cubans have developed an extensive knowledge of the medicinal effects of organic herbs and spices, which are often used to make soothing drinks as natural remedies for a variety of ailments.

Since sugar cane is abundant in Cuba, drinks made with sugar and ice have become popular as a classic cooler. One will often find local *guaraperas* (people who make the *guarapo* drinks) pushing stalks of sugarcane through a metal press to produce a frothy sweet liquid, which is nationally known as an inexpensive and energizing drink.

Beer originally came to Cuba through nearby Jamaica, and after the British captured Havana in 1762, many types of English beer were imported. In 1888, the Herrera family began brewing La Tropical beer in Cuba. Today, it is known as the Cuban national brand Cristal and continues to be one of the most popular beers on the island, along with Bucanero and a few other locally brewed brands.

The history of cocktails in Cuba precedes Prohibition in the United States, when many Americans traveled to this tropical Caribbean paradise for culture and cocktails. Although famous for also being the source of rum-running, or bootlegging, during this time, historians believe classic Cuban cocktails were actually first created in the mid-1800s when Cubans developed the term *Cuba Libre* (Free Cuba) during their liberation struggle from Spain. Soldiers supposedly mixed honey or molasses with water and aguardiente, a generic term for spirits such as the country's now famous rum.

The Cuban style of throwing while bartending—mixing a cocktail from one shaker held high into another held low—is thought to have come with the immigrants from the Asturias region of Spain, where they originally used this technique to serve their *sidra* (cider). Some people claim it was Cuban bartenders who introduced the blender to bars, a technique that led to the creation of frozen drinks. Throughout the years, a variety of classic Cuban drinks have emerged and become internationally recognized as some of the most popular cocktails. Most bars in Cuba are well-stocked with a complete variety of wines, whiskey, vodka, gin, and, of course, Cuban rum of varying ages and quality, all needed to mix the finest libations. Bartenders at many new and trendy paladares are now adding their "Cuban touch" to recipes for Cuba's classic drinks, making changes either to their ingredients or presentation, to allure and satisfy every guest's thirst and desire in a unique and memorable style.

Page 276: *A statue of Ernest Hemingway in La Floridita.*

Below: *The entrance to La Floridita.*

HEMINGWAY'S DRINKS

Ernest Hemingway famously made his presence known in many parts of Cuba, and in several bars. He is known for saying, "I prefer my daiquiris at El Floridita and my mojitos at La Bodeguita del Medio." El Floridita has a bronze sculpture of the author in his regular spot at their bar, with his spectacles on the counter and the writer's creation of the "Doble Daiquiri" (a daiquiri with two shots of rum) in his hand.

It was in Cuba that Hemingway first sampled pineapple, a taste he would treasure. Today, Hemingway's former home in Cuba, the Finca Vigía (Lookout

Farm), located in a small town outside Havana called San Fransisco de Paula, is the site of the Hemingway museum, which serves "Hemingway Guarapos." This drink is made with his beloved pineapple, plus lemon and sugar cane juice. For a small additional cost, one can get the drink with added Cuban rum. The romanticism surrounding Hemingway's life in Cuba still pervades many bars and restaurants throughout Cuba.

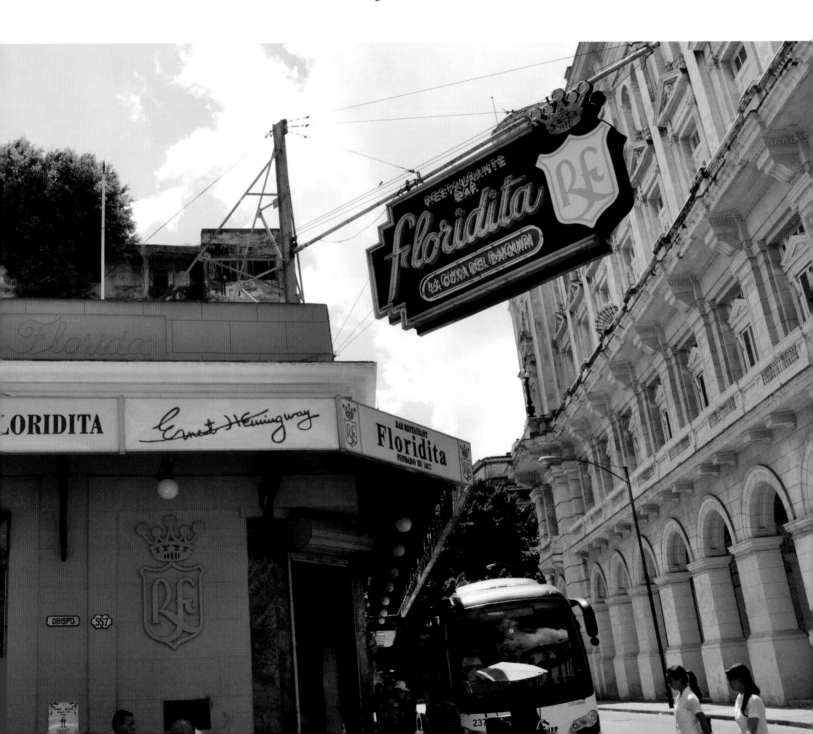

CLASSIC DAIQUIRI

The daiquiri originated in Cuba as a refreshing balance of sweet, sour, and spirit tastes made with rum. Although local residents probably enjoyed this mixture before the arrival of Americans to the island, the daiquiri's history goes back to the late 1800s, when Cuba was fighting for independence from Spain and the United States intervened. It was in 1898, during the Spanish-American War, when President Theodore Roosevelt led the first US volunteer cavalry, named the Rough Riders, and landed on Cuba's eastern shores, near a beach and iron mine named Daiquirí. Soon after their victory, popular lore says that an American mining engineer named Jennings Cox, who was in Cuba profiting from the Daiquirí mine, may have created the first version of the daiquiri drink. Cox was entertaining guests one evening when he ran out of the gin used in their punch libation. The only replacement Cox could find was the island's ubiquitous rum, which he combined with lime and sugar to sweeten for his visitors. When everyone enjoyed the new drink and asked for its name, he called it the "Daiquiri," after the nearby beach and iron mine of the same name. Throughout the next several years, bartenders revised the original mixture and made it as both a multi-serving punch beverage served over ice and a single-serving cocktail made by shaking the ingredients with ice in a shaker. It was two American authors who then gave the daiquiri its recognition and reputation. In 1920, F. Scott Fitzgerald mentioned the daiquiri in his novel *This Side of Paradise*. Later, Hemingway referred to the drink and the place where he drank it, one of his favorite Havana haunts, in his novel *Islands in the Stream*. Years later, President John F. Kennedy was known for favoring daiquiris as his preferred before-dinner drink, which brought the cocktail increased fame and popularity. It remains popular today and many bartenders add their own special twist to this classic recipe.

Right: *Bartender Rolando Fernandez Gonzalez makes classic and strawberry daiquiris at La Floridita.*

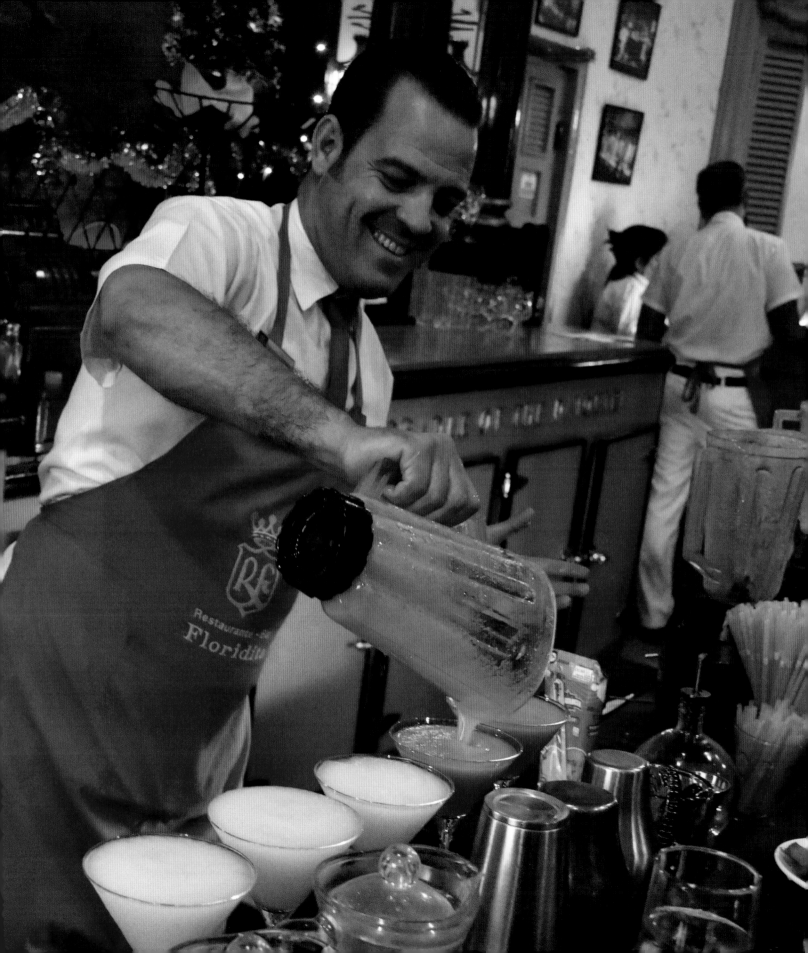

CLASSIC DAIQUIRI

3 tablespoons light rum

1 teaspoon sugar

1 ½ teaspoons fresh lime juice

5 drops maraschino liqueur

Blend all ingredients together with 4 ounces of crushed ice until smooth, and then serve.

NOTE: Some bartenders make a variation on the Classic Daiquiri by adding fresh fruit or juices such as strawberries or guava.

HEMINGWAY DAIQUIRI

Also known as the Papa Doble

4 tablespoons light rum

1 tablespoon grapefruit juice

1 ½ teaspoons fresh lime juice

5 drops maraschino liqueur

Hemingway was affectionately referred to as "Papa" in Cuba. After trying the Classic Daiquiri at El Foridita bar in Havana, Hemingway is said to have commented to Constantino Ribalaigua Vert, the bartender: "It's good, but I like mine with twice as much rum and no sugar." Constantino then created the new drink and named it after the well-known writer and his request to *double* the amount of rum, calling it a "Papa Doble." Bartenders at El Floridita have since added grapefruit and maraschino juice to the drink and this version is known as the "Hemingway Special Daiquiri." However, here, we give you Hemingway's preferred version of the cocktail.

Blend all ingredients together with 4 ounces of crushed ice until smooth, and then serve.

Opposite: *This bartender from El del Frente paladar in Old Havana is making guava daiquiris and using the style of "throwing" the rum into the blender.*

CLASSIC MOJITO

There is some controversy over the true origins of the mojito, a cool, citrus combination with rum. Many historians believe the distinctive Cuban beverage was originally created when Cuban rum was harsh and not as palatable as it is today, so the easily accessible, sweet ingredients of sugar, yerba buena (a mint-like herb), and lime were added to the poor-tasting rum for a smoother and tastier swallow. Professional bartenders eventually adopted the combination, and it became popular among the American tourists who flew to the nearby island of Cuba for a good cocktail during Prohibition. The "mojito" name is believed to have come from the Spanish word *mojar*, which means to wet, or the African word *mojo*, which means a magic spell. The classic mojito has become one of the world's most popular and refreshing cocktails.

Below: *The bartender at Iván Chefs Justo makes mojitos.*

Opposite: *La Bodeguita del Medio, in Havana, is best known as the place where Hemingway liked to have his mojitos.*

SERVES 1 CLASSIC MOJITO

4 sprigs mint (In Cuba, they use yerba buena, a mint-like herb that is hard to find in the United States)

1 tablespoon Simple Syrup (below), or more to taste

3 tablespoons light rum

1 tablespoon freshly squeezed lime juice

Splash of seltzer, to taste

Muddle the mint leaves with a mortar and pestle and mix them with the simple syrup. Add the rum and lime juice and pour into a glass over ice. Add the seltzer, and serve.

MAKES 1 CUP SYRUP SIMPLE SYRUP

1 cup sugar

Combine the sugar and ½ cup cold water in a saucepan over high heat. Boil until the sugar is dissolved, then remove from the heat and refrigerate to cool before use. The syrup can be refrigerated for up to one month.

DuPONT SPECIAL

The DuPont Special is named after American industrialist Irénée Du Pont de Nemours, the original owner of the exclusive Xanadú mansion, in Varadero, where this drink is served.

Thirteen miles of uninterrupted white sand emerging from warm turquoise and blue water make the beach of the Varadero resort town one of the most picturesque beaches in the world. This peninsula is about ninety miles east of Havana, a two-hour drive. Founded in 1887 by ten families seeking permission to build vacation houses, Varadero has always been a place for people in search of refuge from their busy lives. Since its humble beginning, the area has become known as an elite resort location favored by wealthy international travelers. In 1927, Irénée Du Pont de Nemours, former president of the DuPont company, built a mansion for himself that exists today as the elegant Xanadú Mansion, named after the exotic city built by the legendary Mongolian warrior, Kublai Khan.

After the 1959 Cuban revolution, the government expropriated private mansions for the use of the people and the once elitist Varadero resort town was made accessible to everyone. The main park housed facilities for people to take a break from the hot sun and beach. Cubans began flocking to this resort area and local cultural experiences flourished after the revolution and continued until the 1990s.

Communism turned the town into a democratic vacation mecca offering music, dance, and entertainment for everyone, not just the privileged elite, but socioeconomic changes occurred again, and capitalism turned it back into a playground for the wealthy. In the 1990s, with the loss of the economic support of the USSR, foreign hotel operators were invited by the Cuban government to build beach resorts and hotels. Varadero was transformed back into an exclusive destination for tourists willing and able to pay for fancy hotel rooms and meals. In fact, until 2008, local Cubans were banned from the beaches and town.

There are now many luxurious hotels along the beach serving pina coladas, Cuba libres, and other classic cocktails to vacationers. But the Xanadú Mansion stands out as a unique oasis, with panoramic ocean views and an outdoor area to enjoy the sounds of the sea while sipping tropical cocktails, such as their very own DuPont Special.

SERVES 1 DuPONT SPECIAL

2 teaspoons sugar

6 tablespoons pineapple juice

3 tablespoons whole milk

3 tablespoons rum

 Sprinkle cinnamon

Mix all ingredients and ice in a blender. Top with cinnamon for decoration.

CUBA LIBRE
Serves 1

½ cup Coca-Cola

3 tablespoons rum

1 teaspoon freshly squeezed lime juice

1 lime wedge, for garnish

Mix the Coca-Cola, rum, and lime juice and pour into a glass over ice. Garnish with the lime wedge.

Left: *A Cuba Libre shown by the pool at the Melia Cohiba hotel in Havana.*

CUBANITO

SERVES 1

½ ounce lemon juice

2 drops hot sauce

1 ½ ounces rum

4 ounces tomato juice

Salt and pepper, to taste

Lemon wedge, for decoration

Mix all ingredients into a 10 ounce glass filled with ice cubes. Stir and serve with a lemon wedge as decoration.

Right: *A Cubanito shown at the bar of Tierra paladar inside Fabrica del Arte Cubano in Havana.*

FRESH FRUIT JUICES, MILK SHAKES, AND COLA

Jugos Frescos, Batidos, y Cola

Locally made nonalcoholic drinks in Cuba range from a batido (a Cuban milkshake) flavored with Cuba's rich ice cream, sometimes decorated with strawberry or chocolate syrup, to cola (soda) or a *malta* (lightly carbonated malt beverage), which Cuban children receive as a treat on special occasions. Finca Agroecologica el Paraiso in Viñales Valley, Pinar del Río, is known for helping visitors relax upon arrival with their herbal Anti-Stress Drink.

Right: *Vanilla milkshakes with strawberry syrup at Café Laurent.*

Opposite: *Fresh guava juice at Villa Lagarto.*

VIGÍA COCKTAIL WITH SUGARCANE JUICE

SERVES 1

Coctel Vigía con Guarapo

1 cup pineapple juice

Dash of freshly squeezed lemon juice

Sugarcane juice or Simple Syrup (page 287), to taste

Combine the pineapple juice, lemon juice, and sugarcane juice, and then serve.

Opposite: *A Vigía Cocktail sits on a vintage red Chevrolet car with a chrome airplane hood ornament.*

Above: *A woman puts sugarcane into a* trapiche, *a sugar mill, to extract the juice. The sugarcane juice will be served as a drink known as a* guarapo, *at a local* guarapera.

CUBAN COFFEE AND ITS CULTURAL SIGNIFICANCE

Cuban coffee is world-renowned and is an integral part of Cuban culture and social life. On a *visita* (a visit with a neighbor, friend, or relative), the host usually warmly and immediately offers guests a *cafecito*, Cuban espresso made of dark coffee beans. While the coffee is brewing, sugar is added to the *cafetera* (stovetop espresso machine), which makes the drink sweeter than adding sugar after the espresso is already made. For decades it has been Cuban custom to socialize with a *cafecito*, and it is almost rude to decline the offering.

In addition to brewing and enjoying coffee at home, Cubans often buy coffee directly from the window or doorway of a private seller's home, or at a local cafeteria or restaurant. A Cuban will drink the espresso shot, chitchat about life, philosophize on love and art, gossip about family and friends, and then return the coffee cup before continuing the day. Some Cubans prefer café con leche (two shots of espresso with steamed milk), rather than black espresso alone or with sugar, or the smaller-size portion with just one shot of espresso, known as a cortado or *cortadito*.

Another Cuban technique for coffee preparation is to put sugar in a small espresso cup, then add a small amount of espresso and stir vigorously to create a creamy coffee paste. The rest of the espresso is then poured into the cup, creating the *espumita* (light brown foam layer) on the top. It's common for Cubans to enjoy a café con leche and buttered bread for breakfast; a cafecito as an afternoon pick-me-up treat; and a cortadito with dessert after dinner.

No matter where or when it is shared, coffee in Cuba brings people together to enjoy their time, reflect, and spin problems or negativity into a more positive perspective.

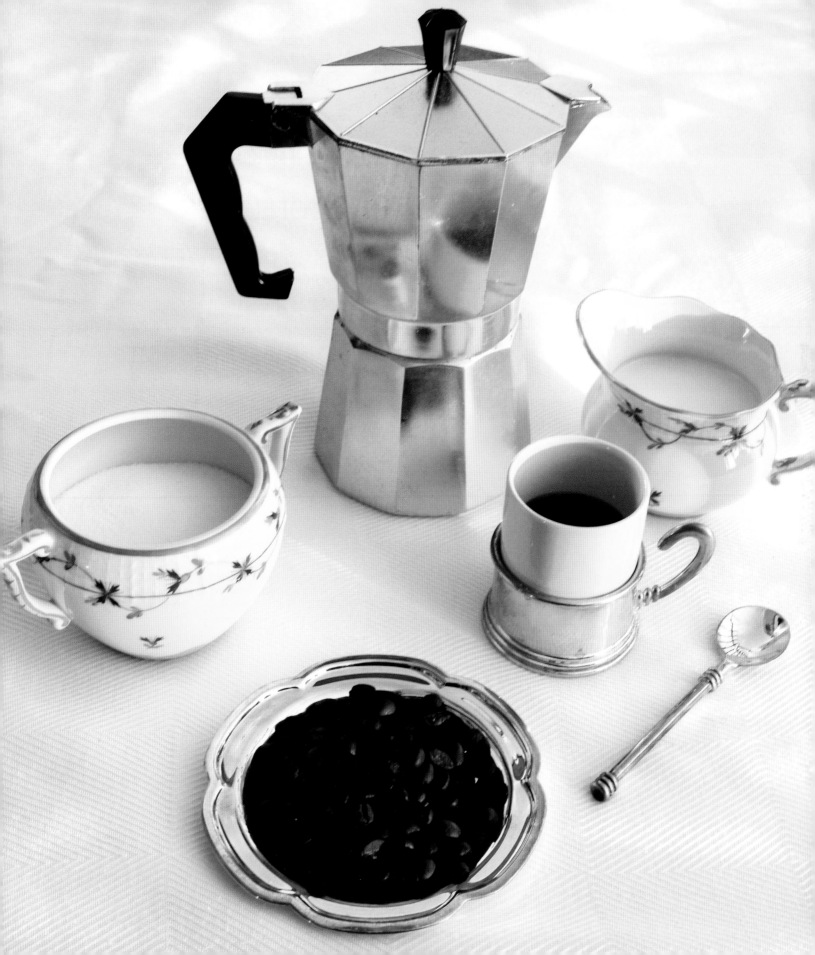

LA GUARIDA COFFEE

La Guarida Café

1 tablespoon sweetened
 condensed milk or Dulce de
 Leche (page 58), melted

1 piece of lemon peel

1 tablespoon rum (optional)

1 shot espresso, hot

½ cup steamed whole milk
 or cream, or to taste

⅛ teaspoon cinnamon

In a tall heatproof glass, combine the sweetened condensed milk, lemon peel, and rum, if using, then add the espresso. Stir to combine. Layer on the steamed milk and sprinkle the cinnamon on top.

———————————————

NOTE: La Guarida Coffee is made and served at La Guarida paladar in Central Havana.

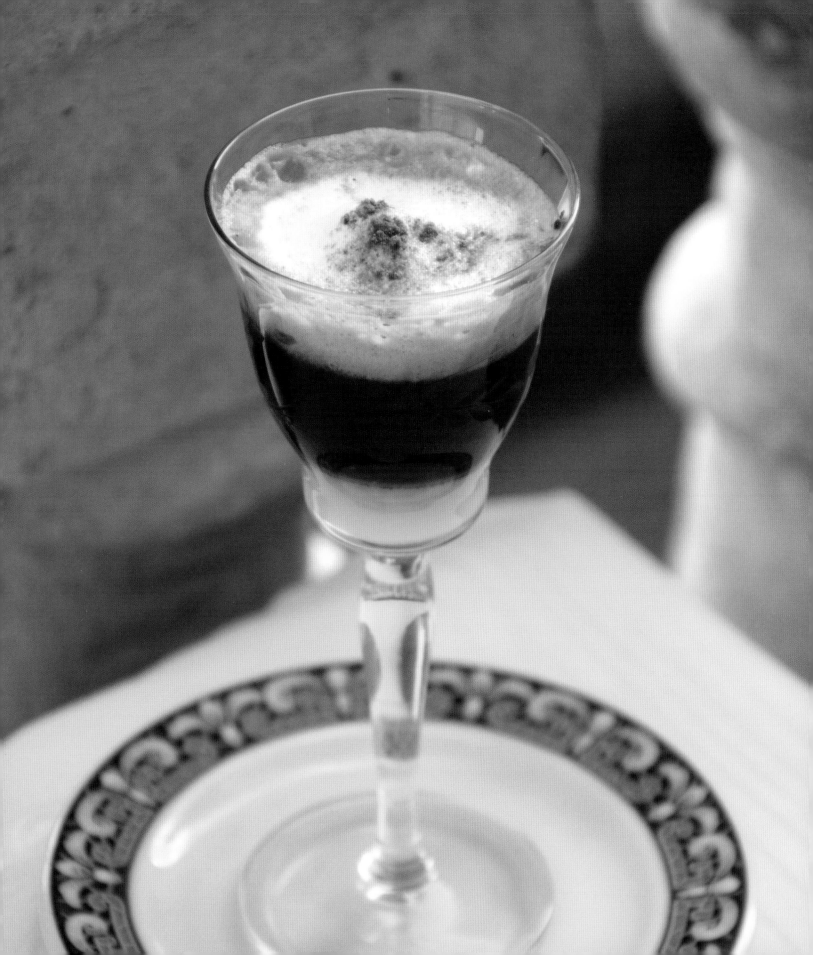

RECIPE INDEX

ACKNOWLEDGMENTS

I t is with infinite gratitude and appreciation that we would like to thank the chefs and paladar owners and their staff members and families who participated in this project, for their enthusiasm, generosity, time, stories, and, ultimately, sharing their truly authentic original recipes for our journey: *A Taste of Cuba.*

Con infinito y sincero aprecio, queremos agradecer a todos los chefs, propietarios y empleados de los paladares, y sus familias, que colaboraron en este proyecto, brindando un inmenso entusiasmo, generosidad, tiempo, historias y finalmente, por compartir sus auténticas, originales y deliciosas recetas durante nuestro trayecto en: A Taste of Cuba.

Thank you to our immediate families who have traveled with us, cooked with us, dined with us, and laughed with us. We could not have made this journey and book without your assistance, support, and encouragement.

With additional thanks to our extended family and friends in both Cuba and the United States for their infinite support of our project.

We would also like to acknowledge and thank Carrie Fediuk, Erica Selesky, Ian Baker, and the Alumni Association of the University of Michigan's Travel Program, who worked with us, and Molly Resnick, for gathering a group of her fabulous and fun friends to travel to Cuba. The recipe research and photography for this book began many moons ago during this inspiring trip together. *Go Blue!* We would also like to thank Judie Lax and A. J. LaCourse for their assistance reporting, tasting, and consulting, and for their support of this project in both Cuba and the United States.

We are grateful to Scott and Anne Reisinger and several Trevor Day School faculty members, for their interest in Cuba and support of this project during travel, professional development, academic research, and cultural exchange. Additional thanks to Cuban-born

Opposite: *The infinity pool at Vistamar Paladar in Havana.*

Spanish teacher Beatriz Rodriguez for coleading the Trevor student academic and cultural exchange experience in Cuba, as well as sharing her knowledge of Cuban food and her homeland.

We are also very appreciative of Luly Duke and the work of Fundación Amistad, which made this exchange, including our continued exploration of Cuban cuisine, possible.

Thanks also to Marriott Hotels for their assistance in our coverage of President Barack Obama's historic visit to Cuba, when some of these recipes were discovered.

The planning for our travel over the years was exceptionally coordinated by Jet Blue, Go Next Travel, Myriam Castillo with Bespoke Travel, Steve Cox with International Expeditions Travel, and Mayra Alonso with Marazul Travel. Thank you for your excellent advice, arrangements, and overall support of this book!

Finally, our utmost gratitude to Julia Abramoff and Alex Merrill at Apollo Publishers for believing in us while sharing our vision and enthusiasm for the Cuban culture and cuisine, and for working patiently, creatively, and tirelessly to help us bring this book into the world. It is an honor and a pleasure to be among your authors, to work with you, and to share the magic of Cuba with a worldwide audience.

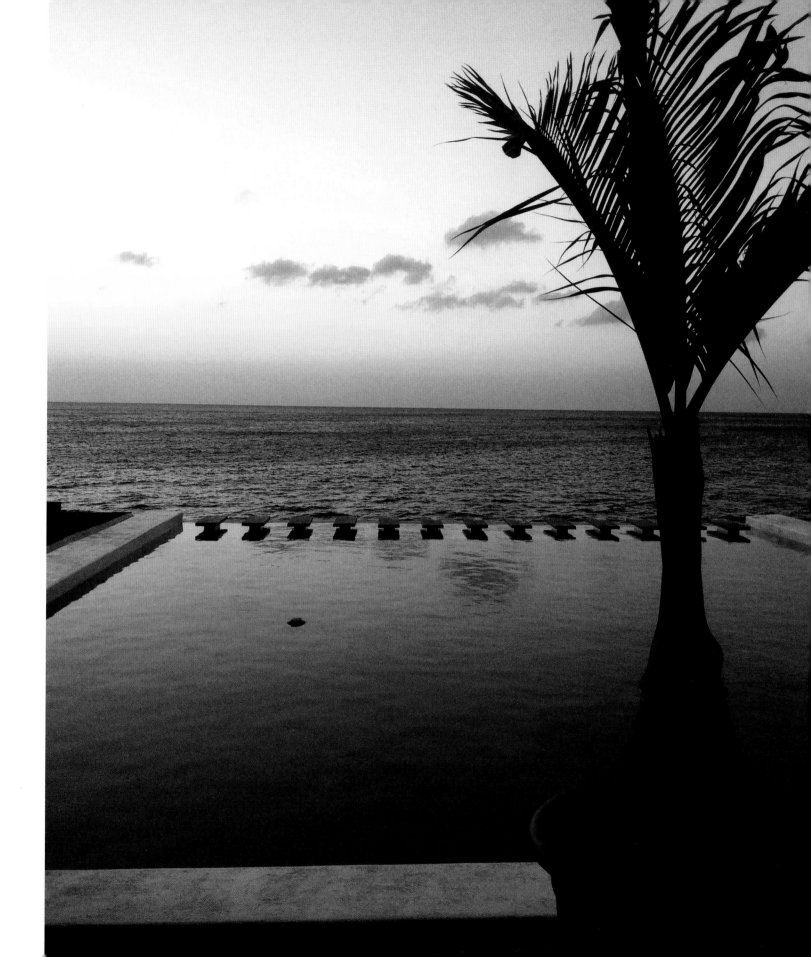

ABOUT THE AUTHORS

© Alicia Michele Alonso

CYNTHIA CARRIS ALONSO has been a photographer and photo editor for the past twenty-five years, working for media such as *Newsweek*, *BusinessWeek*, Time.com, ABCnews.com, *New York Times*, *Vanity Fair*, *Adweek*, and Scholastic. Since 1992, Carris Alonso has regularly traveled to Cuba, documenting its news, musicians, and culture for music recording companies and publications. She is a Cuba consultant on national television, in print, and on radio, and the author of *Passage to Cuba*. Her photographs have exhibited throughout the United States, as well as in Canada and Brazil. She lives in New York City.

© Marea Evans

VALERIE FEIGEN is a self-taught chef who previously worked as a corporate lawyer, stock analyst, and co-owner of Edit, a women's fashion specialty store. At age seventeen, Feigen professionally baked and sold her buttercrunch candy to stores in New York City and Philadelphia. Feigen writes the blog recipistsdiary.com, which shares some of her original recipes. She lives in New York City.

© David DuPuy

JOSÉ LUIS ALONSO is a teacher, writer, and award-winning children's book author of *Secretos con Mi Almohada*, published in Cuba in 1980. Alonso was born in Cuba and lived there for thirty-two years. He met Cynthia Carris Alonso, now his wife, in Havana in 1993. Together the couple has collaborated on lectures and exhibits to celebrate Cuban culture. Prior to working in academia, Alonso was a chef and restaurant manager. He lives in New York City.